Gainsborough Drawings

Distributed by
CHARLES E. TUTTLE CO., INC.
Rutland, Vermont

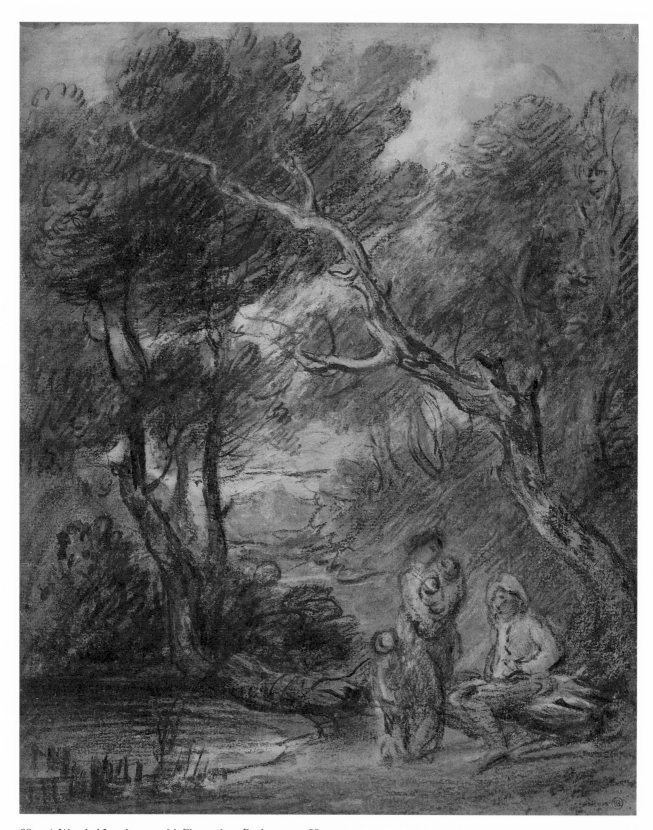

88. A Wooded Landscape with Figures by a Pool c. 1788

JOHN HAYES AND LINDSAY STAINTON

Gainsborough Drawings

INTERNATIONAL EXHIBITIONS FOUNDATION

This project is supported by an indemnity from the Federal Council on the Arts and the Humanities. The catalogue is underwritten in part by grants from The Andrew W. Mellon Foundation and The British Council.

Cover: 82. Study of a Lady, perhaps for *The Richmond Water-walk* c. 1785
Trustees of the British Museum

TABLE OF CONTENTS

ACKNOWLEDGMENTS

The International Exhibitions Foundation takes particular pleasure in bringing to America this major loan exhibition of drawings by the renowned English painter Thomas Gainsborough. Gainsborough produced thousands of drawings during his lifetime (1727–1788), some 800–900 of which are known today. This exhibition, the first in twenty years to be devoted entirely to the drawings of this most gifted artist, brings together 91 of the finest examples drawn from public and private collections in England, Europe, the United States and Canada. Such an achievement could not have been realized without the generous cooperation of the many lenders, to whom we extend our most grateful thanks.

An international exhibition is always a complex undertaking, and many individuals have given unstintingly of their time and talents to ensure the success of this project. First and foremost, we wish to express our profound thanks to Dr. John Hayes, Director of the National Portrait Gallery, London, and the foremost authority on Gainsborough, and to Miss Lindsay Stainton, Assistant Keeper of Prints and Drawings at the British Museum, for their selection of the superb examples of the master's work which appear in this exhibition. Together they have produced a marvelous catalogue with an introduction by Dr. Hayes and individual entries by Miss Stainton. The results attest to the careful attention and scholarly dedication which they brought to both endeavors, and we are indeed in their debt.

Special thanks are due His Excellency Sir Oliver Wright, Ambassador of Great Britain to the United States, who has graciously agreed to serve as honorary patron of the exhibition during its tour.

It is a pleasure to acknowledge once again the support received in the form of an indemnity from the Federal Council on the Arts and the Humanities. And we are most grateful to the British Council and The Andrew W. Mellon Foundation for underwriting a significant portion of catalogue production.

Our colleagues at the participating museums have been helpful and cooperative throughout the long months of preparation and, in every way, deserve our thanks, as does the staff of the Department of Prints and Drawings of the British Museum, whose help in preparing the exhibition and catalogue has been invaluable. We also appreciate the work of our designer and printer in the production of the catalogue, and to Alex and Caroline Castro of The Hollow Press, and William Glick of The Meriden Gravure Company, we extend our heartfelt thanks. We are grateful to our editors, Janet Walker and Angela Gwynn John, for their painstaking supervision of all phases of catalogue production. Finally, I wish to thank the staff of the International Exhibitions Foundation, notably Taffy Swandby, Christina Flocken and Carma Fauntleroy, for their fine performance and diligent and capable attention to the many practical details involved in organizing this exhibition for tour.

ANNEMARIE H. POPE o.b.e.
President
International Exhibitions Foundation

PARTICIPATING MUSEUMS

NATIONAL GALLERY OF ART
Washington, D.C.

KIMBELL ART MUSEUM
Fort Worth, Texas

YALE CENTER FOR BRITISH ART
New Haven, Connecticut

LENDERS TO THE EXHIBITION

THE ASHMOLEAN MUSEUM, Oxford
BIRMINGHAM MUSEUMS AND ART GALLERIES
THE BRITISH MUSEUM, London
CABINET DES DESSINS DU MUSÉE DU LOUVRE, Paris
CASTLE HOWARD COLLECTION
COLLECTION OF HUGH CAVENDISH
THE CECIL HIGGINS ART GALLERY, Bedford
COURTAULD INSTITUTE GALLERIES, London
EXECUTORS OF THE LATE VISCOUNTESS WARD
 OF WITLEY
H.R.H. THE DUCHESS OF KENT
INGRAM FAMILY COLLECTION
THE METROPOLITAN MUSEUM OF ART, New York
MUSEO DE ARTE DE PONCE, Ponce
MUSEUM BOYMANS-VAN BEUNINGEN, Rotterdam
NATIONAL GALLERY OF ART, Washington
NATIONAL GALLERY OF IRELAND, Dublin

NATIONAL GALLERY OF SCOTLAND, Edinburgh
THE NATIONAL PORTRAIT GALLERY, London
PENNINGTON-MELLOR-MUNTHE INHERITANCE, England
THE PIERPONT MORGAN LIBRARY, New York
PRIVATE COLLECTIONS
RIJKSPRENTENKABINET, RIJKSMUSEUM, Amsterdam
STAATLICHE MUSEEN PREUSSISCHER KULTURBESITZ,
 KUPFERSTICHKABINETT, Berlin
THE TATE GALLERY, London
THE TOLEDO MUSEUM OF ART, Toledo
COLLECTION OF MR. ERIC H. L. SEXTON
WM. ELLERY SMITH, Stonington
VICTORIA AND ALBERT MUSEUM, London
J. ST. A. WARDE, ESQ.
WHITWORTH ART GALLERY, Manchester
COLLECTION OF LADY WITT
YALE CENTER FOR BRITISH ART, New Haven

YALE UNIVERSITY ART GALLERY, New Haven

NOTE:

The following drawings are restricted to showing only at the National Gallery of Art:
Cat. nos. 3, 17, 19, 20, 23, 72, and 91.

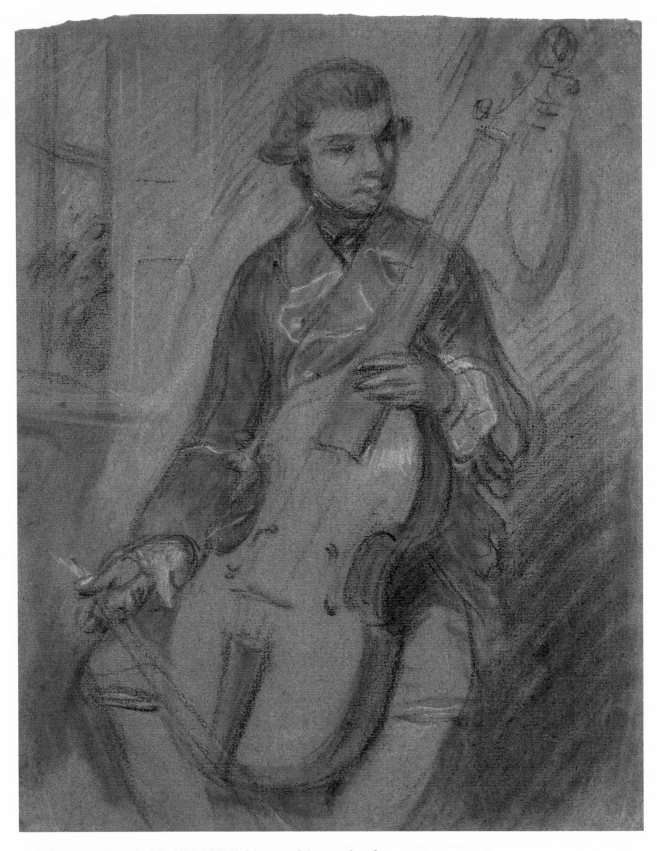

32. Study for a Portrait of Carl Friedrich Abel (1725–1787) early 1760s

INTRODUCTION

NOT LONG AGO one of the foremost American historians of British art, Robert Wark, curator of the Huntington Art Gallery, San Marino, wrote that "Gainsborough's landscape drawings are among the most beautiful works of art on paper ever produced by an Englishman." If one stops for a moment to think of the masterpieces on paper of Girtin, Cotman, or Turner, to name just three of the more illustrious among British draftsmen and watercolorists, this is high praise. But Gainsborough's genius lay not only in landscape, which was his main preoccupation, but in figure drawing. And in this field he is fully the equal of such brilliant contemporaries as Fuseli or Rowlandson, or, on the Continent, Boucher, Fragonard or Tiepolo. On this showing he must be accounted one of the master draftsmen of the European tradition; and his place in this tradition art lovers may judge for themselves in the present exhibition, the first devoted solely to Gainsborough's drawings for over twenty years and in which some of his finest work has been assembled for the visitor's enjoyment.

Some artists make drawings chiefly for a specific artistic purpose; they are a preparation for paintings. This was the Italian tradition, for which Raphael may stand representative. Others draw for the same reason as many people sing; it is the most spontaneous expression of their personality. Gainsborough, like Rembrandt and Degas, belongs to the latter class. He was a compulsive draftsman. We are told that "he loved to sit by the side of his wife during the evenings, and make sketches of whatever occurred to his fancy, all of which he threw below the table, save such as were more than commonly happy, and these were preserved, and either finished as sketches or expanded into paintings." So obsessive was this evening activity that, as he grew older, it ceased to be the relaxation it had been once from the pressures of his daytime work as a fashionable professional portrait painter; and it began to affect his health, never robust. His daughter Margaret reported that he "had drawn much by Candle Light towards the latter part of his life when He thought he did not sleep so well after having applied to drawing in the evening not being able to divest himself of the ideas which occupied his mind, He therefore amused himself with Music."

1

Music was the one other occupation which absorbed Gainsborough's energies; indeed "he himself thought he was not intended by nature for a painter, but a musician." Praised as an executant on the viola da gamba, the harpsichord and other instruments, he was an intimate of most of the leading composers and performers of the day—the age of Giardini, the Linleys, Abel and J. C. Bach—and accepted wholeheartedly their belief that "music must, first and foremost, stir the heart," himself excelling as an extempore player. There can be little doubt that music, and contemporary musical style in particular, had a profound effect on the character of Gainsborough's art; and sentiment, rhythm and bravura were of the essence of his draftsmanship.

It is in keeping with Gainsborough's very personal attitude to drawing that, except in his early days—when he was often hard up, and Panton Betew, a dealer in Old Compton Street, London, stocked his finished drawings as well as his landscape paintings—he never regarded his drawings as works for sale. According to his close friend of the 1780s, Sir Henry Bate-Dudley, editor and proprietor of *The Morning Herald*, "the few he parted with during life were either *gifts* to very particular friends, or select persons of fashion; . . . he could never be prevailed upon to receive money for those effusions of his genius." Abel (no. 32), an enthusiast for anything by Gainsborough, owned a choice collection; some he in turn gave away, principally to his mistress, Signora Grassi, but no fewer than thirty-two were to figure in the sale of his effects after his death in 1787. Sheridan, husband of the beautiful amateur singer, Elizabeth Linley, had twelve of Gainsborough's drawings; the lovely Duchess of Marlborough eight or ten. But it was not only intimate friends, the great or grand who were so fortunate; six, for example, were presented to Charles Wray, the chief accountant at Hoare's Bank, where Gainsborough kept an account. One recipient of twenty of his drawings "pasted them to the wainscot of her dressing-room" (it was then a fashion to paste prints onto walls). Gainsborough rarely signed his drawings, indeed any of his works, but on some of the drawings he gave away he stamped his monogram in gold while others he embellished for the purpose with gold-tooled arabesque borders, adding to them stamped signatures or initials (no. 75); these latter form an especially interesting group as, for the most part, they are unusually impressionistic in character and would seem to be an unlikely type of presentation drawing—presumably, however, they accorded with the taste of the time, a point which we shall touch on later.

Even a proportion of Gainsborough's working sketches or studies from nature found their way into friends' hands. Joshua Kirby and Philip Thicknesse, both of whom first met Gainsborough in the 1750s, had a large number of drawings done at this period; Kirby owned over a hundred and Thicknesse "a great many sketches of Trees, Rocks, Shepherds, Ploughmen, and pastoral scenes, drawn on slips of paper, or old dirty letters, which he called *his riding School*." But many such sketches, of course, he kept for his own use. In the earlier part of his life his studies *ad vivum*, especially of plants and animals, seem to have served, like the studies Watteau made, as a repertory of motifs he could

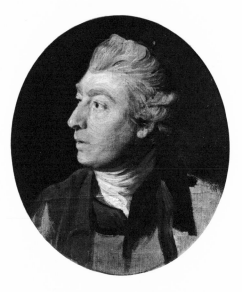

Fig. 1 Johann Zoffany. *Portrait of Thomas Gainsborough* in about 1771–72, when he was in his early forties. Canvas. 7⅝ × 6⅝ in. (19.4 × 16.8 cm.). The Trustees of the Tate Gallery, London.

2

look through and employ, as appropriate, in his landscape paintings. Later he tended not to operate this way, working more directly, as he did with his portraits, and most often dispensing altogether with sketches other than as an initial compositional idea. So far as we can judge from surviving drawings, the ten sketchbooks that remained in the studio and which were offered for sale after Mrs. Gainsborough's death, in 1799, were mainly early ones the artist had happened to keep.

Gainsborough (fig. 1) was born in 1727, the year George II ascended the throne, in the little market town of Sudbury, in Suffolk. His family had long been connected with the wool trade in East Anglia, and were independent-minded nonconformists. Gainsborough was brought up as, and in many ways remained, a countryman. His great delight as a youngster was to go sketching in the surrounding countryside, for which purpose he often played truant from school, and he recalled later that "during his *Boy-hood* . . . there was not a Picturesque clump of Trees, nor even a single Tree of beauty, no, nor hedge row, stone or post, at the corner of the Lanes, for some miles round about the place of his nativity, that he had not . . . perfectly in his *mind's eye*." The account reads like Constable, also a Suffolk man.

When he was only thirteen Gainsborough prevailed upon his father to send him up to London to become an artist, and he was fortunate to be trained in the studio of the distinguished and influential French draftsman, designer and book illustrator, Hubert-François Gravelot, who established himself in London from 1732 until 1745 and did more than anyone to disseminate in England the style of the French rococo, especially in the field of the decorative arts. Thus from the beginning Gainsborough moved in the *avant-garde*, centered on the St. Martin's Lane Academy—what aptly has been called the St. Martin's Lane set, of which the redoubtable, innovative leader was Hogarth. But it was not an *avant-garde* much concerned with landscape. Though it is impossible now to demonstrate whether Gainsborough designed and drew for Gravelot most of the decorative surrounds for the portraits in Birch's mammoth publication, *The Heads of Illustrious Persons of Great Britain*, as asserted in a well-informed obituary notice in *The Morning Chronicle* in 1788, this particular enterprise was in progress all the time Gainsborough was associated with Gravelot, and there seems little doubt that he must have been closely involved with work either of this kind or for the decorative arts. Certainly the vigorous and swirling rhythms of the rococo of the 1740s, so marked a feature of the best of the ornamental frames for Birch's portraits (fig. 2), were to run in his head for the rest of his life. They were the very foundation of his drawing style.

At this distance in time it is unlikely that any drawings will emerge that can be connected with Gainsborough's work for Gravelot; their style as well as their subject matter would probably be so different from the Gainsborough we know as to preclude recognition. Even his first independent drawings, a pair of portraits, would be hard to attribute, except on grounds of sheer quality, were they not documented. These are the small ovals of an unknown man and woman, signed and dated 1743–44 (nos. 1 and 2), which are executed in pencil in a meticulous

Fig. 2 Assistant of Hubert-François Gravelot. Drawing for one of the surrounds for Thomas Birch's *The Heads of Illustrious Persons of Great Britain*. The oval portrait inset of Francis Russell, 2nd. Earl of Bedford, is by George Knapton. Published in 1740. Brown wash. 6¹³/₁₆ × 5¾ in. (17.3 × 14.6 cm.). Visitors of the Ashmolean Museum, Oxford (Sutherland Collection).

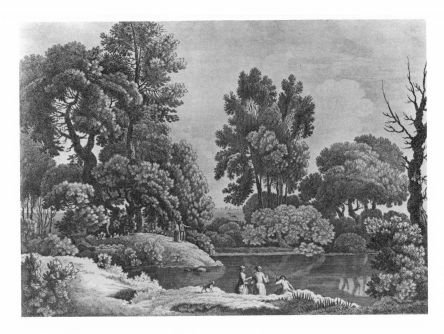

Fig. 3 Thomas Gainsborough. *Wooded Landscape with Fishing Party*. Engraving published by John Boydell, 1747. The Trustees of the British Museum, London.

but sensitive miniature-like technique; the work of the sixteen-year-old Gainsborough, a year before he set up on his own, there is nothing else like them in his *oeuvre* as we know it. Closer to Gravelot are the dainty, elegant figures that make up the staffage in a set of four very schematic landscape compositions (fig. 3) which were engraved by John Boydell, then only in his twenties and newly established as a print publisher, in 1747. So fascinating are these for the study of very early Gainsborough that one may not pause to reflect how unusual such elaborate landscape prints were for this date. Boydell was nothing if not enterprising from the very outset of his long and successful career. Gainsborough's original drawings for this series do not survive, and were probably executed a year or so earlier, as by 1747 his compositions were already a good deal more sophisticated.

He matured quickly, turning to Dutch painting and drawing of the seventeenth century for the formation of his landscape style. In particular he copied and imitated the more naturalistic landscapists, Ruisdael (no. 6), Waterloo and Wijnants, deriving from their practice a mastery of depth and ground plan—specifically the device of alternating dark and light planes—a recognition of the importance of the sky both compositionally and for the expression of emotion, an enduring feeling for light, and certain technical tricks for the rendering of foliage, grasses and other detail (figs. 4 and 5). In 1748 Gainsborough left London to return to his native Suffolk, and practiced both as a portrait and as a landscape painter—but principally perforce the former, for such demand as there was lay in this field—first in Sudbury, then, from 1752, in the more lively seafaring town of Ipswich. At Ipswich he found patrons even among the Dutch who traded with East Anglia, as his pastel portrait of a bluff Dutch sea captain demonstrates (no. 10). Such

4

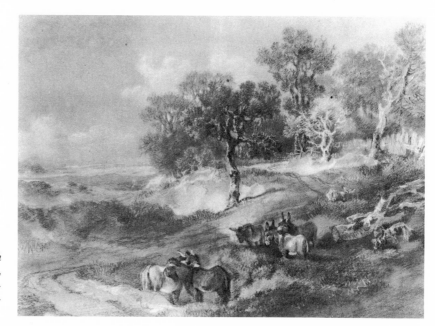

Fig. 4 Thomas Gainsborough. *Landscape with Donkeys*. Late 1740s. Black chalk and stump, gray stump and white chalk on buff paper. 14⁹/₁₆ × 20⁵/₁₆ in. (37.0 × 51.6 cm.). T. R. C. Blofeld, Esq., Hoveton House, Norfolk.

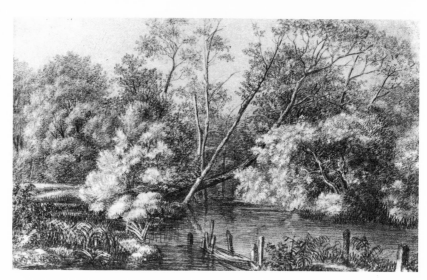

Fig. 5 Anthonie Waterloo. *Wooded Landscape with Stream*. Black and white chalks on gray-green paper. 12⁷/₁₆ × 20⁵/₈ in. (31.5 × 52.5 cm.). Visitors of the Ashmolean Museum, Oxford.

few portrait studies as have come down to us from this period exhibit a similar assurance and angular sweep of chalk work, and are comparable both in technique and in quality with the work of Chardin or Parrocel. As the years went by he developed, too, a more vigorous and personal style in his landscape drawing, in which Dutch elements and compositions were fused with a pronounced rococo swing and undulation, foliage was treated more rhythmically, and the touch became freer (no. 22). In this genre, however, he continued to work almost exclusively in pencil, which inhibited broad effects. It was not until he left Suffolk, in 1759, to seek a wider practice and a better income in the exclusive spa town of Bath—then at the very height of its fashion and prosperity—that his style significantly changed.

Like Newport *vis-à-vis* New York in more recent times, the company at Bath was London society translated, and at leisure, for the season, and opportunity abounded. Surprisingly, however, the competition was negligible, and Gainsborough achieved an instant success. He was no longer confined to head and shoulders portraits for a limited clientele, as he had been in East Anglia; demand was equally for grand full-lengths, and he mixed freely with the aristocracy. He had the opportunity to see fine collections of old master paintings in the great country houses in the vicinity, such as Corsham, or further away, at Wilton and Longford Castle, and he came deeply under the spell of Van Dyck and Rubens. He was on course for a spectacular career.

Most of Gainsborough's portrait drawings of these years are studies of costume, sketches by means of which he learnt to cope with the disposition of the flounces and folds of the elaborate women's dresses of the day. Perhaps the most charming of these works is the drawing of a lady holding a rose in the British Museum (no. 34), a study brought to an unusually high state of finish and probably less a sketch than a drawing *con amore*. For the purpose of these studies Gainsborough often used for his model, as Gravelot and Roubiliac had done, an articulated doll with its own wardrobe of clothes. Full composition sketches are much rarer, though one does exist for the very first full-length he painted at Bath, the portrait of the vivacious Ann Ford, shortly to marry his friend Philip Thicknesse. Except in cases where the design was complex, as later with his group of the Duke and Duchess of Cumberland attended by Lady Elizabeth Luttrell (no. 65), Gainsborough, always impetuous and anxious to get on with the job, preferred to work out his compositions directly upon the canvas. He worked a good deal at this time in pastel, a medium popular in the mid and late eighteenth century, though not on the scale—either in extent or in size—characteristic of such specialists as Cotes, Russell or Daniel Gardner. But his most enchanting portrait drawings of this period are undoubtedly those rapid and spontaneous sketches done entirely for his own pleasure or to delight his friends, sketches such as the group of musicians round a harpsichord (no. 45), to which we shall refer again, in which the figures are not only brought vividly to life but keenly portrayed in all their individuality, with the freest of chalk work, or the more finished study of a cat sketched in six different positions, purring and licking itself on the hearth rug (no. 40), a work as graceful and as sharply observed as a sheet of studies by Watteau. Such drawings are, indeed, among the most appealing ever produced during the eighteenth century.

Never was Gainsborough's technique as a landscape draftsman more varied than during the fifteen years he spent at Bath. Pencil he now abandoned except as an initial outline, and he worked in wash and watercolor as well as in chalks. Some of his pen and brown wash drawings are close in technique to a certain type of Claude, or to such Dutch Italianate seventeenth-century draftsmen as Both or Swanevelt; his watercolors, on the other hand, gentle in mood and the medium for such delightful effects as the play of summer sunshine in a woodland

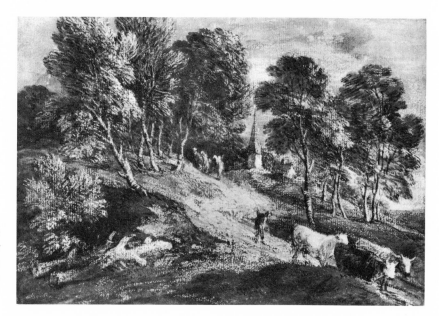

Fig. 6 Thomas Gainsborough. *Landscape with Church on a Hilltop and Herdsman Driving Cattle Home.* Early 1770s. Black and white chalks, gray wash and oil on brown-toned paper, varnished. 8⅝ × 12⁷∕₁₆ in. (21.9 × 31.6 cm.). Private Collection, England.

glade (no. 39), are related more to the native tradition of Taverner and Skelton. An increasing interest in chiaroscuro and in effects of light, which led Gainsborough to find candlelight more useful for his painting than natural daylight, resulted in his adoption of an opaque lead white for heightening, both in his wash drawings and his watercolors; this he applied broadly and loosely in the sky, using quick, nervous touches for the reflected lights in tree trunks and foliage. It was a technique probably suggested to him by the gouache drawings of Giovanni Battista Busiri, examples of whose work he could have seen in the Price collection at Foxley. Later still he began to experiment with more complex techniques in a variety of media, using an admixture of oil to give added richness and force to these works and finishing with a coat of varnish (fig. 6); one such process he described in detail in a letter to his friend William Jackson, "Swear now never to impart my secret to any one living. . . ." In common with those watercolorists who sought, by giving their work something of the strength of oil paintings, to raise their status as artists and to win acclaim amidst the glare and competition of the new public exhibitions (the Society of Artists was founded in 1760, the Royal Academy in 1768), Gainsborough exhibited a series of drawings in imitation of oil painting in 1772. Two years after this he left his comfortable practice in Bath, and his equally comfortable house in Wood's magnificent new Circus, and settled in London. Gainsborough remained there, occupying the west wing of Schomberg House in Pall Mall, the façade of which still stands, until his death in 1788, a year before the French Revolution.

Gainsborough's later styles in landscape painting, from the mid 1760s onwards, owe most to his captivation with the effects and the brilliance and force of handling of Rubens's landscapes, so many of which were then in British collections. This all-pervasive influence of

7

Rubens also affected his drawings, though less directly than in the case of Watteau. Hoppner described the late drawings as composed of an "agreeable flow of lines, and breadth of effect." Works such as the mountain scene (no. 64) based on a drawing which Gainsborough made of Langdale Pikes during his tour of the Lake District in 1783, demonstrate the powerful lateral rhythms that so excited him at this period and into which the forms are swept willy-nilly, their shapes and contours inexorably softened. At its extreme the effect can be similar to a Van Gogh. This pulsating sense of rhythm was accentuated by the whirlwind and often staccato application of white chalk, scattering highlights across the surface of the paper in rococo fashion.

Gainsborough's technique naturally became more summary as it became more rapid. Both characteristics were already apparent to observers as early as the 1760s, and two accounts are worth quoting in full, if principally to convey something of the flavor of Gainsborough at work. Edward Edwards, who in 1808 published a volume of anecdotes of English painters, and was himself a watercolorist, wrote of Gainsborough's Bath period drawings that some "were executed by a process rather capricious, truly deserving the epithet bestowed upon them by a witty lady, who called them moppings. Many of these were in black and white, which colours were applied in the following manner: a small bit of sponge tied to a bit of stick, served as a pencil for the shadows, and a small lump of whiting, held by a pair of tea-tongs was the instrument by which the high lights were applied; beside these, there were others in black and white chalks, India ink, bister, and some in a slight tint of oil colours." Henry Angelo, a gossip-writer who was the son of Gainsborough's friend, Domenico Angelo, the fencing master, also uses the term "moppings" in his description. "Not acknowledgeing bounds to his freaks, instead of using crayons, brushes, or chalks, he adopted for his painting tools his fingers and bits of sponge. His fingers, however, not proving sufficiently eligible, one evening, whilst his family and friends were taking coffee, and his drawing thus proceeding, he seized the sugar-tongs. . . . He had all the kitchen saucers in requisition; these were filled with warm and cold tints, and dipping the sponges in these, he mopped away on cartridge paper, thus preparing the masses, or general contours and effects; and drying them by the fire, (for he was as impatient as a spoiled child waiting for a new toy,) he touched them into character, with black, red, and white chalks." Gainsborough's excitability as he worked is stressed by his daughter, Margaret, who later told the diarist and friend of Constable, Joseph Farington, that her father "scarcely ever in the advanced part of his life drew with black lead pencil as He cd. not with sufficient expedition make out his effects."

Gainsborough's technical mastery and manual dexterity were astonishing; perhaps no other English painter or draftsman save Turner has possessed quite such remarkable natural gifts. His application of wash was unerring, his highlights brilliant and sure. He was capable of an expressive line so broken and intermittent as almost to be shorthand in places, and in certain late drawings used wash impressionistically to

suggest rather than to delineate forms (no. 91), in a manner akin to Alexander Cozens's "blottings." Cozens's manual for assisting landscape invention was a book of which Gainsborough must have been very well aware. Two lost drawings, the object of which, so we are informed, was "to illustrate the effect of sunbeams piercing through clouds in opposite directions," sound remarkably like imitations of studies by Cozens.

If Gainsborough's characteristic landscape drawings proceeded from the imagination rather than from natural perception, this is not to say that he neglected nature. Far from it. A man of feeling whose every response was finely tuned, he was keenly observant of his surroundings, and Reynolds's description is well known: "Among others he had a habit of continually remarking to those who happened to be about him, whatever peculiarity of countenance, whatever accidental combination of figures, or happy effects of light and shadow, occurred in prospects, in the sky, in walking the streets, or in company." Uvedale Price wrote of making "frequent excursions with him into the country" during his youth, and the miniaturist, Ozias Humphry, also referring to Gainsborough's period of residence at Bath, recalled, in his unpublished autobiographical memoir, that "When the Summer advanced, and the Luxuriance of Nature invited and admitted of it, he accompanied Mr. Gainsborough in his Afternoon Rides on Horseback to the circumjacent Scenery, which was in many Parts, picturesque, and beautiful in a high Degree. — To those and succeeding Excursions the Public are indebted, for the greater Part of the Sketches, and more finished Drawings from time to time made public by that whimsical, ingenious, but very deserving Artist."

Apart from these daily rides, which seem to have been prompted, or at any rate encouraged, by a serious illness he suffered in 1763, Gainsborough was often in the country visiting friends. A delightful oil sketch survives of a young lad who used to carry his materials when he was staying with Goodenough Earle at Barton Grange, near Taunton, in Somerset, and his host was given, over the years, fourteen exceptionally fine drawings, most of which are now in American collections, having been sold *en bloc* in New York in 1913. There are references in his letters to plans to stay with William Jackson on the Devonshire coast, and with the Unwins in Derbyshire: "I suppose your Country is very woody—pray have you Rocks and Water-falls! for I am as fond of Landskip as ever." Two longer trips are recorded from his London days, one in about 1782 in the West of England with his nephew and studio assistant, Gainsborough Dupont, and another in the late summer of 1783, an excursion to the Lake District, by then the mecca of the picturesque tourist, in the company of his old Suffolk friend, later his executor, Samuel Kilderbee. Sadly, few sketches survive from these trips: only pencil drawings of Tintern and Glastonbury Abbeys (no. 63), and more atmospheric studies in wash of Langdale Pikes and another Lakeland scene, so far unidentified.

A number of Gainsborough's more finished watercolors may also have been done directly from nature. Certainly the study of some beech

trees at Foxley (no. 24) is described as such. However, he was fully capable of producing, from rough sketches, even so sensitive an evocation of summer sunlight as the woodland scene in the British Museum (no. 39); Turner, we may remember, habitually worked up his watercolors from scrappy jottings in pencil and, aided by a prodigious visual memory, found this no problem.

What were the subjects Gainsborough habitually drew? Most English landscape drawings and watercolors of the eighteenth century were connected in one way or another with topography; apart from the sketches to which we have referred, Gainsborough's, on the whole, were not. As Robert Wark has written, his "flow and rhythm could hardly coexist comfortably with the conscious deliberation required to record a particular view with topographical accuracy." In fact, he gave up straight topographical commissions (the best known is Thicknesse's request for a view of Landguard Fort and the River Orwell) when he was in his twenties. His early drawings were chiefly woodland scenes of undulating country with winding tracks, figures and animals, often including sandy or chalky banks, ponds and pollarded trees, cottages nestling among trees or church towers rising over them; the figures, cows and donkeys were introduced principally as accents and, as late as 1767, Gainsborough described his staffage as there merely "to fill a place (I won't say stop a Gap) or to create a little business for the Eye to be drawn from the Trees in order to return to them with more glee."

Gradually both his subject matter and his attitude towards it changed, though the trees remained the principal feature, assuming a vigorous life of their own and charged with a greater and greater expressive power. His repertoire began to include classical compositions derived from his knowledge of the works of Claude and Gaspard Dughet, mountain, coastal and village scenes, and such extravaganzas as imaginary country mansions, often with figures on the terraces. Much of his later imagery was similar to that of the celebrated writer on the picturesque, William Gilpin: winding rivers, ruined castles, deep ravines with masses of dark bushy trees, flocks of sheep scattered about steep cliffs, the rugged edges of foreground cliffs and hills, and every kind of irregularity or broken ground were all features of Gainsborough's later drawings among those Gilpin picked out as materials for picture-making. Though not a reading man Gainsborough was certainly aware of picturesque literature, since we know that one of his declared aims in visiting the Lakes was to demonstrate that Dr. Browne and Gray, the poet, were "tawdry fan-painters" in their published descriptions, but it would be quite wrong to conclude that he was in any way influenced by Gilpin. Rather the truth is that the two men shared a certain identity of outlook; indeed it is increasingly apparent, as a perceptive early nineteenth-century writer noted, that Gainsborough, who knew Uvedale Price when he was a youngster, was himself, partly through his absorption of the imagery of Dutch landscape art, the founder of what we now call the "rough" picturesque, as propounded in the 1790s by Price.

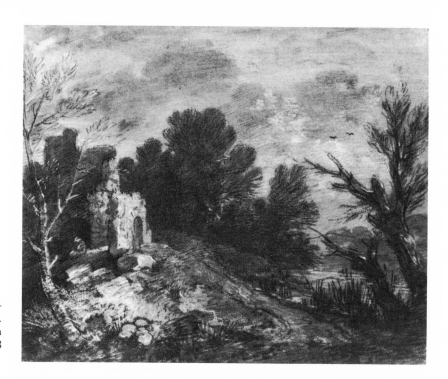

Fig. 7 Thomas Gainsborough. *River Land-scape with Figure Beside a Ruin*. Early 1770s. Black chalk and stump and white chalk on gray-blue paper. 9^{11}/$_{16}$ × 12^{1}/$_{8}$ in. (24.6 × 30.8 cm.). Private Collection, England.

But it was not the picturesque that lay at the heart of Gainsborough's imagination. His essential subject matter was pastoral in intent; his affinity with Claude lay far deeper than the adoption of certain of his techniques or methods of design. A shepherd and his scattered flock of sheep, a herdsman driving cattle home, cows at a sequestered watering place, peasants traveling to or returning from market, a woodcutter trudging home after the day's labors, a peasant family grouped outside their cottage: these were the characteristic themes of Gainsborough's later landscapes, repeated in varying forms over and over again. The common factor throughout is repose or that sense of peace which inter-venes as evening draws close. Thus the "cottage door" in particular (no. 88) obsessed Gainsborough as the most persuasive image of ten-derness and sentimental appeal, and some of his greatest late paintings are of this subject; we may recall Uvedale Price's words, speaking of their rides together, that "when we came to cottage or village scenes, to groups of children, or to any objects of that kind which struck his fancy, I have often remarked in his countenance an expression of particular gentleness and complacency." In one of his best known letters Gains-borough went so far as to say that he wanted nothing better than to take up his viola da gamba and escape to some "sweet Village" where he could "enjoy the fag End of Life in quietness & ease." His landscape drawings, atavistic products of his imagination, are the embodiment of the peace that, partly owing to the incessant pressures resulting from his fame as a portrait painter, partly because of his unsettled domestic life and his own restless, highly-strung temperament, he could never find. Perhaps also those dark and densely wooded dells and bleak

11

upland scenes, features not long absent from his drawings, or the motif of the figure resting beside a ruin highlit beneath a stormy sky (fig. 7), are in reality less picturesque or dramatic than manifestations of a mood imbued with melancholy.

Some of the little figures in his landscapes, now much more than staffage, Gainsborough elevated in the 1780s into subjects in their own right: the beggar children for which he looked back to Murillo (rustic images that accorded especially well with the sentiment of the late eighteenth century, and were instantly popular) he painted a number of times on the scale of life. His large-scale canvas entitled *The Woodman* (see no. 87) he regarded as his finest work. But if some of these so-called "fancy" paintings verge on the winsome, the related drawings avoid sentimentality through the sheer energy and brilliance of the draftsmanship.

Gainsborough's late figure drawings stand in a class apart. We have already spoken of his brilliant sketch of a music party, done in his last years at Bath. Here loose, imprecise but vigorous chalk line is used with miraculous skill to convey the weight and stance of the figures and their intentness on the music before them; indeed it is the very imprecision of touch which seems to create form. The white of the paper beautifully suggests the flood of candlelight over the scene, while the hatching is indicative of shadow. It may seem sacrilegious to invoke the name of Rembrandt, but the latter's enchanting chalk drawing of two women teaching a baby to walk makes an instructive comparison. Both are brilliant and assured evocations of living form, though where the Rembrandt is classical in its incredible economy, the Gainsborough is rococo in its lively, broken touch and scatter of internal line (figs. 8 and 9). Yet more splendid are the magnificent large drawings done in the

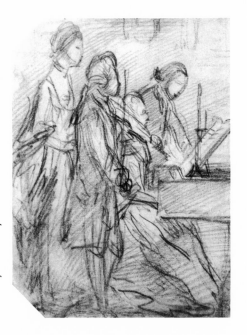

Fig. 8 Thomas Gainsborough. *A Music Party* (detail). Early 1770s. Red chalk and stump. 9¹/₂ × 12³/₄ in. (24.1 × 32.4 cm.). The Trustees of the British Museum, London.

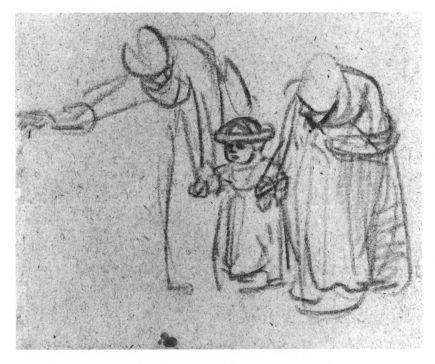

Fig. 9 Rembrandt. *Two Women Teaching a Baby to Walk*. Red chalk on gray-buff paper. 4¹/₁₆ × 5¹/₁₆ in. (10.3 × 12.8 cm.). The Trustees of the British Museum, London.

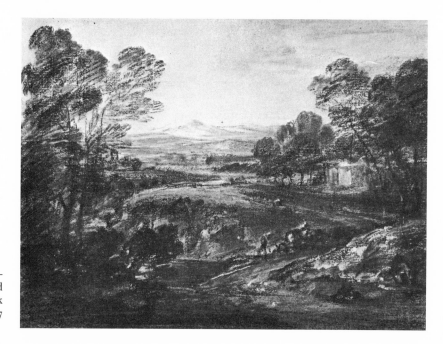

Fig. 10 Thomas Gainsborough. *Evening Landscape with Herdsman Driving Cattle Home*. Mid 1770s. Black chalk and stump and white chalk on gray paper. 8¹⁵/₁₆ × 12½ in. (22.7 × 31.7 cm.). The Executors of the late Lord Clark.

mid 1780s of women in large picture hats set against a woodland background (nos. 82–85). These were intended as studies for an impressive subject picture, the *Richmond Water-walk*, destined for the collection of George III. The painting was never finished, if, indeed, it was ever begun, for there are no contemporary references to the canvas, as there are with most of Gainsborough's principal late works. The drawings are characterized by an extraordinary sense of movement, both on the part of the figures and of the landscape. The abandon of hair and costume is taken up in the almost dizzy rhythms of the conventions for depicting foliage and tree trunks, with which the figures are thus so closely integrated, and the astonishingly vigorous highlights in white chalk, while modeling the dresses with a marvelous plasticity unusual in Gainsborough, also display a spirited independent life of their own, echoing and hinting at, rather than delineating, form. Nonetheless, beneath the costumes which billow out so splendidly behind them, the figures possess a remarkable weight and substance.

As we have already noted in considering the mountain landscape derived from Gainsborough's study of Langdale Pikes, the qualities of the late figure drawings have their counterpart in the landscapes of these years. If a rococo rhythmic flow had already been characteristic of the designs of the 1750s, the scallops outlining foliage now become freer and freer, the forms of the landscape energized to a degree inconsistent with their pastoral subject matter. Suggestiveness, movement and brilliant effects of light are the essentials of the style. In the late Lord Clark's landscape (fig. 10), Claudean in design, the shimmer and vitality of the drawing depend upon the scattered lights throughout the scene, lights reflecting the setting sun, whilst against the broad glow at the horizon the shapes of the trees are hardly more than suggested in

13

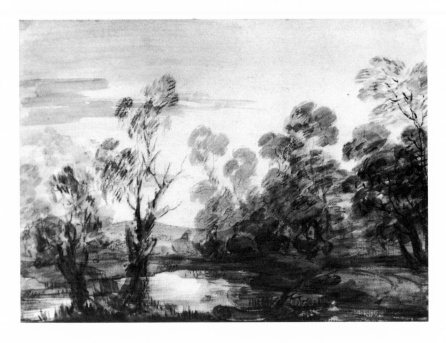

Fig. 11 Thomas Gainsborough. *Evening Landscape with Figures Riding Home.* Mid to later 1780s. Black chalk and watercolor. 8⁷/₈ × 12⁷/₁₆ in. (22.5 × 31.6 cm.). Private Collection, England.

sensitive modulations of chalk and stump. It is a composition in which, as in nature, nothing stands still. The effect should be compared with a free drawing by Claude. In an equally atmospheric drawing, formerly in the celebrated J. Leslie Wright collection, it is the figures and horses, as well as the trees, that are barely suggested as they move round the edge of the pool in which the evening sunlight is brightly reflected; this exquisite work is enriched by a breadth of chiaroscuro lacking in many of the other late drawings, which depend rather upon expressive line. Again it is the ineffable beauty of a Claude wash drawing of the Campagna that comes to mind, and there is no reason to estimate one drawing superior to the other (figs. 11 and 12).

It may seem curious, when one considers Gainsborough's relationship, and obvious indebtedness, to the seventeenth-century traditions of draftsmanship in Holland, Flanders and Italy that, unlike Reynolds and Lawrence, he should never have collected drawings himself. He was not a connoisseur. He acquired a number of paintings some, or many, of which he bought because they related to his own painting style of the moment. But this was rather different from the attitude of the artist-amateur who accumulated a cabinet of drawings for its own sake.

After his death Gainsborough's drawings were themselves assiduously collected. Thicknesse wrote at the time that Mrs. Gainsborough had "a great number of drawings . . . which she *hoarded* up, observing *justly*, that they would fetch a *deal* of money when *Tom was dead*." Over a hundred and fifty were put on sale at Schomberg House in 1789, and Queen Charlotte was among the purchasers. Among the early collectors, pride of place must go to Dr. Thomas Monro, the well-known patron of Girtin, Turner and other watercolorists, and founder of the

14

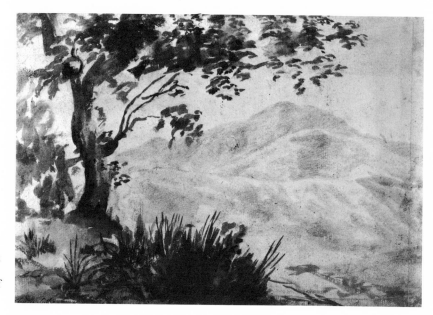

Fig. 12 Claude Lorrain. *Mount Soratte*. Chalk and brown and light cream wash. 7¹¹/₁₆ × 10³/₄ in. (18.7 × 27.2 cm.). The Trustees of the British Museum, London.

so-called Monro Academy. What is especially interesting to note in his case is his perhaps not unhealthy attitude towards drawings, since he did not prize them and preserve them in boxes, like a modern collector: "these sketches," his granddaughter recalled, "he pasted on to the wall side by side, neither mounted nor framed, and he would nail up strips of gilt beading to divide the one from the other, and give the appearance of frames." The more spirited black-and-white chalk sketches were most valued in the pre-Victorian period. Critics of the day who cavilled at draftsmen for substituting "incoherence and scrawling, for correctness of drawing; and blotting and sponging, for precision of touch," were prepared to acknowledge that Gainsborough's drawings stood in a class of their own. Gainsborough's friend, William Jackson, in summing up his view of the artist, went so far as to declare: "If I were to rest his reputation upon one point, it should be on his Drawings. No man ever possessed methods so various in producing effect, and all excellent. . . . The subject, which is scarce enough for a picture, is sufficient for a drawing, and the hasty loose handling, which in painting is poor, is rich in a transparent wash of bistre and Indian ink." Gainsborough was an intuitive genius, a man of the age of feeling not so dissimilar in the way he expressed himself from Sterne, and at the very opposite end of the scale from the Augustan decorum upheld by Reynolds. There is much to be said for Jackson's evaluation. We may go further. Garrick, another close friend of the artist, is reputed to have remarked that "his cranium is so crammed with genius of every kind that it is in danger of bursting upon you, like a steam-engine overcharged." This quality his greatest drawings undoubtedly possessed, and it is perhaps their principal glory.

15

COLOR PLATES

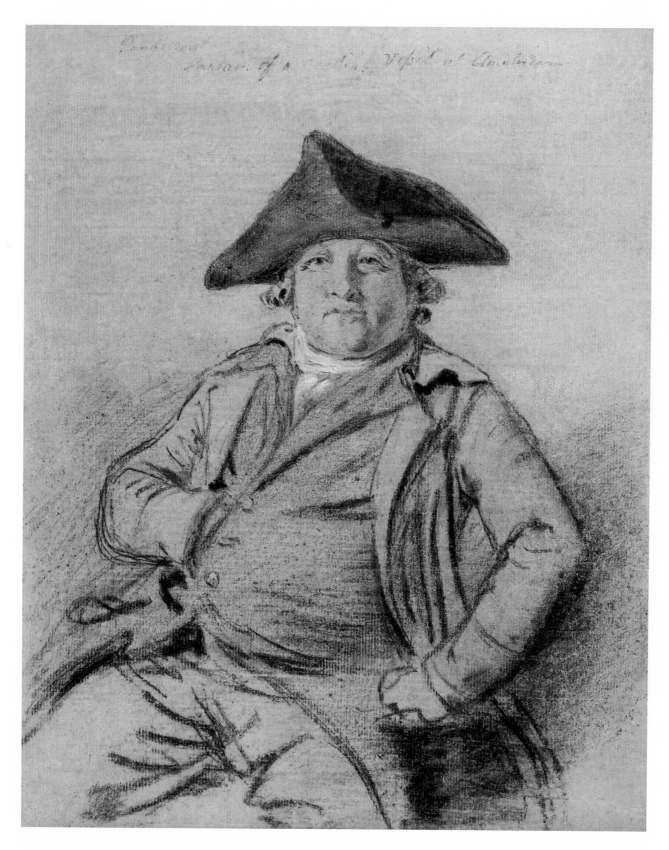

10. Portrait of a Dutch Sea-captain c. 1750–55

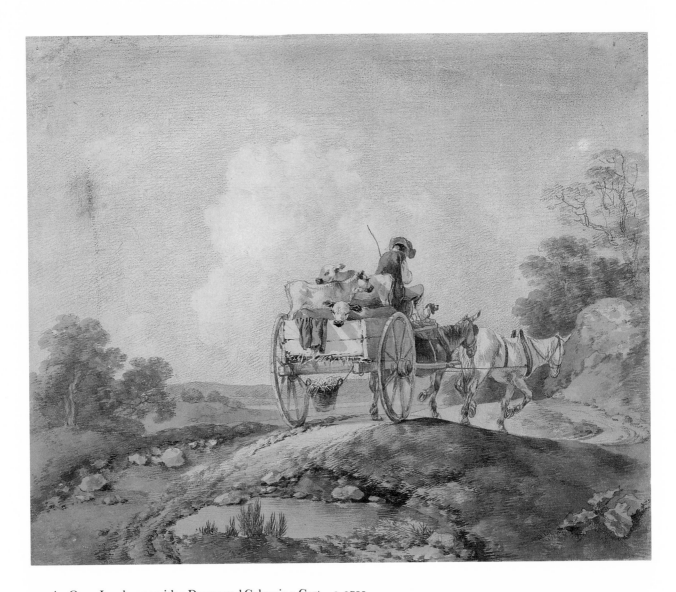

12. An Open Landscape with a Drover and Calves in a Cart c. 1755

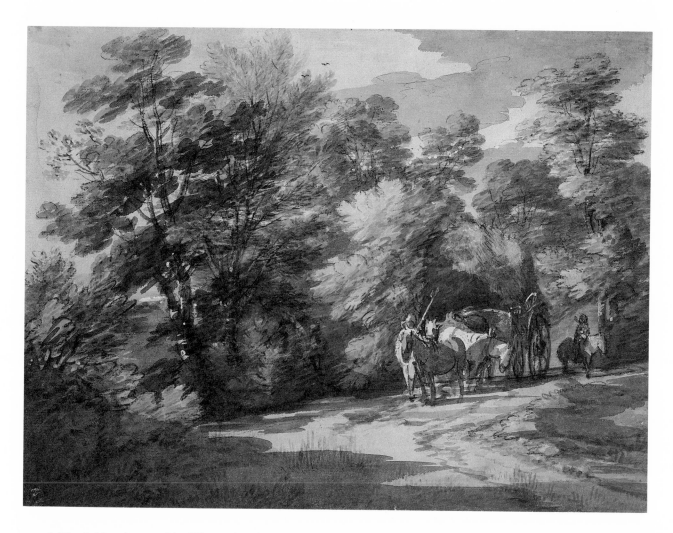

39. A Wooded Landscape with a Waggon in a Glade c. 1765–67

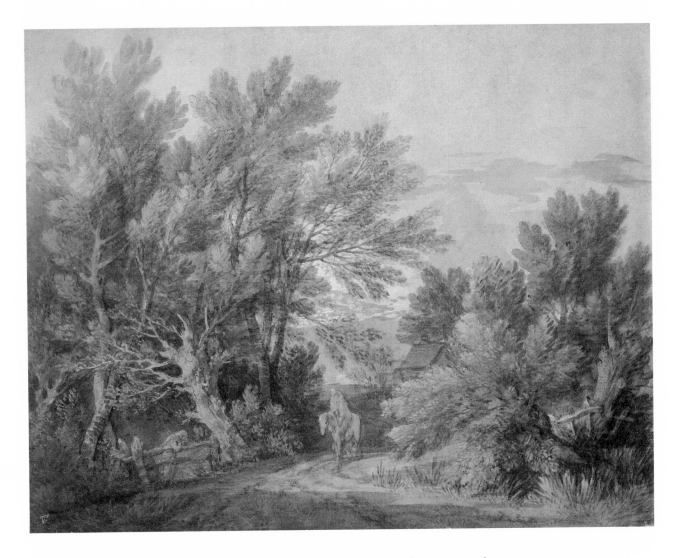

37. Wooded Landscape with a Horseman, a Figure leaning over a Stile, and a Cottage c. 1765

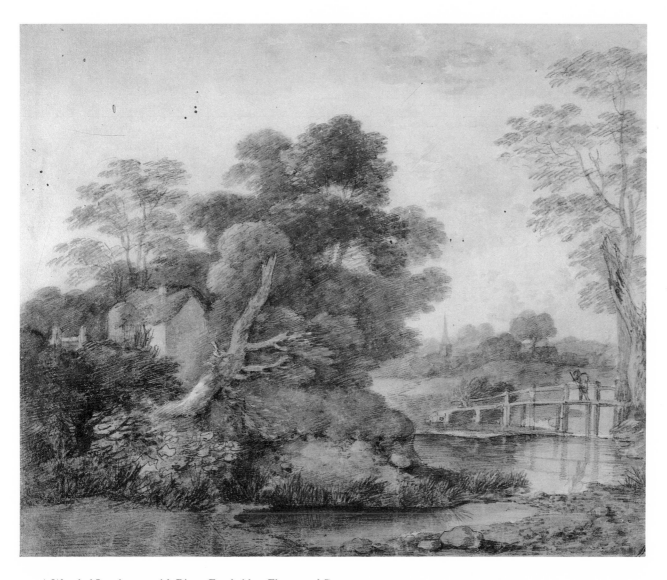

13. A Wooded Landscape with River, Footbridge, Figure and Cottage c. 1755

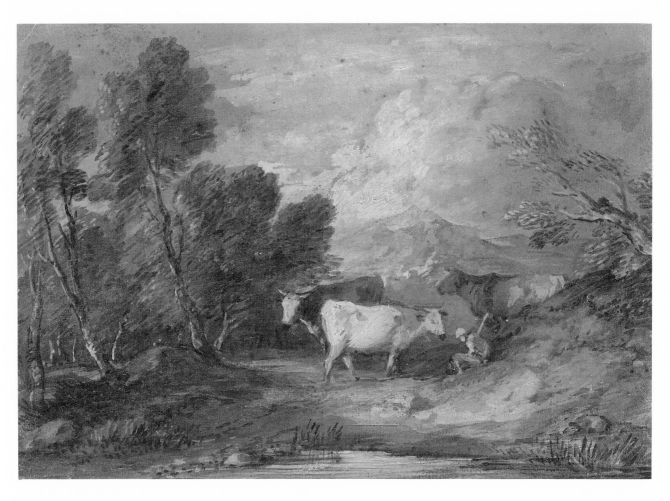

79. A Herdsman and Cows near a Watering Place c. 1785–87

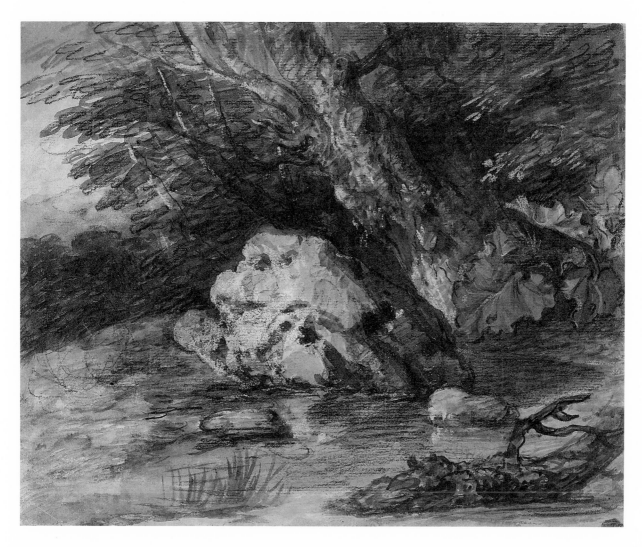

48. A Woodland Pool with Rocks and Plants c. 1765–70

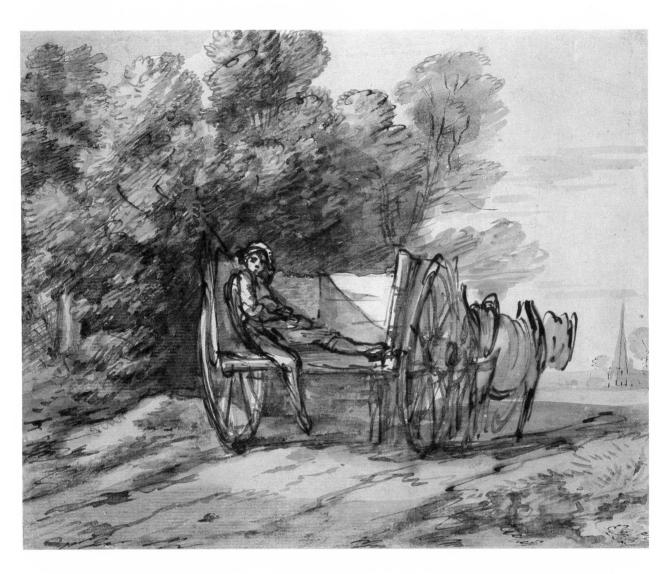

41. A Boy Reclining in a Cart c. 1767–70

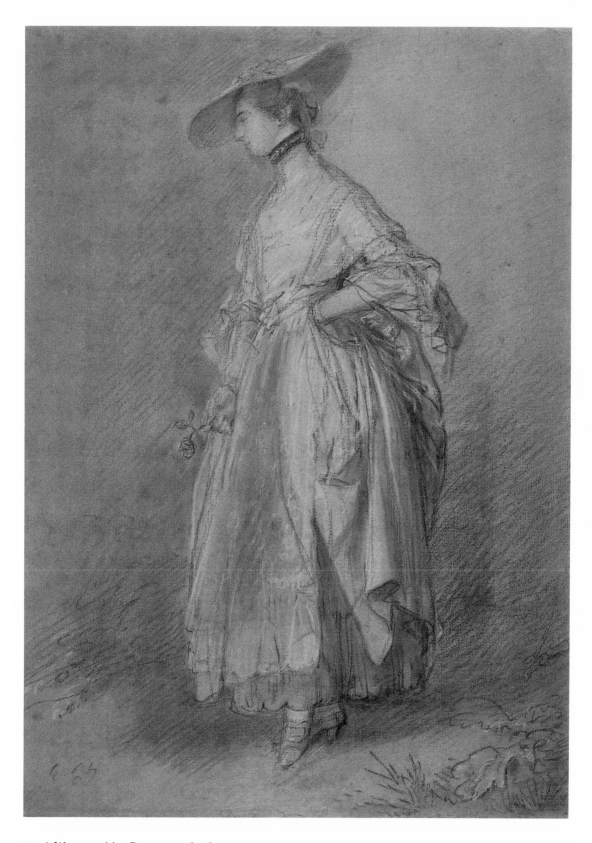

34. A Woman with a Rose c. 1763–65

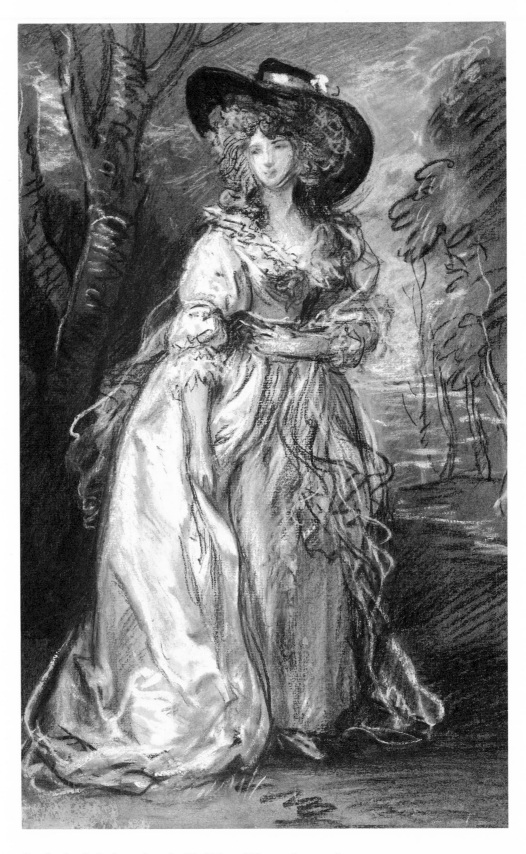

84. Study of a Lady, perhaps for *The Richmond Water-walk* c. 1785

CATALOGUE

CATALOGUE NOTE

Measurements are given in inches, followed by centimeters in brackets; height precedes width. Bibliographic references and those to exhibitions have been confined to the minimum, none before 1970 being noted, since John Hayes's catalogue raisonné includes full details.

Hayes, *Drawings*: John Hayes, *The Drawings of Thomas Gainsborough*, 2 vols., London, 1970.

Hayes, *Gainsborough*, 1975: John Hayes, *Gainsborough*, London, 1975.

Hayes, *Landscape Paintings*, 1982: John Hayes, *The Landscape Paintings of Thomas Gainsborough*, 2 vols., London, 1982.

Waterhouse: Ellis Waterhouse, *Gainsborough*, London, 1958.

Woodall, *Letters*: Mary Woodall, ed., *The Letters of Thomas Gainsborough*, 2nd edition, revised, 1963.

Richard Lane: Richard Lane, *Studies of Figures by Gainsborough*, London, 1825.

Wells and Laporte: W. F. Wells and J. Laporte, *A Collection of Prints, illustrative of English Scenery: from the Drawings and Sketches of Gainsborough: In the various Collections of the Right Honourable Baroness Lucas; Viscount Palmerston; George Hibbert, Esq.; Dr. Monro; and several other Gentlemen*, London, 1802–05.

1. PORTRAIT OF AN UNKNOWN MAN 1744

Pencil.
Oval, 4$^{15}/_{16}$ × 4$^{1}/_{16}$ in. (12.5 × 10.3 cm.)
Signed and dated at bottom left: *Tho: Gainsborough fecit 1743–4.*
Literature: Hayes, *Drawings*, no. 1.
National Gallery of Ireland.

This portrait miniature and its companion are Gainsborough's earliest surviving drawings. The form in which they are dated shows that they must have been drawn between 1 January and 25 March 1744: the inscription refers to the Julian calendar in which the year began on 25 March. It was not until 1752 that England adopted the Gregorian calendar. Drawn when Gainsborough was sixteen years old, they are in the by then outmoded tradition of the plumbago (black-lead) miniature established by such late seventeenth-century portrait draftsmen as David Loggan (1635–1692) or Thomas Forster (1677 to c. 1712). Conservative in style, they are carefully drawn and anticipate the straightforward characterization of the portraits painted after Gainsborough's return to Suffolk in the late 1740s. Nevertheless, it is surprising that these miniatures should have been drawn when Gainsborough was most strongly under the influence of the leading exponent of the rococo style in England, Hubert-François Gravelot.

The sitters have not been identified. Menpes and Greig (*Gainsborough*, 1909) proposed that they might be William Horobine and his wife Susanna (née Gainsborough) with whom they suggested Gainsborough lived while studying in London. There is no evidence to support this identification.

2. PORTRAIT OF AN UNKNOWN WOMAN 1744

Pencil.
Oval, 4$^{15}/_{16}$ × 4 in. (12.5 × 10.2 cm.)
Signed and dated at bottom left: *Tho: Gainsborough fecit 1743–4.*
Literature: Hayes, *Drawings*, no. 2.
National Gallery of Ireland.

A companion to the preceding drawing.

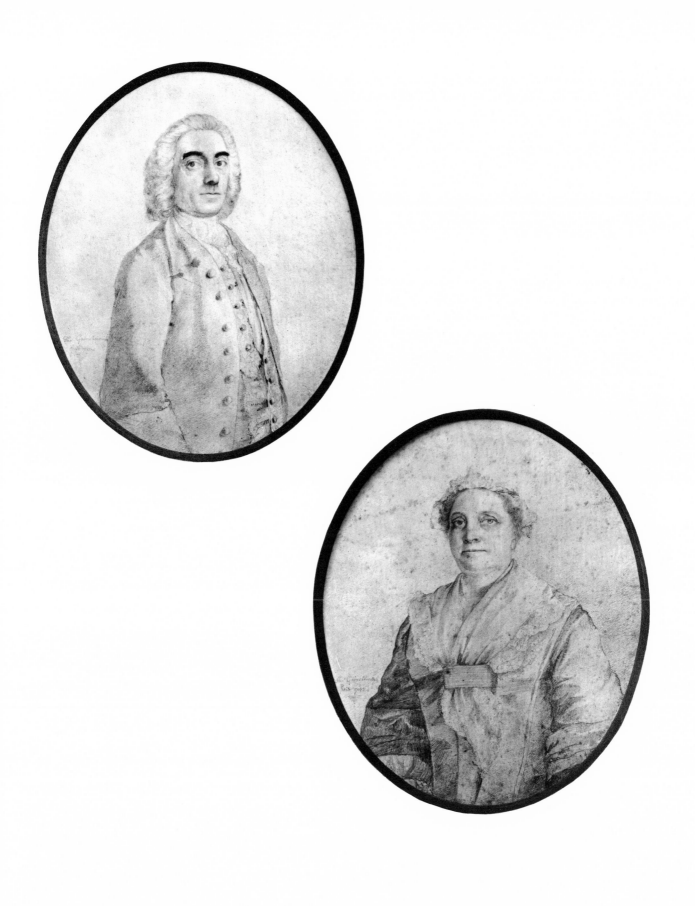

3. A YOUNG MAN AND A GIRL, PERHAPS THE ARTIST AND HIS WIFE, IN A WOODLAND SETTING c. 1746–48

Pencil.

7^{15}/$_{16}$ × 10^9/$_{16}$ in. (20.2 × 26.8 cm.)

Inscribed at bottom left in pencil, in a later hand: *Mr P. Sandby and his wife*.

Literature: Hayes, *Drawings*, no. 3; Hayes, *Gainsborough*, 1975, pp. 202–3 and pl. 9.

Exhibitions: *Gainsborough*, The Tate Gallery, London, 1980–81, no. 1; Grand Palais, Paris, no. 78.

Cabinet des dessins du Musée du Louvre, Paris.

The inscription on the drawing identifies the couple as the artist Paul Sandby and his wife, but they were not married until 1757 whereas this study can be dated c. 1745–50 on grounds of style. The figures resemble those in a painting in the Louvre (Waterhouse, no. 752) which has been known since the 1830s as a portrait of Thomas Gainsborough and his wife, Margaret Burr. It is possible that this drawing, which was for many years in the same collection, likewise represents the Gainsboroughs at about the time of their marriage in July 1746. The idea of the informal portrait in a landscape, which Gainsborough was to develop in the late 1740s and 1750s, was derived from Francis Hayman. Although more highly finished, this drawing may be compared, particularly in the treatment of the wooded background, with the studies for the portrait of a girl, possibly Miss Lloyd (nos. 7, 8 and 9); but there is nothing to suggest that Gainsborough had a painting in mind—indeed, the drawing seems to have the character of a work complete in itself.

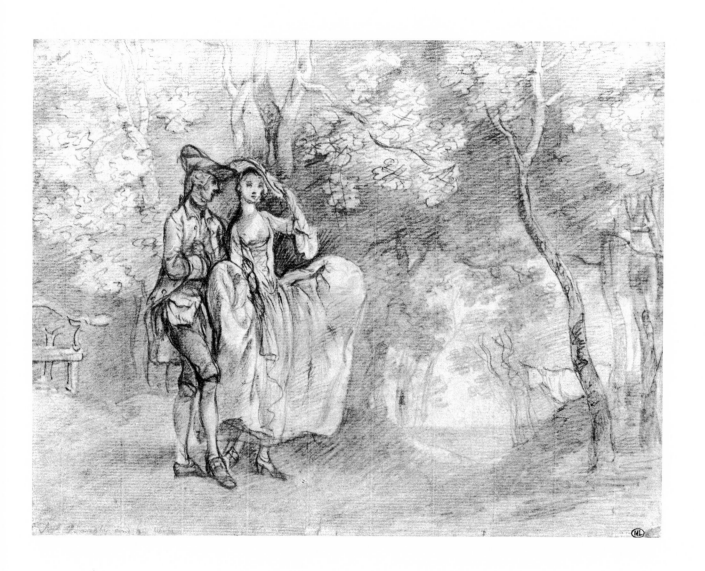

4. STUDY OF A GIRL WALKING c. 1745–50

Black chalk and stump, with white chalk and pencil on brown paper.
15⅛ × 9⅜ in. (38.3 × 23.8 cm.)
Literature: Hayes, *Drawings*, no. 815.
Private Collection.

This study has every appearance of being drawn from life; the dress of the girl suggests a date in the late 1740s. Such figures appear as milk-maids or other rustic characters in Gainsborough's early pastoral land-scapes. In the *River Scene* of c. 1747 (National Gallery of Scotland, Edinburgh), for example, a similar girl stands talking to a seated youth. This drawing is Gainsborough's earliest known full-length study of a woman. He made such studies throughout his career: sometimes, par-ticularly in the 1760s, as comparatively highly-finished portrait draw-ings, and sometimes as studies for figures in compositions. This draw-ing foreshadows in pose (and to some extent mood) those made in the mid 1780s probably for the projected painting of *The Richmond Water-walk*, though these were of "high dressed and fashionable" women. Gainsborough's preoccupation with capturing the effect of figures in movement is characteristic of many of his portraits, and first reveals itself in such studies as the present example.

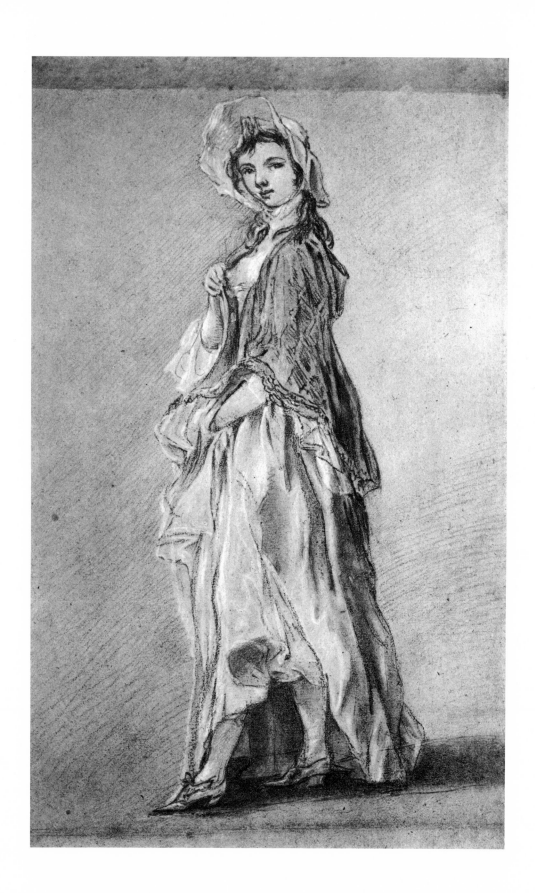

5. THREE FIGURES BY A ROADSIDE c. 1746

Pencil.
7³/₈ × 5³/₄ in. (18.7 × 14.6 cm.)
Literature: Hayes, *Drawings*, no. 72; Hayes, *Landscape Paintings*, 1982, vol. I, p. 258 and
pl. 304.
The Pierpont Morgan Library, New York (III, 52).

The composition of this drawing, which can probably be dated in the
mid 1740s, was adapted with few alterations for a painting in the Yale
Center for British Art, now attributed to an unidentified imitator of
Gainsborough. In the painting, the figures and the intertwined trees
are unchanged, but the composition is considerably extended on the
left with an open landscape revealing distant hills; the standing man
has an even more obviously Teniers-like appearance.

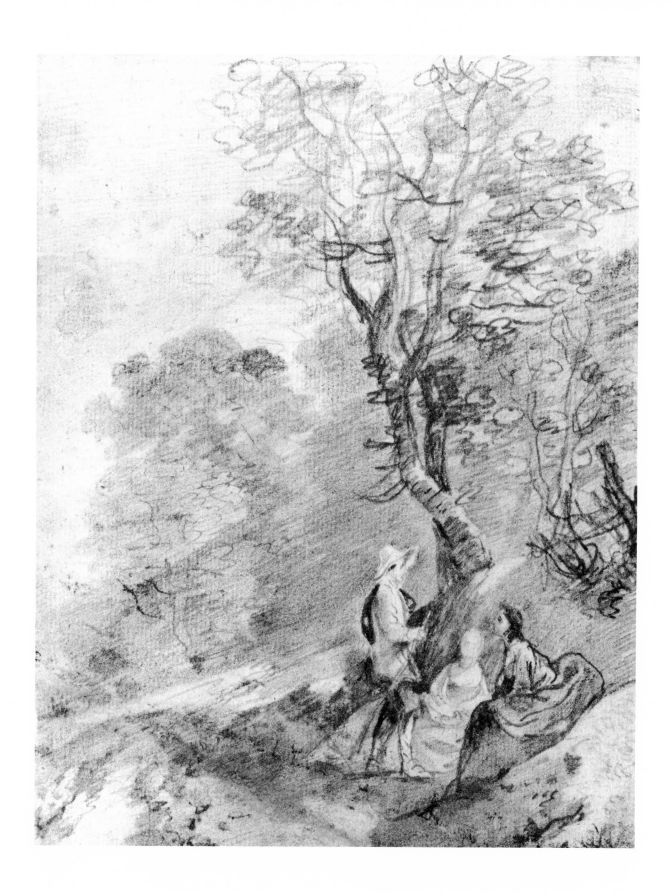

6. THE FOREST, after JACOB VAN RUISDAEL
c. 1746–48

Black and white chalks on buff paper.

16 × 16⅝ in. (40.8 × 42.2 cm.)

Literature: Hayes, *Drawings*, no. 80; Hayes, *Gainsborough*, 1975, p. 202 and pl. 15; Hayes, *Landscape Paintings*, 1982, vol. I, p. 45 and pl. 50, vol. II, p. 348.

Exhibitions: *Shock of Recognition*, Mauritshuis, The Hague, 1970–71, and The Tate Gallery, London, 1971, no. 34; *Landscape in Britain c. 1750–1850*, The Tate Gallery, London, 1973, no. 52; *The Painter's Eye*, Gainsborough's House, Sudbury, 1977, no. 3; *Gainsborough*, Grand Palais, Paris, 1981, no. 79.

Whitworth Art Gallery, University of Manchester (D. 2. 1935).

The Dutch origins of Gainsborough's early landscape style are evident in this drawing, which is in fact a copy after a well-known painting by Jacob van Ruisdael (1628/9–1682), *La Forêt*, belonging to the Louvre (on deposit at Douai). The original has never been in an English collection, so Gainsborough must have seen a version or an early copy —perhaps in an auction room. Taste for the work of Dutch artists like Ruisdael, Hobbema and Wijnants was still a novelty in the 1740s, though such paintings were beginning to find purchasers in England, particularly among the middle-classes. It was from these naturalistic landscapes, rather than from the tradition of ideal Italianate painting, that Gainsborough derived the subject matter, as well as the elements of composition that characterize his first paintings. It is significant that this drawing after Ruisdael is the only surviving example of a direct copy drawn by Gainsborough after any Dutch landscape, for Ruisdael was to exercise a profound influence on him, most obviously during his early years in London and Suffolk, but again towards the end of his life.

This drawing, made when Gainsborough was aged about nineteen or twenty, is a careful copy of the painting, although omitting the lowest area of the canvas. Ruisdael's composition was the direct source for two of Gainsborough's landscapes painted in the late 1740s: the *Wooded Landscape with Cattle at a Watering Place* (c. 1747, São Paolo), and the *Landscape with a Peasant resting beside a winding Track* (signed and dated 1747, Philadelphia Museum of Art). The design of *La Forêt* was also echoed in the painting known as *Gainsborough's Forest* (c. 1746–47, National Gallery, London). Shortly before he died in 1788, the artist wrote to a friend recalling with fondness his "first imatations [sic] of little Dutch landscapes," although it seems to have been these very landscapes which he found most difficult to sell. As John Hayes has noted, as late as 1786 Gainsborough painted a group of landscapes in a manner consciously emulating Wijnants and Ruisdael.

36

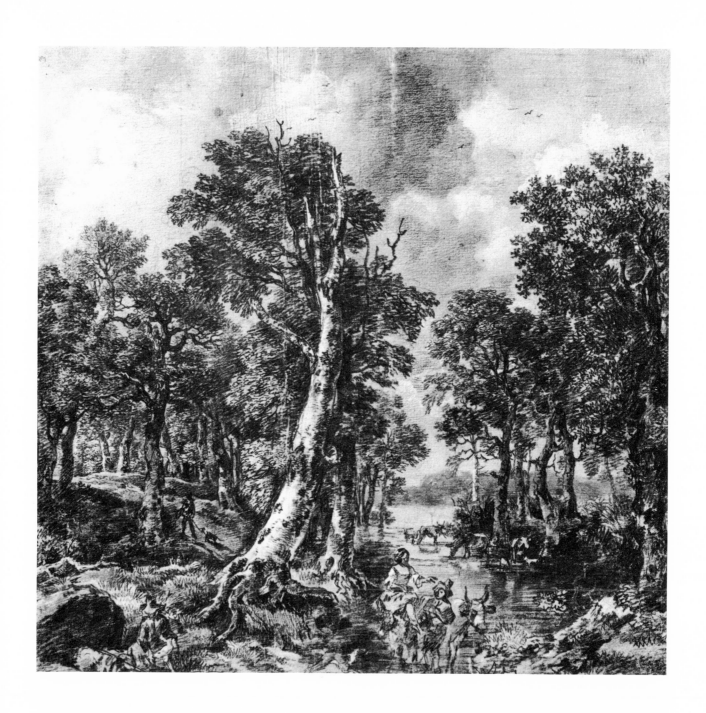

7. A STUDY FOR THE PORTRAIT OF AN UNIDENTIFIED GIRL, POSSIBLY MISS LLOYD c. 1748–50

Pencil.

7³/₈ × 5⁷/₈ in. (18.7 × 14.9 cm.)

Inscribed in pen and brown ink at bottom right: *TG*.

Literature: Hayes, *Drawings*, no. 5.

The Pierpont Morgan Library, New York (III, 46c).

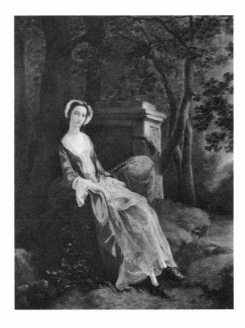

Thomas Gainsborough. *Miss Lloyd (?)*, c. 1748–50. Oil on canvas. 27³/₄ × 21¹/₂ in. (70.5 × 54.6 cm.). Kimbell Art Museum, Fort Worth.

One of three surviving preparatory studies for the portrait of an unidentified girl, traditionally called Miss Lloyd, now in the Kimbell Art Museum, Fort Worth. Gainsborough's training in London under Gravelot and his knowledge of Hayman's conversation-pieces and small full-length portraits in landscape settings, formed his style in portraiture in the late 1740s after he returned to his native Suffolk. The double portrait of Mr. and Mrs. Robert Andrews (National Gallery, London), painted c. 1748–49, is the best known example from this period. In this the extensive landscape was as important as the figures, but other Suffolk patrons seem to have preferred a more contrived, conventionally decorative background. There are only a few outdoor portraits of this date which demonstrate Gainsborough's originality as a naturalistic landscape painter. The portrait for which this study was made is influenced by Hayman's practice of placing his sitters in a conventionalized landscape setting, often in the shade of a group of trees with a piece of classical statuary in the background suggesting an atmosphere of refined elegance. A characteristic example is Hayman's portrait of *Jonathan Tyers with his Daughter Elizabeth and her Husband John Wood*, in the collection of the Yale Center for British Art, New Haven.

In the late 1740s and 1750s Gainsborough probably made many more such studies for portraits than have survived. His intention in doing so was to plot out the general composition; he was not concerned at this stage with the sitter's likeness—indeed, the head is often omitted altogether. In this study, the girl is seated in front of a tree, behind which can be glimpsed an urn on a plinth. The figure is only summarily sketched in, and the right-hand side of the sheet is left empty.

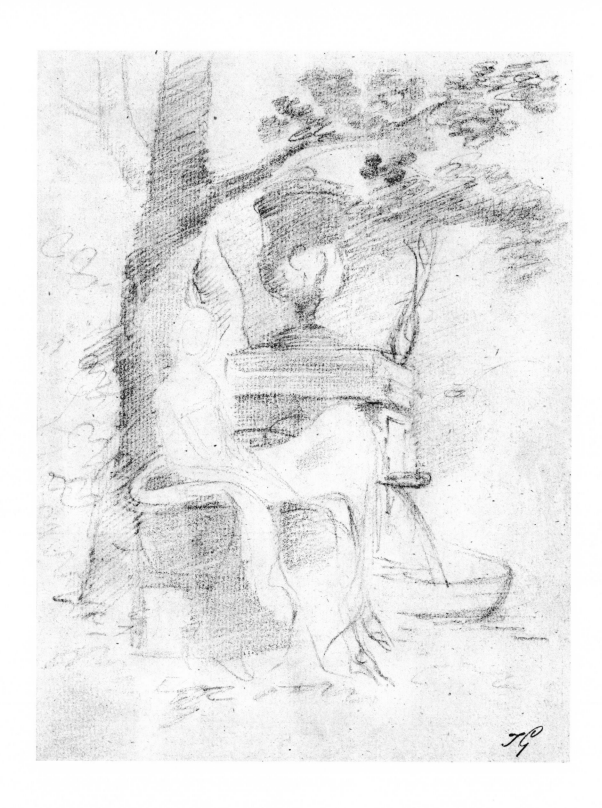

8. A STUDY FOR THE PORTRAIT OF AN UNIDENTIFIED GIRL, POSSIBLY MISS LLOYD c. 1748–50

Pencil.

7³/₈ × 5⁷/₈ in. (18.7 × 14.9 cm.)

Inscribed in pen and brown ink at bottom right: *TG*.

Literature: Hayes, *Drawings*, no. 6.

The Pierpont Morgan Library, New York (III, 46a).

The second study for the portrait at Fort Worth (see no. 7). Gainsborough has moved the plinth with its urn to the right of the tree, and turned its base into a fountain, an idea also used in the portrait of *A Girl seated in a Park*, Yale Center for British Art, New Haven (probably also datable in the late 1740s). The figure is more detailed than in the preceding study, and the effect of the panniered skirt silhouetted against the plinth is almost as finally painted. A second tree has been added, presumably in order to give depth to the composition.

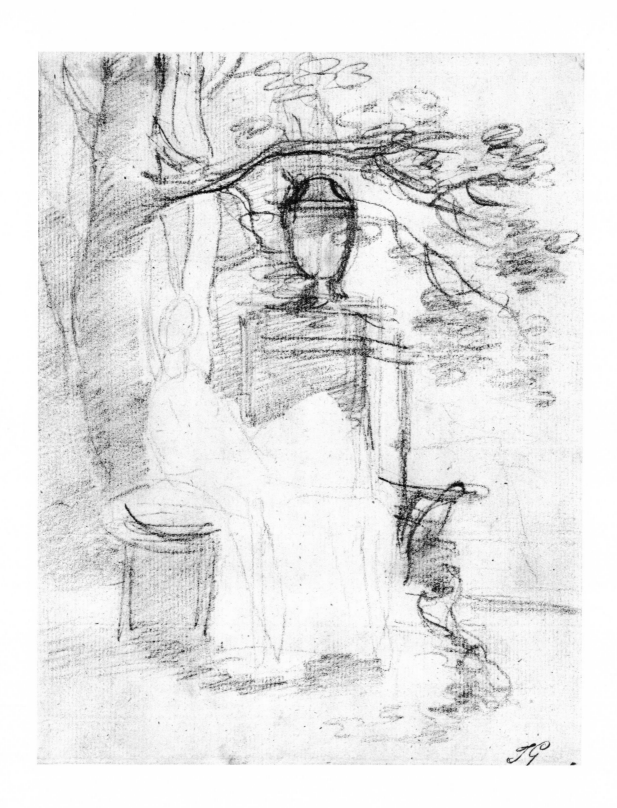

9. A STUDY FOR THE PORTRAIT OF AN UNIDENTIFIED GIRL, POSSIBLY MISS LLOYD
c. 1748–50

Pencil.
7³/₈ × 5⁵/₈ in. (18.7 × 14.3 cm.)
Inscribed in pen and brown ink at bottom right: *TG*.
Literature: Hayes, *Drawings*, no. 7.
The Pierpont Morgan Library, New York (III, 46b).

The third and final design for the portrait at Fort Worth. By comparison with no. 8 the proportions of the urn and plinth have been slightly reduced, the jet of water and stone basin below pencilled over, and the branch above the urn extended to arch over the plinth. Gainsborough's interest is chiefly in the setting, the figure being only lightly sketched in. In the painting, the urn is enlarged and the arching branch is nearer the top of the canvas. The addition of the three trees is a development foreshadowed in the second drawing, the fountain is replaced by a grassy bank, and the clump of mallow plants in the foreground is reminiscent of such detail in Gainsborough's landscape paintings of this date. A similar composition in reverse is that of the portrait of *A Girl seated in a Park* (Yale Center for British Art, New Haven), a more sophisticated variant of the Kimbell design; Gainsborough has there coped more successfully with the difficult silhouette of the panniered dress of the period and has included a more extensive landscape background. A drawing in the British Museum (Hayes, *Drawings*, no. 8) is the only surviving example of a number of studies from Antique vases and urns, which Gainsborough probably used for the backgrounds of paintings. The urn in the British Museum drawing is similar to that in the Yale portrait.

10. PORTRAIT OF A DUTCH SEA-CAPTAIN
c. 1750–55

Black, white and colored chalks on gray prepared paper.

12½ × 10⅛ in. (31.7 × 25.7 cm.)

Inscribed at the top in a later hand: *Van Gieront* [?] *Captain of a sailing Vessel at Amsterdam.*

Literature: Hayes, *Drawings*, no. 11.

Exhibitions: *Gainsborough*, The Tate Gallery, London, 1980–81, no. 4; Grand Palais, Paris, 1981, no. 81.

National Gallery of Scotland, Edinburgh (4926).

This drawing of a Dutch sea-captain can be dated in the first half of the 1750s, perhaps soon after Gainsborough had moved to the busy seafaring town of Ipswich in Suffolk. To judge from the use of colored chalks and the detailed treatment of the head, it is not a preparatory study for a painting but a portrait in its own right. No other such highly finished portrait drawings by Gainsborough are known from this period although, as a relatively cheap and quickly executed alternative to painted portraits, he may have made others which no longer survive.

The inscription on the drawing has previously been interpreted to read "Van Gieront," but according to Keith Andrews, Keeper of Drawings at the National Gallery of Scotland, no captain of this name is recorded in Dutch marine archives for the period. Since the inscription is in English it may simply reflect a phonetic misunderstanding of the Dutch name. Trade between East Anglia and Holland was extensive at this period, and it is, therefore, not surprising that a Dutch sea-captain should have sat for Gainsborough. The robust characterization of the sitter, a development from the artist's earlier portraits, suggests a date c. 1752–55, when Gainsborough was beginning to work on the scale of life. The portrait of Samuel Kilderbee (M. H. de Young Memorial Museum, San Francisco) from the mid 1750s, is similarly bold in mood.

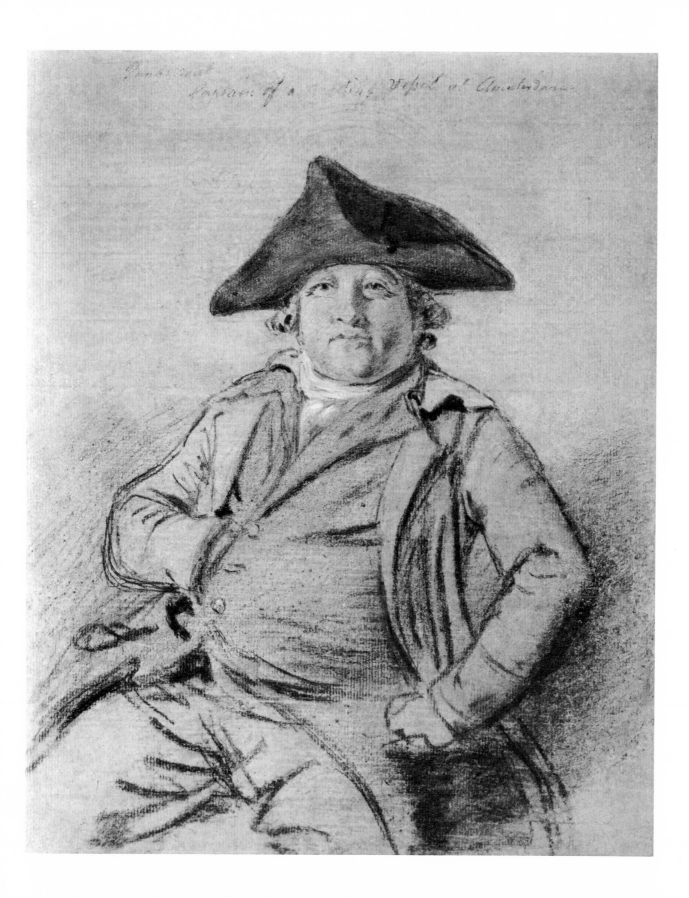

Rembrandt
Captain of a Trading Vessel at Amsterdam

11. WOODED LANDSCAPE WITH A PLOUGHTEAM AND A COTTAGE c. 1753–54

Pencil.

11¼ × 13½ in. (28.6 × 34.3 cm.)

Literature: Hayes, *Drawings*, no. 150.

Engraved: Soft-ground etching (in reverse direction) published by W. F. Wells and J. Laporte, 1 January 1805, in *A Collection of Prints illustrative of English Scenery, from the Drawings and Sketches of Gainsborough, 1802–05.*

The Pierpont Morgan Library, New York (III, 47).

A number of features characteristic of Gainsborough's early landscapes are combined in this drawing. The cart track winding around the pool, the plowman with his horses, the farm buildings, the twisted tree-stump that dominates the foreground, produce between them an over-accumulation of uncoordinated detail. At this period Gainsborough still found it difficult to relate individual elements to make a harmonious composition.

Comparison with his first etching, published in 1754, which includes a similar tree, and with landscape paintings of the same period (for example, Hayes, *Landscape Paintings*, vol. II, 1982, nos. 41 and 46) suggests a date for the drawing in the early 1750s.

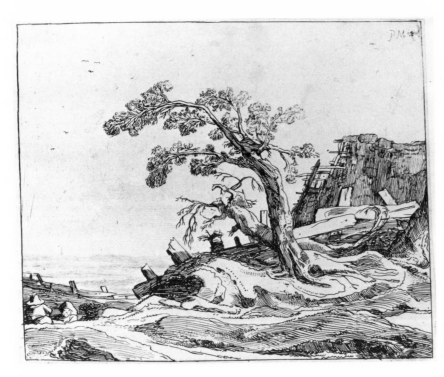

Pieter Molijn (1595–1661). *The Large Tree.* Etching. 5 × 6¼ in. (12.7 × 15.9 cm.). The Trustees of the British Museum.

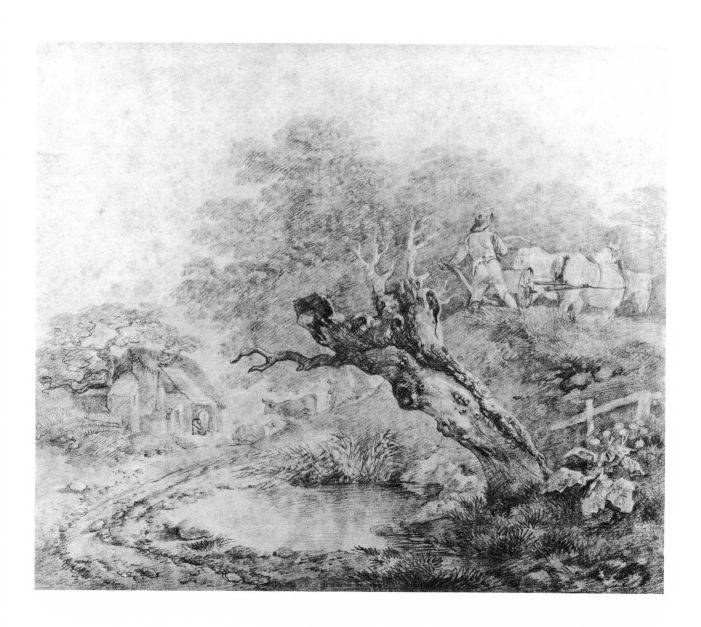

12. AN OPEN LANDSCAPE WITH A DROVER AND CALVES IN A CART c. 1755

Pencil and gray wash.
9½ × 11⅝ in. (26.2 × 25.0 cm.)
Literature: Hayes, *Drawings*, no. 152.
National Gallery of Art, Washington. Gift of Howard Sturges, 1956.

An early example dating from the mid 1750s when Gainsborough was living in his native Suffolk, of a motif that was often to recur in his later drawings and paintings, the country cart on its way to or from market. This is the kind of naturalistic, Dutch-influenced drawing, rendered with a comparatively high degree of finish, that he probably intended for sale. The silversmith and dealer Panton Betew told the sculptor Nollekens that he had "had many and many a drawing of his [Gainsborough's] in my shop-window before he went to Bath; ay, and he has often been glad to receive seven or eight shillings from me for what I have sold" (J. T. Smith, *Nollekens and his Times*, 1828, vol. I, pp. 189–90). In fact, this particular drawing seems to have been unsold and probably remained in Gainsborough's possession until after he moved to Bath in 1759. It was one of a number presented to Goodenough Earle (1699–1788/9) of Barton Grange in Somerset (John Hayes, "The Gainsborough Drawings from Barton Grange," *The Connoisseur*, February 1966).

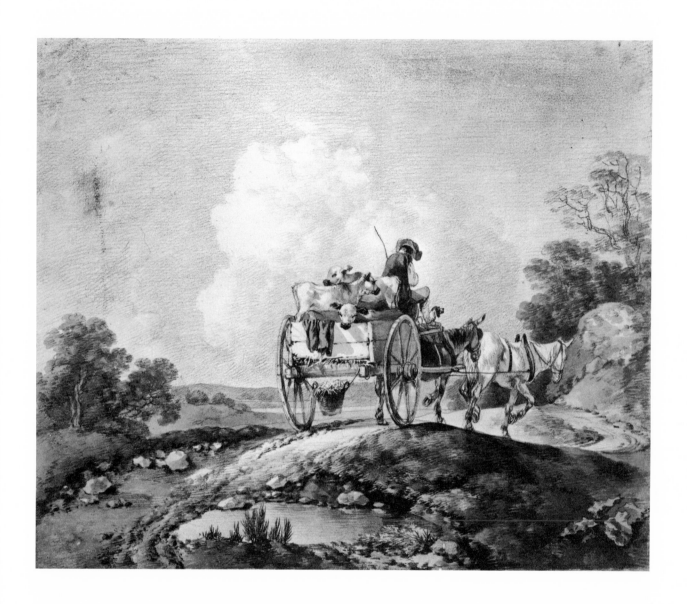

13. A WOODED LANDSCAPE WITH RIVER, FOOTBRIDGE, FIGURE AND COTTAGE c. 1755

Pencil and watercolor, with some bodycolor.
11³/₄ × 14¹/₄ in. (29.8 × 36.2 cm.)
Collector's mark of William Esdaile (Lugt 2617) at bottom right.
Inscribed *verso* by Esdaile at bottom left: *G — Frost's Collⁿ. N50+*.
Literature: Hayes, *Drawings*, no. 153.
Victoria and Albert Museum, London (Dyce 676).

Although Gainsborough's extensive use of watercolor dates from the mid 1760s, this drawing is rather earlier and, to judge from the treatment of the foliage and the foreground detail similar to no. 12, can be dated to c. 1755. It belonged to George Frost (1745–1821), whose own landscape studies owed much to Gainsborough's example. It was partly through him that Gainsborough's drawings became known to John Constable who was, however, certainly aware of his famous predecessor before he met Frost. In some ways the present drawing anticipates Constable: it is almost certainly not drawn from nature, but the combination of features in it is reminiscent of the area around Flatford in Suffolk, which furnished subjects for many of Constable's landscapes.

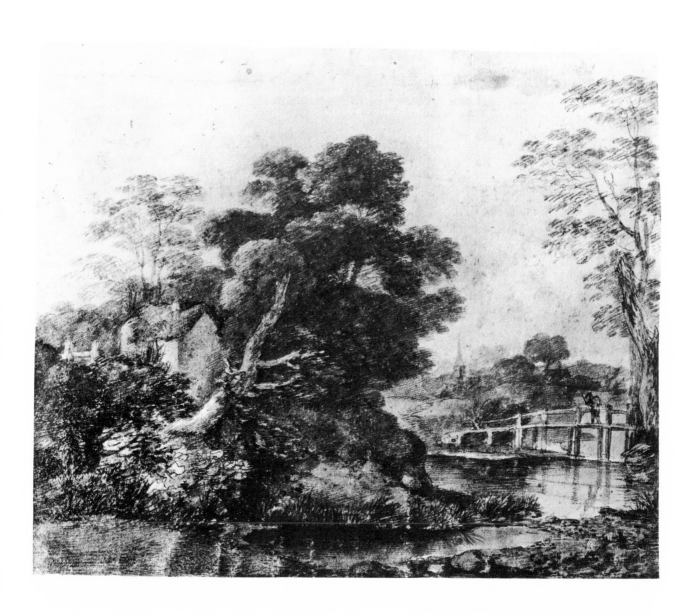

14. STUDY OF A COW c. 1755–57

Pencil on brown-toned paper.
6 × 7⁷/₁₆ in. (15.2 × 18.9 cm.)
Literature: Hayes, *Drawings*, no. 860.
Private Collection, United Kingdom.

Presumably a page from an early sketchbook, this study from life was later used by Gainsborough for the cow lying in the foreground of the drawing owned by William Ellery Smith (no. 16).

15. STUDY OF A COW c. 1755–57

Pencil on brown-toned paper.
5¹¹/₁₆ × 7⁷/₁₆ in. (14.4 × 18.9 cm.)
Literature: Hayes, *Drawings*, no. 861.
Private Collection, United Kingdom.

Like the preceding drawing, this is a study from life, likewise datable in the later 1750s and presumably from the same sketchbook. No corresponding finished drawing or painting is known.

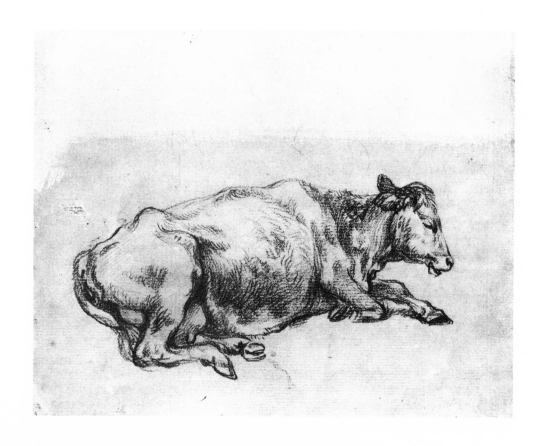

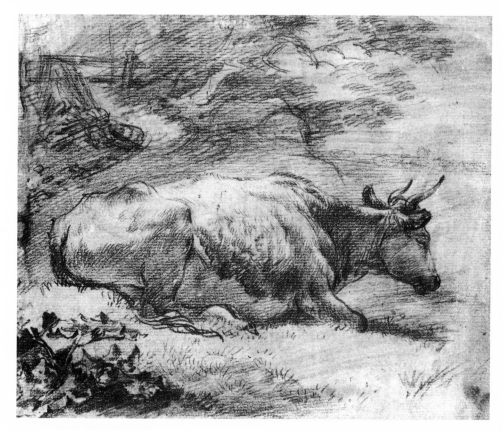

16. A WOODED LANDSCAPE WITH A HERDSMAN, COWS AND BUILDINGS c. 1755–57

Pencil, varnished.

11⅛ × 14½ in. (28.3 × 36.8 cm.)

Literature: Hayes, *Drawings*, no. 158; Hayes, *Landscape Paintings*, 1982, vol. II, p. 398.

Wm. Ellery Smith, Stonington, Connecticut.

One of the most elaborately finished of Gainsborough's Suffolk-period drawings. Like nos. 12, 42, 51 and 79, this appears to have been one of a group given by the artist, probably over a number of years, to Goodenough Earle (1699–1788/9) of Barton Grange in Somerset: see J. Hayes, "The Gainsborough Drawings from Barton Grange," *The Connoisseur*, 1966, pp. 86–93. The unusual complexity of the composition is shown by the number of preparatory studies or related drawings that are known, including no. 14 in the present exhibition (see also Hayes, *Drawings*, nos. 159, 824, 855 and possibly 178). Unusually, since this drawing is in no sense a preparatory study, Gainsborough used it, in reverse and with minor variations, for the left side of a painting executed c. 1755–57 (Hayes, *Landscape Paintings*, 1982, vol. II, no. 62). In this, the landscape is extended so that the format becomes a pronounced horizontal; there is also a greater expanse of sky, which reduces the landscape details in scale so that the church tower, which is a striking feature in the drawing, is less prominent.

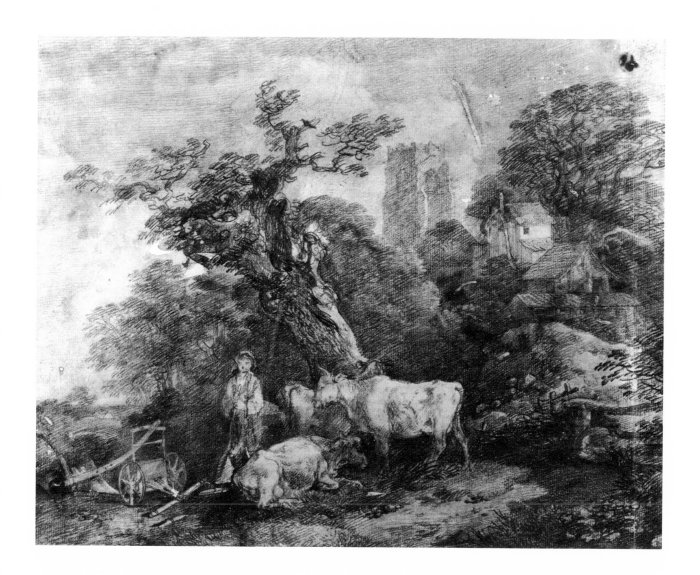

17. STUDY OF TWO SHEEP c. 1757–59

Black and white chalks on gray paper.

6¹/₈ × 8¹/₄ in. (15.6 × 21.0 cm.)

Literature: Hayes, *Drawings*, no. 863; Hayes, *Landscape Paintings*, 1982, vol. II, p. 407 and pl. 69b.

Exhibitions: *Gainsborough*, Grand Palais, Paris, 1981, no. 84.

Staatliche Museen Preussischer Kulturbesitz, Kupferstichkabinett, Berlin (4696).

Gainsborough used this study from life as well as another sketch of a sheep (also in Berlin, Hayes, *Drawings*, no. 864), for the composition drawing (Hayes, *Drawings*, no. 865) related to the *Landscape with Shepherd Boy and Sheep*, painted c. 1757–59, now in the Toledo Museum of Art (Hayes, *Landscape Paintings*, 1982, vol. II, no. 69). The two preliminary sketches, like nos. 18 and 38, come from sketchbooks owned by George Hibbert (1757–1837). In these the sheep are precisely observed, but in the composition drawing their appearance is more generalized. In the painting, the grouping of the sheep is altered and they appear to be of a different breed.

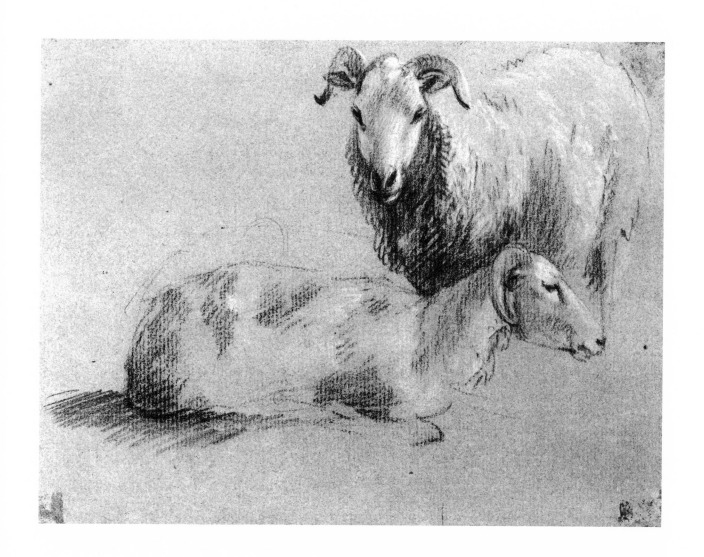

18. STUDY OF TREES c. 1755–59

Pencil.
5½ × 7½ in. (14.0 × 19.0 cm.)
Literature: Hayes, *Drawings*, no. 168.
Exhibitions: *Gainsborough*, The Tate Gallery, London, 1980–81, no. 8; Grand Palais,
Paris, 1981, no. 82.
Private Collection.

A study from nature datable in the 1750s, apparently a page from a
sketchbook. According to Joseph Farington, a group of sketchbooks
were sold by the artist's daughter Margaret in 1799 for £140.3s.6d.; this
sheet probably came from one of the three bought by George Hibbert
(1757–1837), a West India merchant and collector. Some of the more
detailed nature studies were used by Gainsborough as reference for his
finished drawings and paintings; others, including the present example,
are already so generalized that it is not easy even to determine the
species of tree. Pencil drawings of this type, dating from the late 1750s
and early 1760s, were to influence the Ipswich amateur artist George
Frost (1745–1821) and his friend John Constable (1776–1837). Whether
Constable in the late 1790s or early 1800s had first-hand knowledge of
Gainsborough's nature studies or whether he was dependent on Frost's
copies and imitations is uncertain.

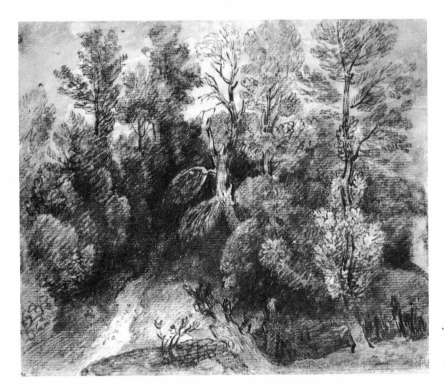

John Constable (1776–1837). *A Path Among
Trees*, c. 1800–05. Pencil and wash. 6½ × 7¾
in. (16.5 × 19.7 cm.). Fitzwilliam Museum,
Cambridge.

19. STUDY FOR THE PORTRAIT OF
THE HON. RICHARD SAVAGE NASSAU
(1723–1780) c. 1757

Black chalk.

11 1/8 × 8 3/16 in. (28.2 × 20.8 cm.)

Literature: Hayes, *Drawings*, no. 13; Hayes, *Gainsborough*, 1975, p. 208 and pl. 42.

Exhibition: *Gainsborough*, The Tate Gallery, London, 1980–81, no. 12.

Staatliche Museen Preussischer Kulturbesitz, Kupferstichkabinett, Berlin (4433).

Gainsborough's first portraits on the scale of life were painted in the early 1750s; his style at this period was neatly (if a little unkindly) characterized by his biographer, Philip Thicknesse, who visited him in 1753: "Mr Gainsborough received me in his painting room, in which stood several portraits truly drawn, perfectly like, but stiffly painted and worse coloured" (*A Sketch of the Life and Paintings of Thomas Gainsborough, Esq.*, 1788, p. 11). By the end of the decade, in 1758, the year before he moved to Bath, his portraits were described by the tutor of one of his patrons in very different terms, which anticipate Reynolds's comments of thirty years later: "We have a painter here who takes the most exact likenesses I ever saw. His painting is coarse and slight, but has ease and spirit." One of the most original and striking portraits of this period is that of Richard Savage Nassau, painted c. 1757 (Brodick Castle, Scotland), for which this drawing is a study. While most of Gainsborough's Suffolk patrons belonged to the lesser gentry or the professional middle classes, Nassau was an aristocrat, being the younger son of the 3rd Earl of Rochford. In 1751 he had married the widow of the 5th Duke of Hamilton, who was a Suffolk heiress, and came to live at Easton Park, near Ipswich in Suffolk. But if Gainsborough hoped for further patronage from the local aristocracy, he was disappointed.

Studies for portraits of the 1740s and 1750s are rare (however, see nos. 7, 8, 9 and 10). In this drawing, one of the finest from the artist's early years, Gainsborough is concerned not with the facial likeness, which he would have painted directly onto the canvas, but with the pose, an unusual but effective variation of a more conventional one. Nassau is sitting sideways on an upright chair with his arm held casually over the back. The apparent informality of the composition contributes to the "ease and spirit" of the portrait. Similarly emphatic poses, in which Gainsborough suggests liveliness and movement, were used by the artist for the portraits of William Wollaston, c. 1758–59 (Ipswich, Suffolk) and Miss Ford, 1760 (Cincinnati). The fluent and expressive quality of the drawing itself is largely a result of Gainsborough's use of a soft chalk, rather than pencil, which can be handled more rapidly, and gives a wider gradation of tone. The character of the draftsmanship recalls the drawings of Watteau.

20. STUDY OF A BULL-DOG c. 1757–59

Black, red and white chalks on buff paper.
12^7/16 × 9^5/8 in. (31.6 × 24.4 cm.)
Verso: Study of the coat of a man facing left (Hayes, *Drawings*, no. 14).
Collector's mark of Barthold Suermondt (Lugt 415).
Literature: Hayes, *Drawings*, no. 872.
Staatliche Museen Preussischer Kulturbesitz, Kupferstichkabinett, Berlin (4436).

One of Gainsborough's earliest signed and dated paintings was of a dog
in a landscape setting (1745; Waterhouse, no. 817), and he painted
them throughout his career, usually as details in portraits or land-
scapes, but occasionally in their own right as portraits. The bull-dog in
this vigorously executed study has been accorded the same attention as
a human sitter. Gainsborough would perhaps have agreed with Dr.
Johnson's dictum: "I would rather see the portrait of a dog I know than
all the allegorical paintings they can show me in the world."

On the *verso* Gainsborough drew a rapid study of a man's coat,
perhaps for a lost or unexecuted portrait. The resemblance of both *recto*
and *verso* to the study for the portrait of the Hon. Richard Savage
Nassau (no. 19) suggests a date in the late 1750s.

21. A WOODED LANDSCAPE WITH HERDSMAN, COWS AND A RUINED CASTLE c. 1758–59

Pencil.
10³/16 × 14¹/8 in. (25.9 × 35.9 cm.)
Literature: Hayes, *Drawings*, no. 227.
Collection of Mr. Eric H. L. Sexton.

In its soft, feathery pencilling this landscape resembles the drawing belonging to Lady Witt (no. 22), and may likewise have been made for engraving. It must date from the end of Gainsborough's Suffolk period, c. 1758–59, but the ruined castle, solitary herdsman and distant hills anticipate the subject matter of the artist's drawings of the 1780s.

22. A WOODED LANDSCAPE WITH A HERDSMAN AND A COW c. 1758–59

Pencil.
11 × 15¹/8 in. (27.9 × 28.3 cm.)
Literature: Hayes, *Drawings*, no. 233; Hayes, *Gainsborough as Printmaker*, 1972, p. 6 and pl. 31; Hayes, *Gainsborough*, 1975, pp. 209–10 and pl. 47.
Exhibitions: *Gainsborough*, The Tate Gallery, London, 1980–81, no. 14; Grand Palais, Paris, 1981, no. 86.
Collection of Lady Witt.

This is one of the most highly finished drawings from the period shortly before Gainsborough left Ipswich in 1759. The artist may have intended it for sale or, more possibly, for engraving: a similar drawing of much the same size in the Witt Collection (Hayes, *Drawings*, no. 238) is inscribed in the lower margin *Gainsborough fec. 1759-1*, and another, *Thomas Gainsborough inv. et delineavit 1759* (Hayes, *Drawings*, no. 243). However, only three etchings by Gainsborough dating from the 1750s are known (see Hayes, *Gainsborough as Printmaker*, 1972, nos. 1, 2 and 21), and after these, none until the 1770s when he began to experiment with soft-ground, an effect which the present drawing seems to anticipate.

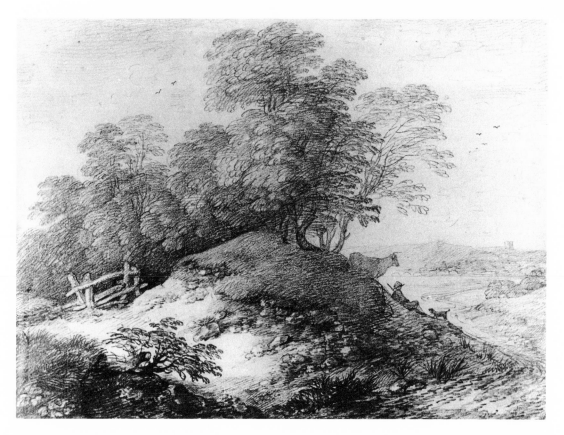

23. STUDY FOR THE PORTRAIT OF A WOMAN WITH TWO CHILDREN (?MRS GAINSBOROUGH AND HER DAUGHTERS) c. 1759–62

Pencil, trimmed at all four corners.
14^{15}/$_{16}$ × 9^{5}/$_{8}$ in. (37.9 × 24.4 cm.)
Literature: Hayes, *Drawings*, no. 17.
Engraved: Lithograph published by the artist's great-nephew Richard Lane, 1 January 1825.
Staatliche Museen Preussischer Kulturbesitz, Kupferstichkabinett, Berlin (6850).

A former owner of this drawing, J. P. Heseltine, suggested a connection with the full-length portrait of Mrs. Moodey and her children at Dulwich (Waterhouse, no. 498); but, to judge from the costume, this painting must have been painted in the late 1770s, whereas the present drawing can be dated in the late 1750s or early 1760s, on grounds both of style and costume. It seems not to have been observed that the woman in the drawing bears a close likeness to the artist's wife, particularly to a portrait of her painted c. 1760 (Waterhouse, no. 297) in the Staatliche Museen zu Berlin, DDR, which, like this drawing, descended to Gainsborough's great-nephew Richard Lane. The two girls, one of whom seems to be aged about eleven and the other about seven, could be the artist's daughters Mary (1748–1826) and Margaret (1752–1820). They seem older than in the painting of them chasing a butterfly (c. 1756, National Gallery, London), but younger than in the one showing them drawing from a statuette of the Farnese Flora (c. 1763–64, Worcester Art Museum, Massachusetts). Gainsborough may have been planning to paint a full-length group portrait: the drawing seems to be more than a mere sketch made with no further purpose in mind, while not being a finished work of art in its own right. Such a painting would probably have been on the scale of life. Gainsborough's first life-size full-length portrait, of William Wollaston (Waterhouse, no. 734), was painted just before he left Ipswich in 1759, and to judge from the apparent ages of the children in the drawing, the hypothetical portrait of his wife and daughters was planned very soon afterwards. This study foreshadows the Van Dyckian elegance of the portraits of the Bath period.

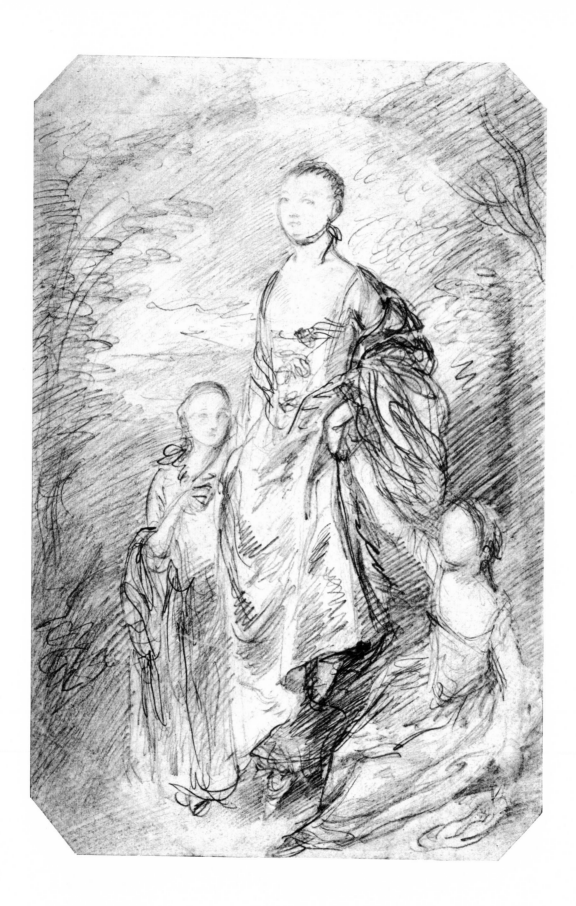

24. BEECH TREES AT FOXLEY, WITH
YAZOR CHURCH IN THE DISTANCE 1760

Brown chalk, watercolor and bodycolor over pencil.

11^5/16 × 15^3/16 in. (28.7 × 38.9 cm.)

Signed and dated on a fragment of paper pasted on the *verso*: *Tho: Gainsborough del 1760*. An old label is inscribed: *A study from nature, by Gainsborough when on a visit to Foxley—the seat of the late Sir Rob! Price Bart—From the Coll. . . .* Another label, in a later hand, notes that the drawing is of beech trees at Foxley and adds that it subsequently belonged to the 2nd Viscount Bateman.

Literature: Hayes, *Drawings*, no. 248; M. Allentuck, "Sir Uvedale Price and the Picturesque Garden: the evidence of the Coleorton Papers," in N. Pevsner (ed.), *The Picturesque Garden and its Influence outside the British Isles*, 1974, pp. 54 ff.

Exhibitions: *Zwei Jahrhunderte Englische Malerei: Britische Kunst und Europa 1680 bis 1880*, Haus der Kunst, Munich 1979–80, no. 62.

Whitworth Art Gallery, University of Manchester.

Shortly after moving to Bath in the autumn of 1759 Gainsborough came to know the Price family of Foxley, Herefordshire. Among the first portraits he painted in Bath was that of Uvedale Tomkyns Price (1685–1764) himself an amateur draftsman. The painting (now in Munich) shows Price with a large framed drawing by Gainsborough hanging on the wall behind him. His grandson Sir Uvedale Price (1749–1829), who in the 1790s was to become a leading writer on the Picturesque, recalled his "frequent excursions with [Gainsborough] into the country" during the period when the artist was living in Bath. As Christopher Hussey first pointed out in 1927, and as John Hayes has subsequently shown (*Landscape Paintings*, 1982, vol. I, p. 163), Gainsborough very probably had a direct influence on Price's theories.

Uvedale Price seems particularly to have admired beech trees and refers to them often both in his private correspondence and in his published writings. For example in the first volume of his *Essays on the Picturesque*, published in 1794, he described a country lane: "It had on one side a high bank full of the beauties I have described; I was particularly struck with a beech which stood single on one part of it, and with the effect and character which its spreading roots gave, both to the bank and to the tree itself: the sheep also had made their sidelong paths to this spot, and often lay in the little compartments between the roots." The "beauties" Price referred to were "all intricacies, . . . all the beautiful varieties of form, tint, and light and shade; every deep recess —every bold projection—the fantastic roots of trees—the winding paths of sheep"—in short, the very characteristics that appear, not only in this drawing, but again and again in Gainsborough's work as a landscapist.

This is a rare example of a drawing of an identified view by Gainsborough, though whether it was drawn on the spot, as the old label states, is uncertain. It is as likely that the artist developed the watercolor from sketches that were made at Foxley.

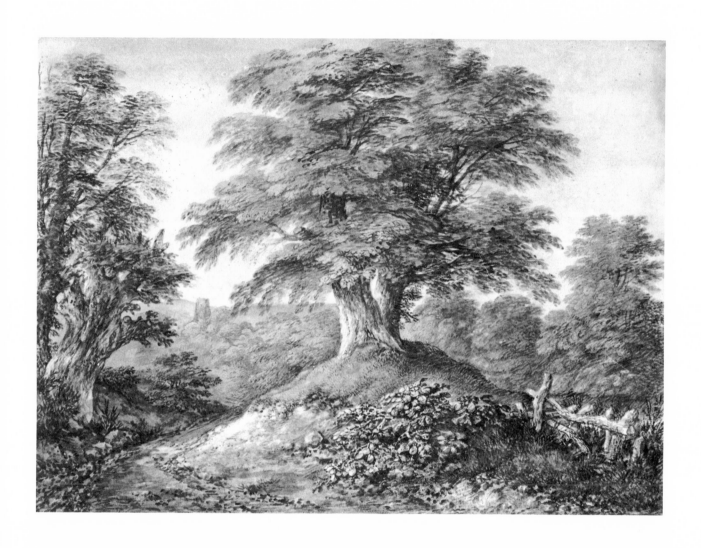

25. STUDY OF TREES c. 1760

Watercolor and bodycolor over pencil.
7⁵/₈ × 9³/₄ in. (19.4 × 24.8 cm.)
Literature: Hayes, *Drawings*, no. 249.
Birmingham Museums and Art Gallery.

It is unlikely that Gainsborough drew this study directly from nature, but the particularized character of the trees suggests that it may have been based on such sketches. The carefully balanced composition and the rather contrived way in which the branches of the tree at the left are silhouetted against the sky suggest that Gainsborough was still harking back to Dutch and Flemish models; he may have had in mind engraved landscapes by artists like Matthijs Bril or Roelant Savery.

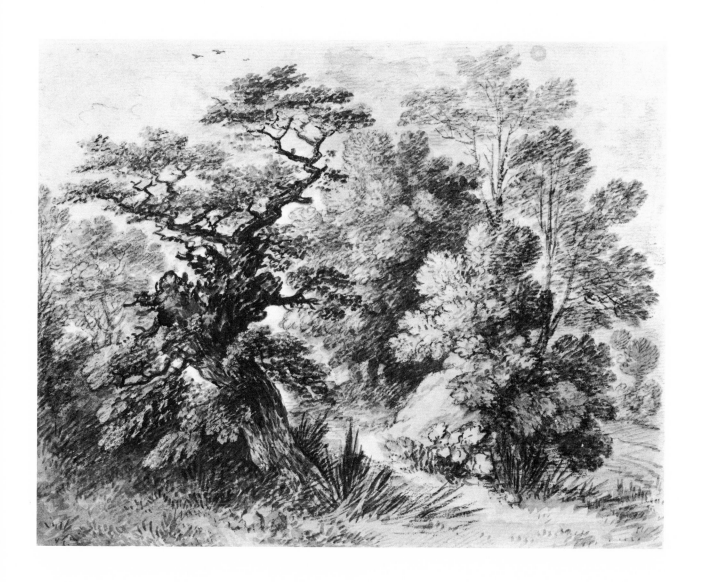

26. STUDY OF A WOMAN WEARING A SHAWL
c. 1760

Black chalk and stump, trimmed at all four corners.

16⅛ × 9 in. (41.0 × 22.9 cm.)

Inscribed *verso*, in pencil, at bottom right, in the hand of John Constable: *Given to me by Rᵈ Lane—A. E. R.A.* and in a later hand: *The above is the writing of John Constable R.A.*

Literature: Hayes, *Drawings*, no. 24.

Engraved: Lithograph (in reverse) published by the artist's great-nephew Richard Lane, 1 January 1825.

The Pierpont Morgan Library, New York (III, 57).

One of a group of figure studies which descended through Gainsborough's daughter Margaret to his great-nephew Richard Lane (1800–1872), who lithographed them in *Studies of Figures by Gainsborough* (1825). The present drawing was later in the possession of John Constable, a life-long admirer of his fellow Suffolk artist.

Dr. Hayes believes that most of these studies were drawn from mannequin figures, a practice which Gainsborough probably learned from Gravelot, although other artists also used such models, notably Hayman and the sculptor Roubiliac. Two such mannequins were included in the sale held in 1799 after Mrs. Gainsborough's death, one "most ingeniously constructed with brass-work joints." William Collins R.A. (1799–1847) later owned such a figure, "dressed by the great painter's hand." In the case of Gainsborough's figure-studies, it is always difficult to decide whether or not such a model was used. Another drawing in the Frick Collection (Hayes, *Drawings*, no. 18) is of a figure in the same dress and, apparently, with the same features. There is a liveliness about both which suggests that they cannot have been drawn wholly from a mannequin; and that they are from life is confirmed by a portrait drawing in the Victoria and Albert Museum (Dyce 696; in the compiler's opinion, wrongly rejected by Dr. Hayes) which is almost certainly of the same girl, who is the subject of a number of figure studies of the early 1760s.

In some of Gainsborough's figure studies the heads are schematically blocked in, but this form of rapid notation, derived from French practice, does not necessarily preclude their having been drawn from life. Gainsborough seems to have made these studies with portraits in mind. The present drawing can be dated c. 1760 on the strength of the apparent connection, (though this is denied by Dr. Hayes), between its companion (Hayes, *Drawings*, no. 18) and the portrait of Ann Ford, later Mrs. Philip Thicknesse (Cincinnati). This portrait, painted at Bath in 1760, was one of Gainsborough's first large-scale canvases, and therefore had particular significance for him. A study in the British Museum (Hayes, *Drawings*, no. 16) sets out the overall composition of the picture, but Gainsborough may well have referred to the drawing in the Frick Collection when painting Miss Ford's dress: the fall of light and shade on the skirt in the drawing is almost exactly repeated in the portrait.

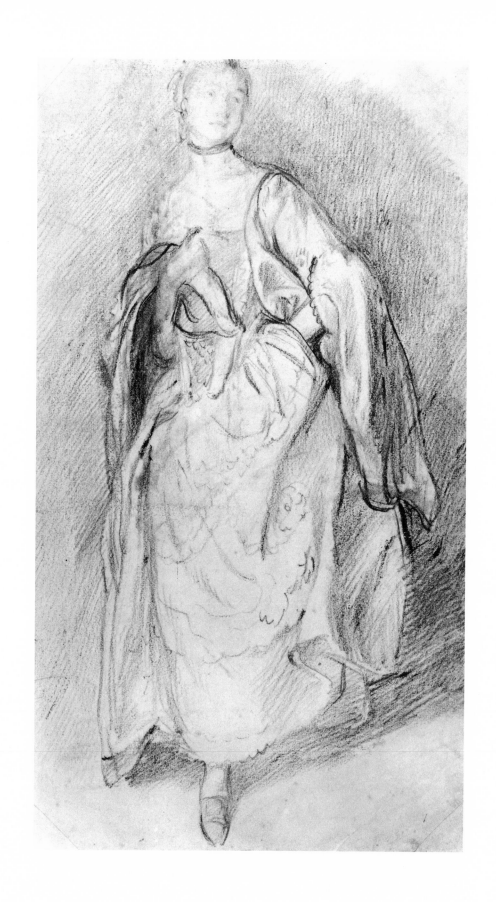

27. A WOODED LANDSCAPE WITH FIGURES AND CATTLE IN A STREAM c. 1760–65

Black chalk and stump with white chalk on buff paper.
10^{11}/16 × 15 in. (27.1 × 38.1 cm.)
Literature: Hayes, *Drawings*, no. 257; Hayes, *Landscape Paintings*, 1982, vol. II, p. 438.
Pennington-Mellor-Munthe Inheritance, England.

One of the chief formative influences on Gainsborough's mature landscape style from the beginning of the 1760s was Rubens. In 1768 Gainsborough wrote enthusiastically to David Garrick about *The Watering Place* (National Gallery, London): "I could wish you to call upon any pretence any day after next Wednesday at the Duke of Montagu's . . . if . . . only to see his Grace's Landskip of Rubens" (Woodall, *Letters*, p. 67). His painting of the same title, also in the National Gallery, exhibited in 1777, is the most obvious example, but Rubens's influence is reflected in many other works, including the present drawing.

Although not actually a study for the picture, Gainsborough seems to have adapted the drawing for the foreground of the *View near King's Bromley-on-Trent, Staffordshire*, c. 1768–71, in the Philadelphia Museum of Art (Hayes, *Landscape Paintings*, 1982, vol. II, no. 94). John Hayes has suggested that Gainsborough's drawings of this type, with their soft, atmospheric quality, may have been known to the young John Constable (Hayes, *Drawings*, p. 75).

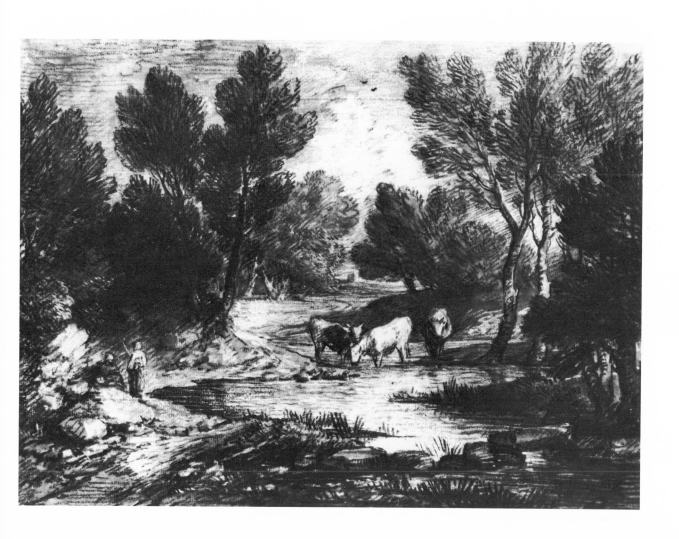

28. A HILLY LANDSCAPE WITH FIGURES APPROACHING A BRIDGE c. 1763

Watercolor and bodycolor.
$10^{13}/_{16} \times 14^{7}/_{8}$ in. (27.5 × 37.6 cm.)
Literature: Hayes, *Drawings*, no. 264.
Exhibitions: *Gainsborough*, The Tate Gallery, London, 1980–81, no. 15; Grand Palais, Paris, no. 81.
Yale University Art Gallery, Collection of Mary C. & James W. Fosburgh, B.A. 1933, M.A. 1935.

One of a number of landscape drawings, dating from the early 1760s, in which Gainsborough made extensive use of white bodycolor to enliven the surface texture. Such a technique may have been derived from the gouache drawings of Marco Ricci or Giovanni Battista Busiri, some of which were owned by the artist's friend Robert Price (see no. 24); and Gainsborough must also have known the gouache landscapes of his contemporary Paul Sandby (1730–1809). In subject, the present drawing anticipates Gainsborough's late representations of mountain scenery. It was probably given by the artist to his physician in Bath, Dr. Rice Charlton, whose portrait he painted c. 1763–64 (Waterhouse, no. 136) and who owned the *Landscape with Woodcutter*, c. 1762–63, now in the Museum of Fine Arts, Houston (Hayes, *Landscape Paintings*, 1982, vol. II, no. 77).

Marco Ricci (1676–1730). *Woodmen Cutting Trees by a Waterfall*. Bodycolor on pigskin. 12 × 17³/4 in. (30.5 × 45.1 cm.). Sold at Christie's New York, on 7 January 1981.

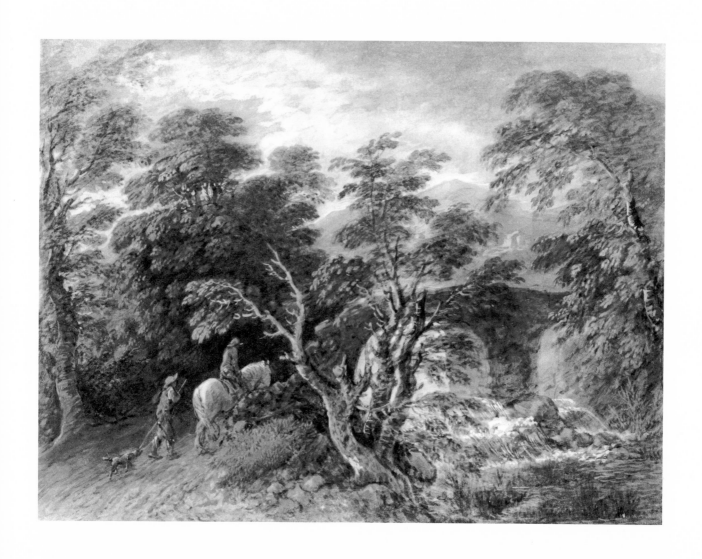

29. A WOODED LANDSCAPE WITH FIGURES AND A DISTANT MOUNTAIN c. 1763–64

Watercolor and bodycolor over pencil, on brown paper.

10^{15}/$_{16}$ × 14^{3}/$_{4}$ in. (27.7 × 37.5 cm.)

Literature: Hayes, *Drawings*, no. 265; L. Herrmann, *British Landscape Painting of the Eighteenth Century*, 1973, pp. 97–8, pl. 92a; D. B. Brown, *Catalogue of the Collection of Drawings in the Ashmolean Museum, Oxford: volume IV*, 1982, pp. 306–7; Hayes, *Landscape Paintings*, 1982, vol. II, p. 423 and pl. 83a.

Exhibitions: *Landscape in Britain c. 1750–1850*, The Tate Gallery, London, 1973, no. 55; *Gainsborough*, Grand Palais, Paris, 1981, no. 88.

Visitors of the Ashmolean Museum, Oxford.

A study used, with few modifications, for a painting now in an English private collection (Hayes, *Landscape Paintings*, 1982, vol. II, no. 83). In the painting, there is additional foreground detail, the dog and the birds are omitted and a bridge is added near the cottage. The strongly contrasted areas of light and shade and the stormy sky of the drawing reappear in the painting. Both in mood and in technique—particularly in the use of white bodycolor to add accents—this drawing may be compared with others datable in the first half of the 1760s (see nos. 28 and 30), though here the modelling of forms is sketchier.

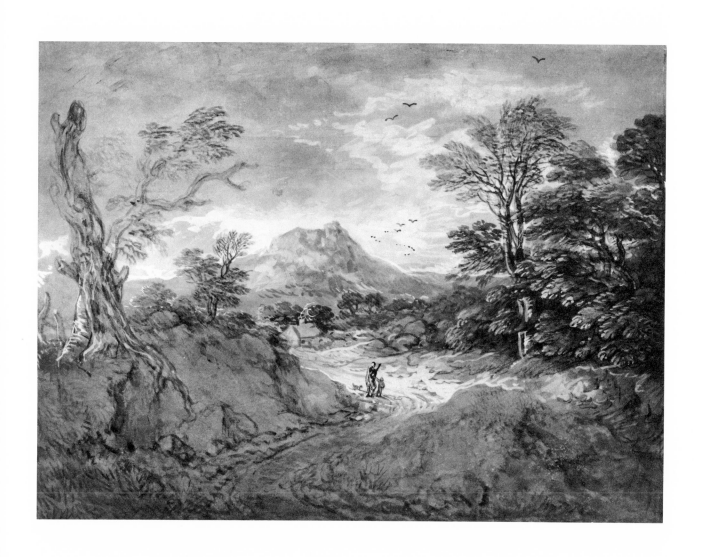

30. A WOODED LANDSCAPE WITH A PEASANT BOY ASLEEP IN A CART c. 1763–64

Watercolor and bodycolor over pencil on brown paper.

11 × 14⅒⁄₁₆ in. (27.9 × 37.9 cm.)

Literature: Hayes, *Drawings*, no. 266; D. B. Brown, *Catalogue of the Collection of Drawings in the Ashmolean Museum, Oxford: volume IV*, 1982, p. 308.

Exhibitions: *The Painter's Eye*, Gainsborough's House, Sudbury, 1977, no. 10.

Visitors of the Ashmolean Museum, Oxford.

In technique (particularly the touches of white bodycolor in the foreground), and in the treatment of foliage, this drawing resembles no. 28 and can likewise be dated in the early 1760s. Such highly-finished examples are characteristic of Gainsborough at this period. They echo the appearance of his oil paintings of the same date (for example Hayes, *Landscape Paintings*, 1982, vol. II, nos. 77 and 79).

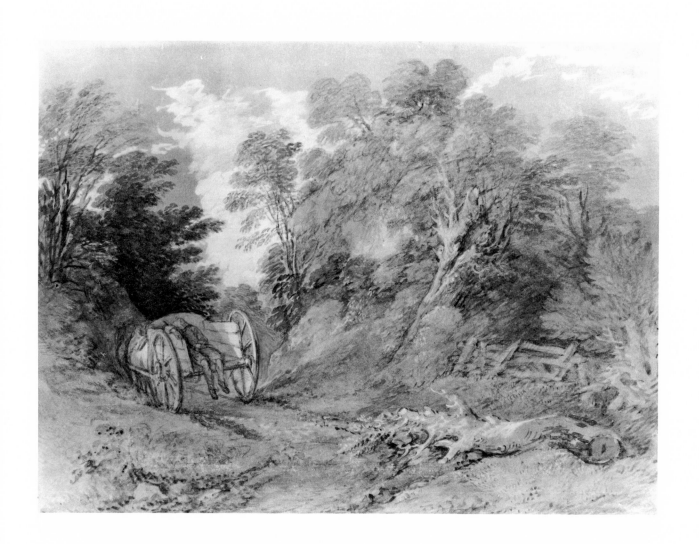

31. STUDY FOR A PORTRAIT OF THE ARTIST'S DAUGHTERS MARY (1748–1826) AND MARGARET (1752–1820) c. 1763–64

Black and white chalks on blue paper.
10³/₄ × 8⁹/₁₆ in. (27.3 × 21.7 cm.)
Literature: Hayes, *Drawings*, no. 45.
Engraved: Lithograph by the artist's great-nephew Richard Lane, published
1 January 1825.
Executors of the late Viscountess Ward of Witley.

A study for the painting now in the Worcester Art Museum, Massachusetts, showing Gainsborough's daughters drawing from a statuette of the Farnese Flora. The portrait has been dated c. 1763–64, when Mary would have been fifteen or sixteen years old and Margaret eleven or twelve; in this drawing they seem slightly younger, but this may be because their features are only lightly sketched in. Both girls were taught to paint and draw by their father, who wrote to a friend in 1764: "You must know I'm upon a scheeme of learning them both to paint Landscape; and that somewhat above the common Fan-mount style. I think them capable of it, if taken in time, and with proper pains bestow'd." (Woodall, *Letters*, 1963, p. 151); Margaret told Joseph Farington in January 1799 that "She regretted much having lost many letters which He wrote to her and Her Sister while they were at . . . School, containing instructions for drawing."

Although Gainsborough saw himself as an instinctive, unacademic artist—an image perpetuated by Reynolds, who said of him that "he did not pay a general attention to the works of the various masters . . . his grace was not academical or antique, but selected by himself from the great school of nature"—his work includes a number of borrowings from the Antique. The statuette of the Farnese Flora presumably belonged to him; it may have been a plaster copy by John Cheere of Rysbrack's reduced terracotta version of 1759 (see F. Haskell and N. Penny, *Taste and the Antique*, 1981, pp. 217–18 and *The Man at Hyde Park Corner: Sculpture by John Cheere 1709–1787*, catalogue of an exhibition held at Temple Newsam, Leeds, 1974, no. 33).

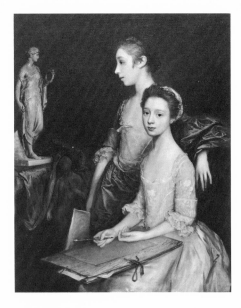

Thomas Gainsborough. *The Artist's Daughters*, c. 1763–64. Oil on canvas. 49¹/₂ × 39¹/₂ in. (125.7 × 100.3 cm.). Worcester Art Museum, Massachusetts.

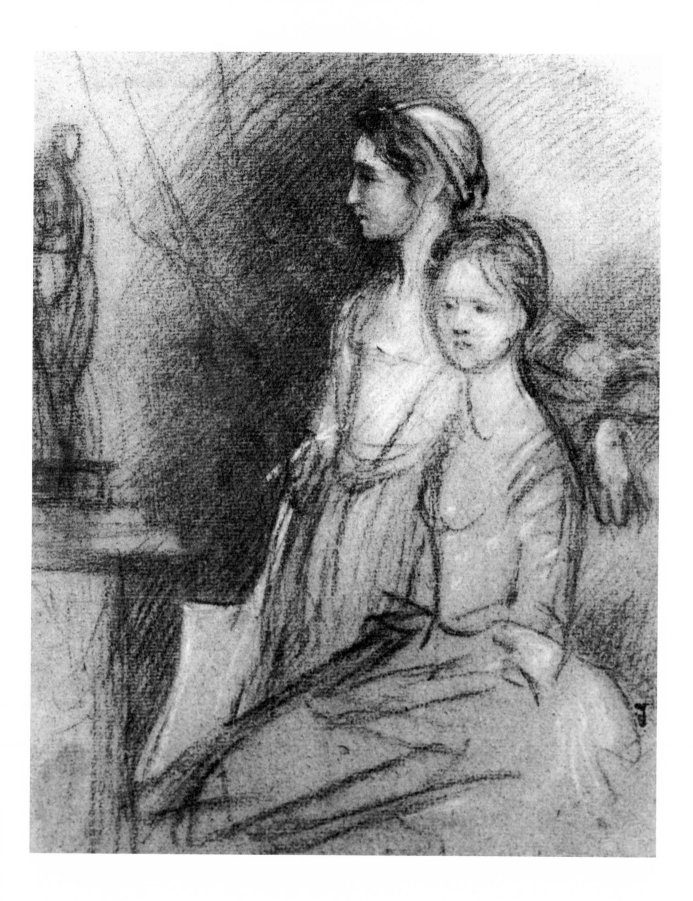

32. STUDY FOR A PORTRAIT OF CARL FRIEDRICH ABEL (1725–1787) early 1760s

Black chalk and stump, heightened with white chalk, on blue paper.

12⅝ × 10¼ in. (32.1 × 25.6 cm.)

Verso: A study for the drawing of a seated woman in the Staatliche Museen Preussischer Kulturbesitz, Kupferstichkabinett, Berlin (Hayes, *Drawings*, no. 56).

Literature: see under Hayes, *Drawings*, no. 27.

Exhibitions: *Gainsborough and his Musical Friends*, Kenwood, London, 1977, no. 17; *Gainsborough*, Grand Palais, Paris, 1981, no. 89.

Engraved: Lithograph by Gainsborough's great-nephew Richard Lane, published 1 January 1825.

National Portrait Gallery, London (NPG 5081).

Carl Friedrich Abel was one of Gainsborough's closest friends. He was the last of the great virtuosi of the viola da gamba, which he called "the king of instruments" despite the fact that by the middle of the century it had become virtually superseded by the violoncello. Abel had played under J. S. Bach in the Electoral orchestra in Dresden, and moved to London in 1759, where he enjoyed immediate popularity. From 1762 until 1773 he shared a house in London with J. C. Bach (another of Gainsborough's friends), and from 1764 their names became inseparable as the joint organisers of a series of subscription concerts, notably at the Hanover Square Rooms, for the decoration of which Gainsborough painted a large transparency on glass of the Muse of Comedy. Abel was also a composer, although overshadowed by the achievements of J. C. Bach, and his overture to *Love in a Village*, 1762, was the first to be written in the fully *galant* style that was to become so popular.

Gainsborough and Abel probably first met in Bath, where numerous concerts were organised by London musicians. This drawing can be dated, on the basis of the costume worn by Abel and by his youthful appearance, to the early 1760s. Although differing in details of dress and setting, this drawing was probably a preparatory study for a portrait in oils last recorded in the collection of Carl P. Dannett, New York, in 1923 and now known only through a photograph. Gainsborough's best-known portrait of Abel, exhibited at the Royal Academy in 1777, and now in the Huntington Art Gallery, shows him as he was in later life, a "tall, big, portly person, with a waistcoat under which might easily have been buttoned twin brothers" (Henry Angelo, *Reminiscences*, 1828, vol. I, p. 184). Admiration for Abel's skill led Gainsborough to study the viola da gamba, though accounts of his success in playing the instrument vary widely. Gainsborough bought one of Abel's most prized instruments at his sale in 1787, perhaps imagining, as he had years earlier when he coveted a violin belonging to Felice Giardini, "that the music lay in the fiddle, he was frantic until he possessed the instrument . . . but seemed much surprised that the music of it remained behind" (William Jackson, *The Four Ages*, 1798, p. 148). In 1799 the artist's younger daughter Margaret told the diarist Joseph Farington that her father was "led much into company with Musicians, with whom he often exceeded the bounds of temperance & His

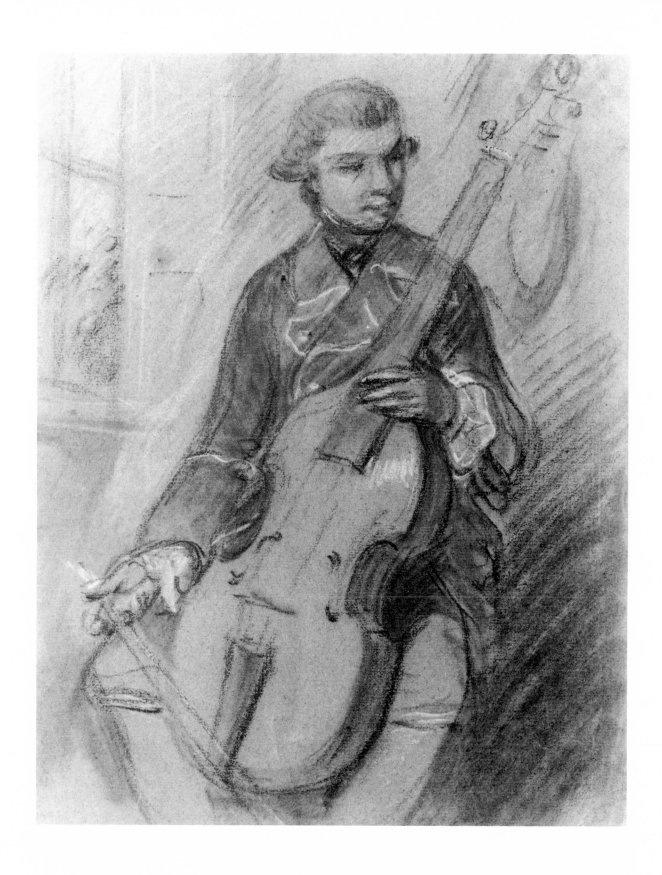

Health suffered from it, being occasionally unable to work for a week afterwards" (*The Farington Diary*, 15 February 1799). The sale held after Abel's death (Christie's, 13 December 1787) included thirty-two drawings by Gainsborough. He may at some point have owned even more, as well as two landscape paintings, given to him by the artist in exchange for a viola da gamba. Henry Angelo recalled that "the walls of his apartment were covered with them, slightly pinned to the paper-hangings" (*Reminiscences*, 1828, vol. I, p. 190).

Abel's death in 1787 affected Gainsborough profoundly. In a letter written on the day he died, to Henry Bate-Dudley, Gainsborough expressed his feelings: "We love a genius for what he leaves and we mourn him for what he takes away.... For my part, I shall never cease looking up to heaven—the little while I have to stay behind—in hopes of getting one more glance of the man I loved from the moment I heard him touch the string.... My heart is too full to say more."

Although this drawing was included in the Briggs sale in 1831, it subsequently disappeared. Its appearance was known, however, from the lithograph published by Richard Lane in 1825, and when the drawing reappeared in 1975 its identity as the lost study of Abel was recognised.

33. A RUSTIC SCENE WITH A PAIR OF LOVERS
 c. 1760–65 ?

Black chalk, heightened with white, on blue paper, trimmed at all four corners.
9¼ × 8¹/₁₆ in. (23.5 × 20.5 cm.)
Literature: Hayes, *Landscape Paintings*, 1982, vol. I, p. 148.
Private Collection, England.

This drawing came to light only in 1975, several years after the publica-tion of John Hayes's catalogue of Gainsborough's drawings. Dr. Hayes suggests that it is a late work, but the style of the draftsmanship and the costume of the girl seem more consistent with the 1760s. It may be compared with the study of Carl Friedrich Abel (no. 32), a drawing datable c. 1760–65. The corners are trimmed, which is characteristic of those drawings that descended in the artist's family, suggesting a simi-lar provenance for this study.

Although it has every appearance of being a study for a detail in a landscape painting, no related picture has yet been identified. Gains-borough included rustic lovers in his landscapes from the mid 1750s, though with only one exception, the *Haymaker and Sleeping Girl*, c. 1785 (Boston Museum of Fine Arts), he never made them the focus of his pastoral compositions in the decorative, lightly erotic way practised by his near-contemporary, François Boucher. The present drawing is per-haps as close as Gainsborough ever came to the French style of rustic *galanterie*, but its slight naiveté gives it an added charm—as of Chelsea porcelain compared with Sèvres.

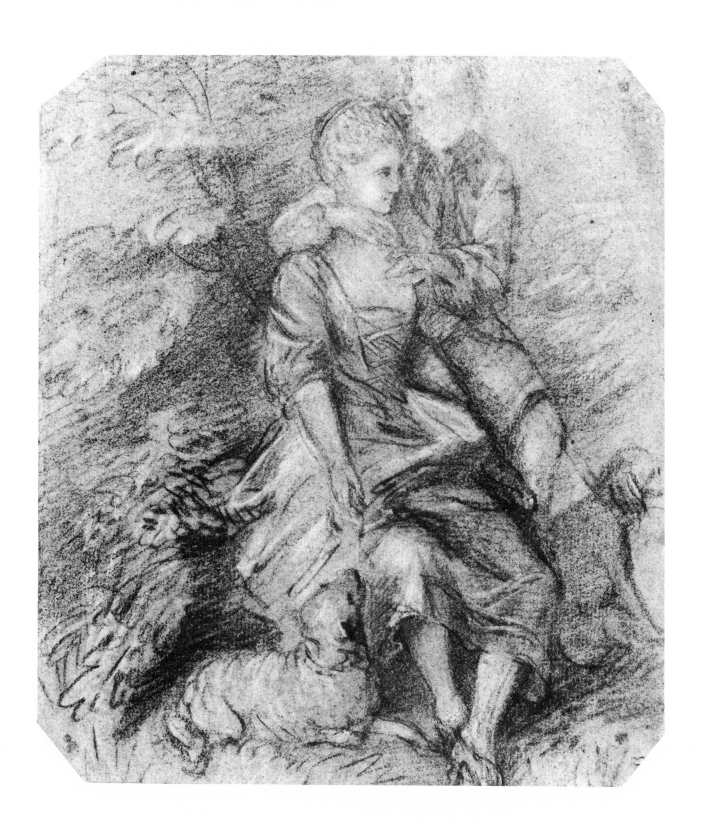

34. A WOMAN WITH A ROSE c. 1763–65

Black chalk and stump, heightened with white, on greenish-buff paper.
18⁵/₁₆ × 13 in. (46.6 × 33.0 cm.)
Literature: Hayes, *Drawings*, no. 29.
Exhibitions: *Gainsborough and Reynolds in the British Museum*, 1978, no. 41.
The Trustees of the British Museum (1855–7–14–70).

John Hayes has suggested that this is a costume study, probably drawn from a lay figure, but it has every appearance of being from life and may be compared with a portrait study such as that of Mary Gainsborough (no. 46). It is not unlike the portrait of Countess Howe (Kenwood), painted c. 1763–64 which, though full-face, resembles it in the details of the dress and in the pose, notably the way in which the hand is placed on the hip. Gainsborough rarely employed drapery painters, and may well have used a model to draw from while experimenting with the disposition of Lady Howe's dress and with possible poses.

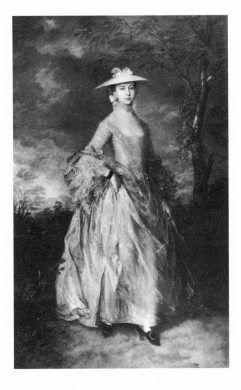

Thomas Gainsborough. *Mary, Countess Howe,* c. 1763–65. Oil on canvas. 96 × 60 in. (243.9 × 152.4 cm.). Greater London Council as Trustees of the Iveagh Bequest, Kenwood.

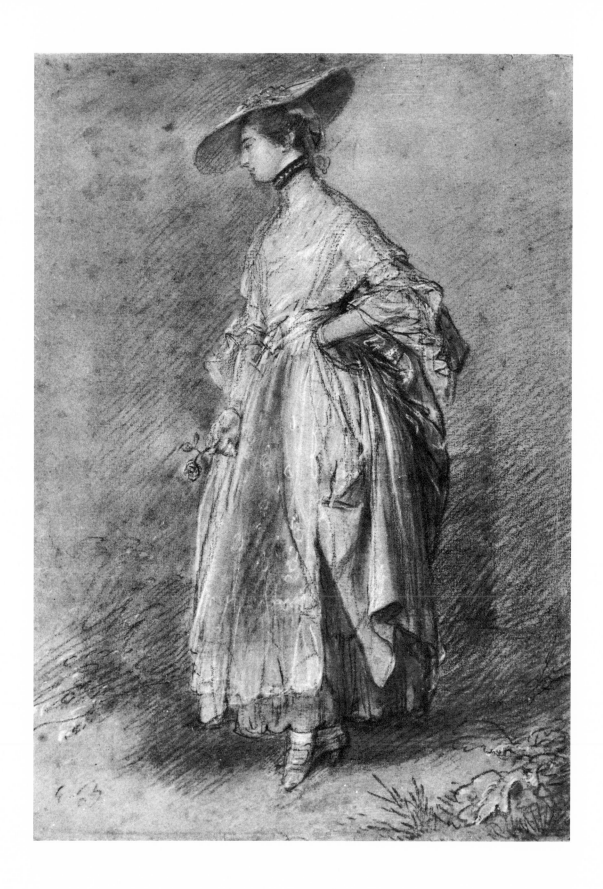

35. STUDY OF A WOMAN SEEN FROM BEHIND
c. 1765–70

Black chalk and stump with white chalk on grayish-brown paper.
19³/₁₆ × 11¹⁵/₁₆ in. (48.8 × 30.4cm.)
Literature: Hayes, *Drawings*, no. 30; D. B. Brown, *Catalogue of the Collection of Drawings in the Ashmolean Museum, Oxford: volume IV*, 1982, pp. 306–7.
Exhibitions: *The Painter's Eye*, Gainsborough's House, Sudbury, 1977, no. 11; I. E. F., 1979–80, no. 37; *Gainsborough*, The Tate Gallery, London, 1980–81, no. 19.
Engraved: Lithograph by the artist's great-nephew Richard Lane, published 1 January 1825.
Visitors of the Ashmolean Museum, Oxford.

This figure study may be grouped with others datable in the 1760s, in particular those of the artist's daughter Mary (no. 46) and of a woman with a rose (no. 34). It is one of a number of figure drawings which descended in Gainsborough's family through his younger daughter Margaret, and was lithographed by his great-nephew Richard Lane in 1825; but the tradition that it represents Mrs. Gainsborough on her way to church is no more than a nineteenth-century myth. It has every appearance of being drawn from life, and it anticipates the studies for the *Richmond Water-walk* (see nos. 82, 83, 84 and 85).

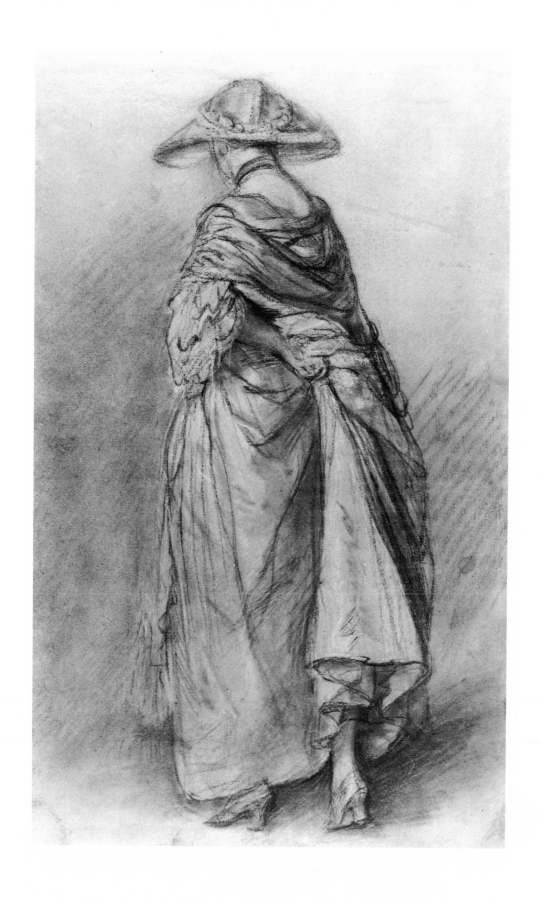

36. A MOUNTED HERDSMAN AND COWS WITH A DISTANT VILLAGE SEEN BETWEEN TREES
c. 1765

Pencil, watercolor and bodycolor on pinkish paper.
8⁷/₁₆ × 11⅛ in. (21.4 × 28.3 cm.)
Literature: Hayes, *Drawings*, no. 273; Hayes, *Gainsborough*, 1975, p. 211 and pl. 69.
Exhibitions: *Gainsborough*, The Tate Gallery, London, 1980–81, no. 16.
Ingram Family Collection.

The delicate, feathery treatment of the foliage and the overall tonality of this watercolor suggest knowledge of the group of landscape sketches in watercolor and bodycolor on blue or gray paper, traditionally attributed to Van Dyck and apparently representing views in England. On the other hand, the hilly landscape with a group of buildings in the distance seems to combine the impression made on Gainsborough by the countryside around Bath, where he was living between 1759 and 1774, with elements derived from the seventeenth-century classicizing landscape of Gaspard Dughet and his followers.

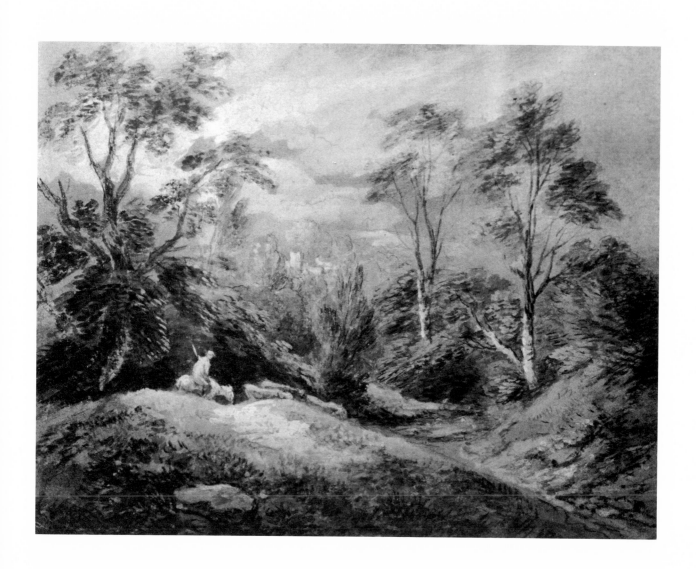

37. WOODED LANDSCAPE WITH A HORSEMAN, A FIGURE LEANING OVER A STILE, AND A COTTAGE c. 1765

Watercolor and bodycolor over pencil.
9^{7}/$_{16}$ × 12^{1}/$_{8}$ in. (24.0 × 30.9 cm.)
Stamped *TG* in monogram in gold at bottom left.
Literature: Hayes, *Drawings*, no. 277.
The Toledo Museum of Art.

Like nos. 28, 29, 30, 36 and 39, this watercolor is datable in the mid 1760s, although its relatively tighter handling suggests that it was executed somewhat earlier than the example in the British Museum. Gainsborough used watercolor extensively only in this period, and it may be significant that he was then particularly concerned with the quality of paper. When he found that the paper used for printing Christopher Anstey's *New Bath Guide* of 1767 would suit his requirements "for making wash'd Drawings" he wrote to the publisher James Dodsley: "There is so little impression of the Wires, and those so very fine, that the surface is like Vellum . . . I want it on account of the substance & not having so much of the Glaze upon it . . . it really comes up to the Italian drawing Paper such as they made formerly" (quoted by Hayes, *Drawings*, vol. I, p. 21). However, the paper that Dodsley sent proved unsatisfactory: "the mischief of that you were so kind to inclose, is not only the small Wires, but a large Cross Wire. I wish, Sir, that one of my Landskips, such as I could make you . . . would prove a sufficient inducement for you to make still further enquiry . . . I am at this moment viewing the difference of that you send & the Bath guide holding them Edgeways to the light, and could cry my Eyes out to see those furrows" (Woodall, *Letters*, p. 59). In fact, most of the drawings of the 1760s—including the present one—are on white laid paper with visible chain-lines and wiremarks. Later, however, he seems to have found a supply of the kind of paper he wanted, for some of his drawings at the end of the 1770s and the 1780s are on paper that is noticeably smooth and untextured.

John Hayes has drawn attention to the parallel between these watercolors of the mid 1760s and those of Jonathan Skelton (c. 1735–59), whose interpretation of the English landscape has much of the same subtlety and delicacy. It is unlikely that Gainsborough knew Skelton's work, which was rediscovered only in the present century: on the other hand, he is known to have admired the drawings of Paul Sandby, though these were chiefly topographical—a type of landscape he usually despised. "With respect to *real Views* from Nature in this country," he wrote to a potential patron probably in 1764 "he has never seen any Place that affords a Subject equal to the poorest imitations of Gaspar or Claude. Paul Sandby is the only Man of Genius, he believes, who has employ'd his Pencil that way" (Woodall, *Letters*, pp. 87, 91).

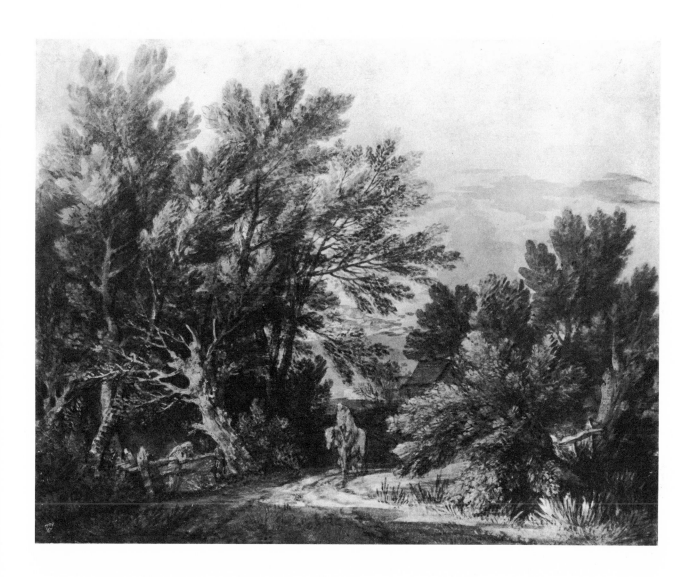

38. STUDY OF FOLIAGE c. 1765

Pencil with gray and blue washes.

5⅝ × 7⅝ in. (14.3 × 19.4 cm.)

Collector's mark of Sir Robert Witt (Lugt 2228[b]) on the mat at bottom left.

Literature: Hayes, *Drawings*, no. 281.

Courtauld Institute Galleries.

Like nos. 17 and 18, this is a sheet from one of the sketchbooks later owned by the West India merchant and collector George Hibbert (1757–1837). Unlike the artist's earlier studies from nature which are in pencil only, this sketch is touched with blue and gray wash. Gainsborough probably made use of such studies for watercolors such as nos. 24 and 39 which seem to be based on observation of nature rather than drawn from artificial landscape models.

39. A WOODED LANDSCAPE WITH A WAGGON IN A GLADE c. 1765–67

Watercolor heightened with white bodycolor, over indications of black chalk.
9⁵/₁₆ × 12¹/₂ in. (23.7 × 31.7 cm.)
Stamped at bottom left with the artist's monogram *TG* in gold.
Verso: study of a tree with a hilly background.
Literature: Hayes, *Drawings*, no. 282 (*verso*, no. 253).
Exhibitions: *Gainsborough and Reynolds in the British Museum*, 1978, no. 54; *Gainsborough*,
The Tate Gallery, London, 1980–81, no. 17; Grand Palais, Paris, 1981, no. 90.
The Trustees of the British Museum (1899–5–16–10).

This is one of the finest examples of Gainsborough's use of the medium of full watercolor. It was probably worked up from sketches made on the spot, perhaps in the countryside around Bath where he was living in the 1760s. Stylistically, this drawing reflects the influence of a group of watercolor studies on blue paper ascribed to Van Dyck (though this attribution has often been questioned); a landscape drawing in the British Museum (now catalogued as "anonymous Flemish seventeenth-century") formerly in the collection of Gainsborough's friend Uvedale Price, is inscribed on the *verso* "Vandyck, thought so by Mr West [Benjamin West]. It was a very favourite drawing of Gainsborough's." However, the present drawing, with its boldly contrasted areas of light and shade, is perhaps even closer in style to those of George Lambert (1700–1765) and William Taverner (1703–1772). The gold-stamped monogram suggests that Gainsborough intended this drawing either for sale or for presentation, but nothing is known of its provenance before the late nineteenth century.

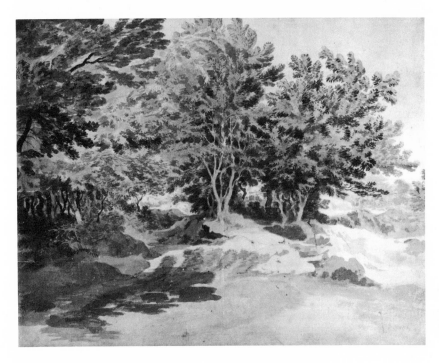

William Taverner (1703–1772). *A Wooded Landscape*. Pencil and watercolor. 14³/₄ × 19 in. (37.5 × 48.3 cm.). The Trustees of the British Museum.

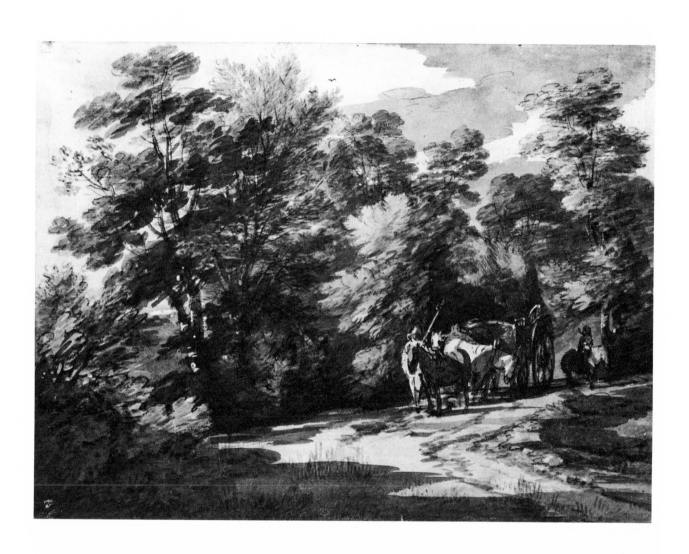

40. STUDIES OF A CAT mid to later 1760s

Black chalk and stump, heightened with white, on buff paper.
13^{1}/$_{16}$ × 18^{1}/$_{16}$ in. (33.2 × 45.9 cm.)
Signed bottom right: *T. Gainsborough.*
Literature: Hayes, *Drawings*, no. 874.
Exhibitions: *Gainsborough*, The Tate Gallery, London, 1980–81, no. 18.
Rijksprentenkabinet, Rijksmuseum, Amsterdam (52.114).

Traditionally believed to have been sketched by Gainsborough at a
country house and presented to his hostess, this delightful sheet of
studies is unusual in being fully signed. John Hayes has suggested a
date in the mid to late 1760s, which would accord with the neatly
finished handling.

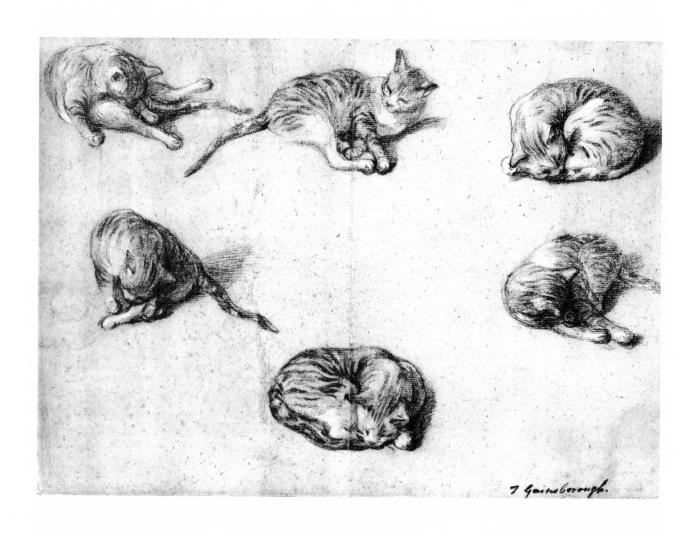

41. A BOY RECLINING IN A CART c. 1767–70

Pen and brown ink with gray and brown washes.

$6^{15}/_{16} \times 8^{11}/_{16}$ in. (17.6 × 22.1 cm.)

Literature: Hayes, *Drawings*, no. 307; Hayes, *Gainsborough*, 1975, p. 214 and pl. 81; J. Barrell, *The Dark Side of the Landscape*, 1980, pp. 65–6; J. Lindsay, *Thomas Gainsborough: His Life and Art*, 1981, p. 94 and pl. 29.

Exhibitions: *Gainsborough and Reynolds in the British Museum*, 1978, no. 35; *Gainsborough*, The Tate Gallery, London, 1980–81, no. 21, Grand Palais, Paris, 1981, no. 93.

The Trustees of the British Museum (1896–5–11–2).

Probably drawn during the late 1760s, this is an example of one of Gainsborough's favorite motifs—the cart moving through a wooded landscape—which he treated in a variety of styles. The present drawing must date from about the same time as the painting of *The Harvest Waggon* (Barber Institute, Birmingham), in which the cart is similarly related to the landscape background. The boy reclining in it with one leg dangling over the edge is a more elegantly rococo figure than those that Gainsborough used later; as John Hayes has remarked, he is "untroubled by the cares of rural husbandry." The use of pen and ink, particularly in the cart wheel and the horse, may have been in emulation of Rembrandt.

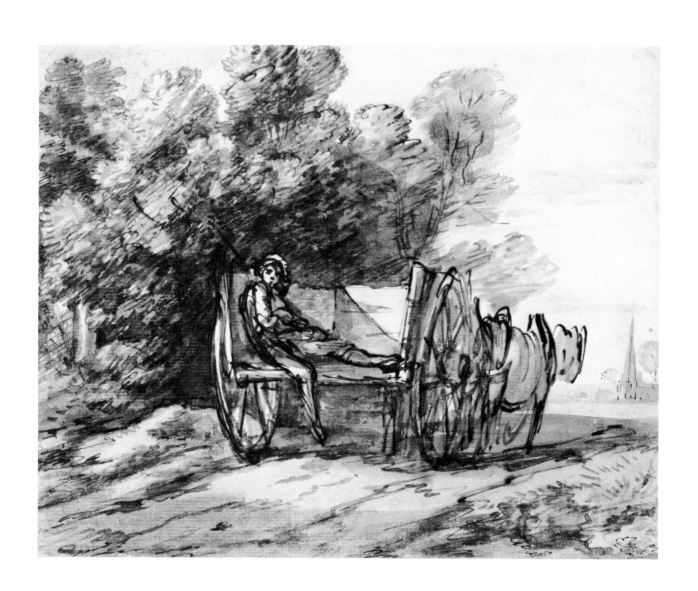

42. A WOODED LANDSCAPE WITH FIGURES AND A COUNTRY CART c. 1767–70

Watercolor and bodycolor over black chalk and pencil.

9¹⁄₂ × 12¹⁄₂ in. (29.0 × 31.5 cm.)

Stamped *TG* in monogram in gold at bottom left.

Literature: Hayes, *Drawings*, no. 308; *Bulletin van het Rijksmuseum*, 1979, p. 86 and ill. p. 90.

Rijksprentenkabinet, Rijksmuseum, Amsterdam (1979.25).

Dated by John Hayes in the late 1760s, this watercolor was among those probably given by Gainsborough to Goodenough Earle (1699–1788/9) of Barton Grange in Somerset (J. Hayes, "The Gainsborough Drawings from Barton Grange," *The Connoisseur*, vol. CLXII, 1966, pp. 86–91). Both in subject and in its technique of watercolor touched with bodycolor to highlight the foliage of the trees on the left, this drawing resembles others datable earlier in the same decade, such as nos. 28, 29, 30 and 37. Its somewhat greater freedom of handling perhaps reflects the influence of the seventeenth-century Dutch landscape draftsman Anthonie Waterloo (see Hayes, *Drawings*, vol. II, pl. 274). Unstudied as such drawings may appear, they were almost certainly not drawn directly from nature. Gainsborough was adept at generalizing landscape details previously observed at first hand, which he evolved into an ideal picturesque form. In this drawing, though he convinces us of the reality of the setting, the graceful rhythmic pattern of the trees with their "all-purpose" foliage—it is quite impossible to determine what kind of tree they are—suggests a certain distillation of reality which nevertheless conforms to Uvedale Price's definition of one aspect of the Picturesque: "I think . . . we may conclude, that where . . . a set of objects, is without smoothness or grandeur, but from its intricacy, its sudden and irregular deviations, its variety of form, tints, and lights and shadows, is interesting to a cultivated eye, it is . . . picturesque; such, for instance, are the rough banks that often enclose a bye-road or a hollow lane."

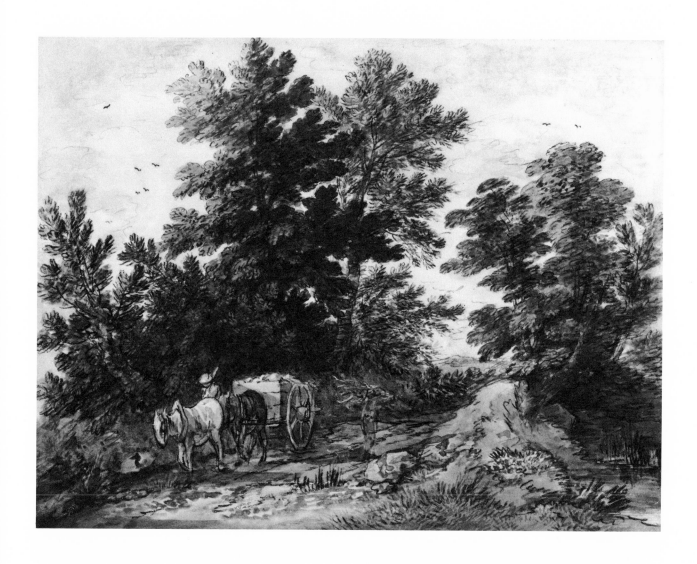

43. STUDY OF A SEATED WOMAN c. 1765–70

Black chalk and stump, with white chalk, on blue paper.
12³/₈ × 9⁵/₁₆ in. (31.4 × 23.7 cm.)
Verso: Study of a small girl seated on a bank.
Literature: Hayes, *Drawings*, no. 32.
Exhibitions: *Gainsborough*, The Tate Gallery, London, 1980–81, no. 20; Grand Palais,
Paris, 1981, no. 92.
Engraved: Lithograph by the artist's great-nephew, Richard Lane, published
1 January 1825.
Private Collection.

As with other figure-studies by Gainsborough, it is difficult to determine whether or not this one was drawn from life. That it may have been studied from a lay figure is suggested by the unconvincing fall of the dress over the knees, the awkward way in which the legs are joined to the body, and the summarily indicated face.

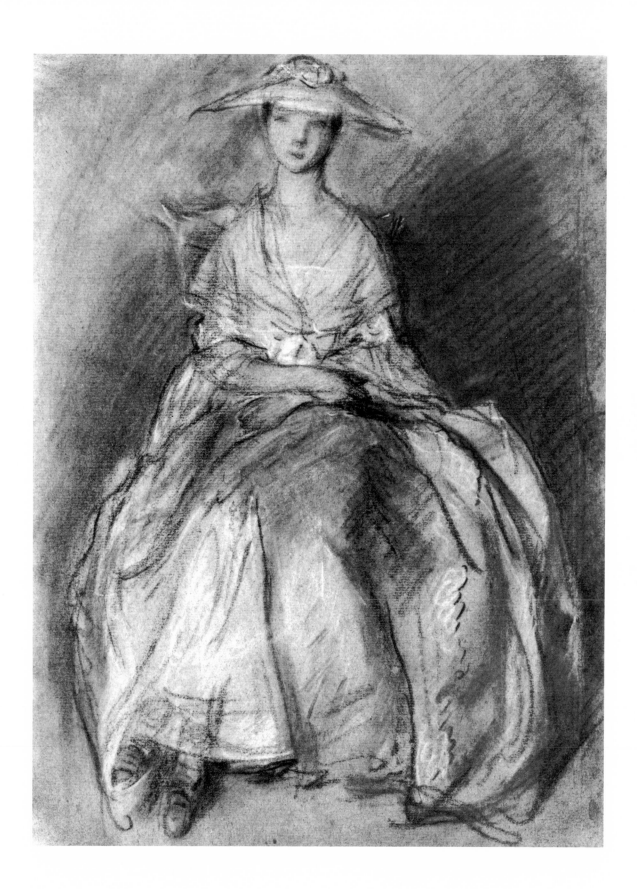

44. A WOMAN SEATED BESIDE A PLINTH
 c. 1765–70

Black chalk and stump, heightened with white, on gray-green paper.
17½ × 14 in. (44.4 × 35.6 cm.)
Literature: Hayes, *Drawings*, no. 39.
The Pierpont Morgan Library, New York (III, 58).

Perhaps a study for a projected portrait. The pose is a development of one favored by the artist in the late 1740s and early 1750s, for example, in the portrait of a girl, possibly Miss Lloyd, now at Fort Worth (see nos. 7, 8, and 9), similarly sitting beside a plinth surmounted by a classical urn. On grounds of style and costume, this drawing can be dated in the late 1760s. The same figure may be represented in a drawing in the British Museum (Hayes, *Drawings*, no. 36).

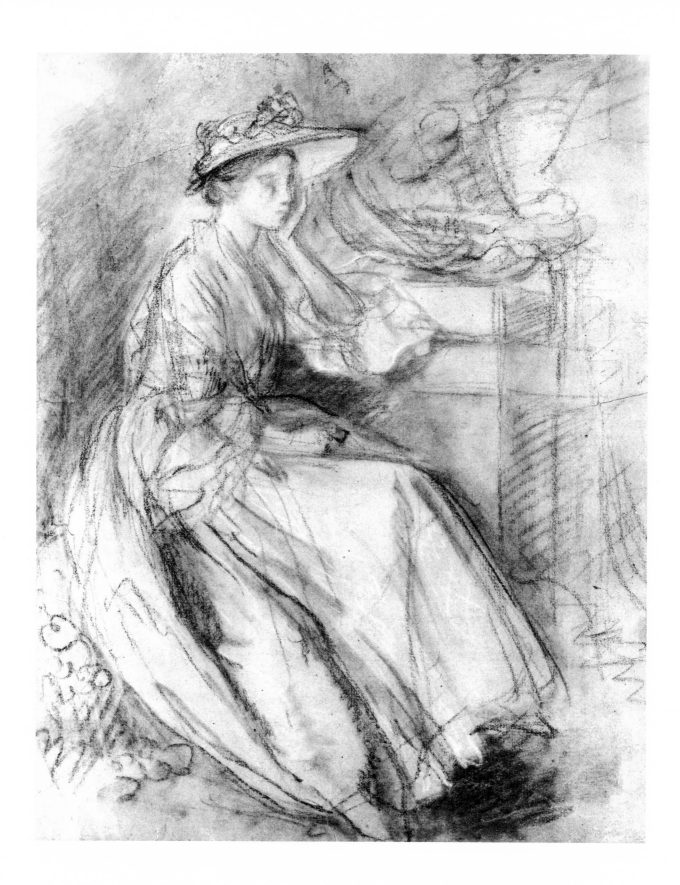

45. A MUSIC PARTY late 1760s?

Red chalk and stump, trimmed at all four corners.

9½ × 12¾ in. (24.1 × 32.4 cm.)

Inscribed *verso* in gray ink: *Portraits (of Himself, his two Daughters, and Abel) by Gainsborough* and *To W. Mularedy* [sic] *Esq^r RA from his obliged Servant Rich^d Lane.*

Literature: Hayes, *Drawings*, no. 47.

Exhibitions: *Gainsborough and his Musical Friends*, Kenwood, London, 1977, no. 18; *Gainsborough and Reynolds in the British Museum*, 1978, no. 37; *Gainsborough*, The Tate Gallery, London, 1980–81, no. 26; Grand Palais, Paris, 1981, no. 98.

The Trustees of the British Museum (1889–7–24–371).

One of Gainsborough's most evocative sketches from life. The use of red chalk, which is unusual for Gainsborough, may have been influenced by contemporary French drawings or perhaps by prints after such drawings in the crayon manner. The inscription on the *verso* by Gainsborough's great-nephew, Richard Lane, shows that, like many others, this drawing descended through the artist's family. Various attempts have been made to identify the members of the music party: Lane's suggestion is probably fanciful, for Gainsborough could hardly have included himself in a study from life, while the woman at the harpsichord appears to be middle-aged and Abel played not the violin but the viola da gamba (see no. 32). Stylistically, the drawing can be dated in the late 1760s when Gainsborough was working in Bath. It is possible that the musicians (or some of them) may be members of the talented Linley family, who lived in this city. The two families were close friends, Gainsborough's passion for music providing a natural link, and in the late 1760s and early 1770s he painted portraits of several of the Linleys. The violinist in the foreground, who seems to be only a boy, may therefore be Thomas Linley (1756–1778), an infant prodigy who was already leading the Bath orchestra at the age of eleven. The tall girl standing beside him could be his sister Elizabeth (1754–1792), who from an early age sang at concerts organized by her father, and became, until her marriage to the playwright Richard Brinsley Sheridan, a leading singer in oratorio. Gainsborough's most striking portrait of her, painted in 1785–86, is now in the National Gallery of Art, Washington.

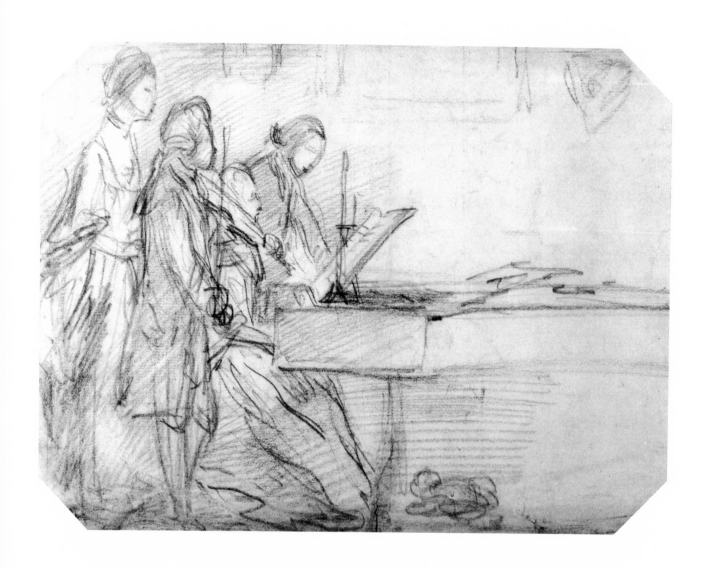

46. MARY GAINSBOROUGH (1748–1826) c. 1765–70

Black chalk and stump heightened with white on yellowish-buff paper.
17⁹/₁₆ × 13⁵/₈ in. (44.7 × 34.7 cm.)
Inscribed in pencil in a recent hand on the old mat: *Mary*.
Literature: Hayes, *Drawings*, no. 35.
Exhibitions: *Gainsborough and Reynolds in the British Museum*, 1978, no. 30.
The Trustees of the British Museum (1960–11–10–1).

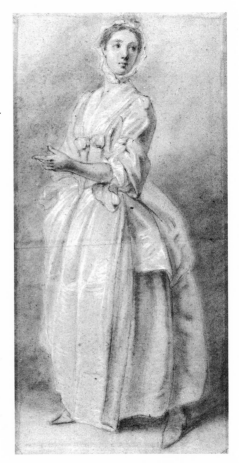

Although the inscription identifying the sitter is in a fairly modern hand, comparison with the portrait of the artist's elder daughter Mary (1748–1826) in the Tate Gallery (Waterhouse, no. 289) suggests that she is the subject of this study. Gainsborough painted and drew Mary and her sister Margaret (1752–1820) on many occasions from earliest childhood (see also nos. 23 and 31). The present drawing was probably made in the late 1760s, judging by the costume and the probable age of the sitter. The fact that her face is carefully drawn, together with the degree of finish to which the study has been brought, suggest that it was not a sketch for a painting but was complete in its own right. In technique and mood such studies can be seen as a development of the figure drawings made by Hubert-François Gravelot in the 1740s, when Gainsborough worked in his studio.

In 1780 Mary Gainsborough married the German-born composer and oboe player J. C. Fischer (1733–1800), who was a friend of her father. Despite this friendship Gainsborough distrusted Fischer's intentions towards his daughter, and was taken aback when he married Mary: "as to his oddities and temper, she must learn to like as she likes his person, for nothing can be altered now. I pray God she may be happy with him and have her health." The marriage was a failure, and Gainsborough's will included the provision that money left to Mary should not be subject to "the debts, power, control or intermeddling" of her husband. In 1799 the diarist Joseph Farington described her as "of a melancholy aspect," and she died in 1826 after years of mental instability.

Hubert-François Gravelot (1699–1773). *A Young Woman Walking to the Left*. Black chalk and stump, heightened with white, on gray paper. 17½ × 8⁷/₈ in. (44.5 × 22.9 cm.). The Trustees of the British Museum.

112

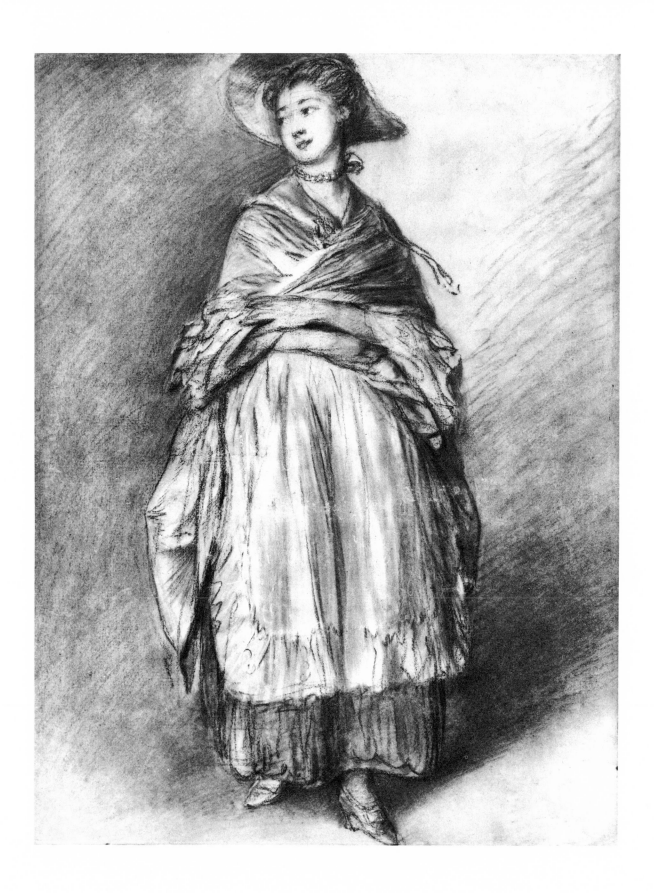

47. A WOODED LANDSCAPE WITH SHEPHERD AND SHEEP c. 1769

Pen and brown ink over traces of pencil, with gray wash, varnished.
6^{15}/$_{16}$ × 9^{1}/$_{4}$ in. (17.7 × 23.5 cm.)
Collector's mark of John Deffett Francis (Lugt 1445) at bottom left.
Literature: Hayes, *Drawings*, no. 303.
Yale Center for British Art, Paul Mellon Collection.

In subject, composition and treatment, this drawing closely resembles those of about the same date executed in watercolor and bodycolor (see nos. 37, 39 and 42). The technique of pen and ink, with a broken line to suggest foliage, and wash to add mass, seems to have been influenced by seventeenth-century Dutch and Flemish examples. John Hayes suggests that Gainsborough may have had landscape studies by Van Dyck in mind, adducing a sketch of trees known to have been in Reynolds's collection and now in the British Museum. The drawings of artists like Jan Both (c. 1610–52) may also have provided inspiration for studies of this type. Inscriptions on two similar drawings (Hayes, *Drawings*, nos. 299 and 301), recording that one was given by the artist to Lord Bateman in 1770 and the other to Colonel St. Paul in 1769, suggest a date in the late 1760s. Such drawings, echoing earlier traditions of draftsmanship, seem to have been prized by those collectors to whom Gainsborough gave them: Henry Bate-Dudley noted shortly after the artist's death that "the few he parted with during life were either gifts to very particular friends, or select persons of fashion; and that he could never be prevailed upon to receive money for those effusions of his genius" (*The Morning Herald*, 10 October 1788).

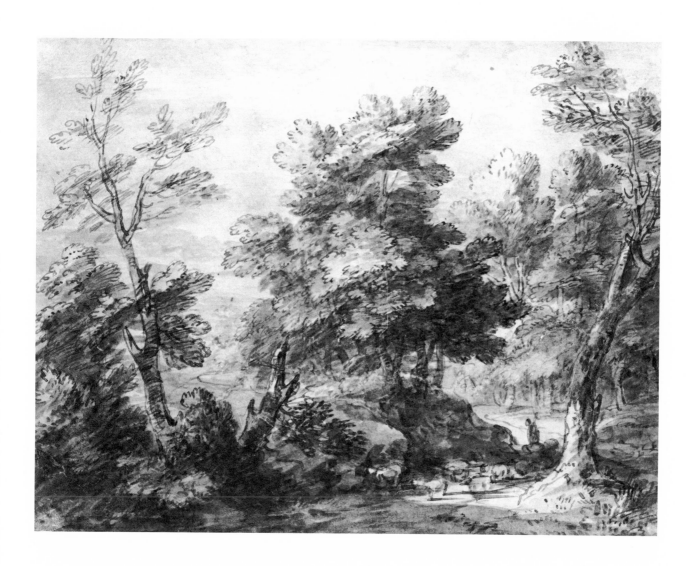

48. A WOODLAND POOL WITH ROCKS AND PLANTS c. 1765–70

Black chalk with watercolor and bodycolor, varnished.

9 × 11⅛ in. (22.9 × 28.3 cm.)

Literature: Hayes, *Drawings*, no. 311.

Exhibitions: *English Drawings and Watercolours 1550–1850 in the Collection of Mr and Mrs Paul Mellon*, The Pierpont Morgan Library, New York, 1972, no. 37; *English Landscape 1630–1850*, Yale Center for British Art, New Haven, 1977, no. 25; *Gainsborough*, The Tate Gallery, London, 1980–81, no. 22; Grand Palais, Paris, 1981, no. 94.

Yale Center for British Art, Paul Mellon Collection.

John Hayes has suggested that this study, probably drawn in the late 1760s, was made directly from nature. However, although there is evidence from Ozias Humphry and Uvedale Price that Gainsborough went on sketching expeditions into the countryside around Bath, it was at this period that he also began to develop the practice of composing landscape models at home of "roots, stones and mosses, from which he formed, and then studied, foregrounds in miniature" (Uvedale Price). Even in the early part of his career, although he sketched from nature, he would study foreground detail from Dutch artists such as Wijnants "whose thistles and dock leaves he frequently introduced into his first pictures" (obituary in *The Morning Chronicle*, 4 August 1788). The present study may have been drawn from nature, but its elaborate technique suggests that it could equally well have been based on recollection combined perhaps with models (Gainsborough's habit of using such aids to composition was remarked on by several contemporaries as if it were particularly noteworthy, but Paul Sandby's sale, Christie's, May 1811, included landscape models "designed to draw from"). In its generalized character, this drawing might almost be an enlargement of a corner of foreground detail in one of his landscape paintings. He is chiefly concerned with establishing the fall of light on the rocks rather than with individual elements in the composition. This drawing is one of the earliest examples of a practice developed by Gainsborough to enrich the pictorial qualities of a drawing—the use of varnish, which was to culminate in the 1770s when he went so far as to exhibit drawings in imitation of oil paintings.

116

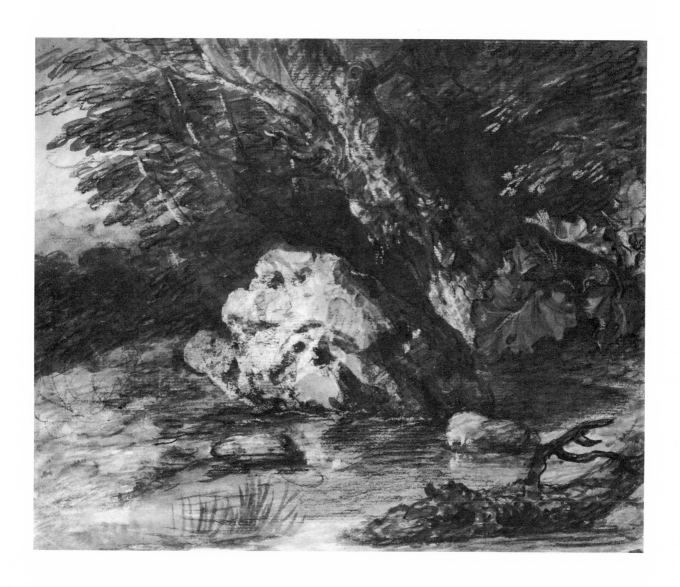

49. A WOODED LANDSCAPE WITH A COUNTRY CART AND WOODGATHERERS c. 1770

Pen and brown ink with watercolor, heightened with white, on brown prepared paper.
$8^3/_8 \times 11^{13}/_{16}$ in. (21.3 × 30.0 cm.)
Literature: Hayes, *Drawings*, no. 317.
J. St. A. Warde, Squerryes Court, Westerham, Kent.

This unusually spacious composition, which can probably be dated towards the end of the 1760s, includes several of Gainsborough's most familiar motifs: the boy sitting in the back of the cart is in the same pose as in a drawing in the British Museum (no. 41), while the women and children gathering sticks in the foreground anticipate the "fancy" subjects of the 1780s in which similar rustic figures were painted on the scale of life.

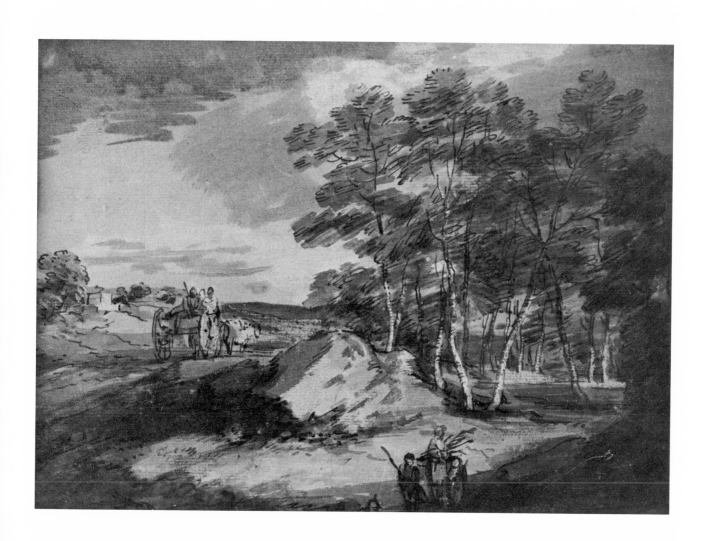

50. A VILLAGE SCENE WITH HORSEMEN AND FIGURES c. 1770

Watercolor over black chalk.
9¼ × 12⅞ in. (23.5 × 32.7 cm.)
Collector's mark of the 4th Earl of Warwick (Lugt 2600) at bottom right.
Literature: Hayes, *Drawings*, no. 318.
Exhibitions: *English Landscape 1630–1850*, Yale Center for British Art, 1977, no. 26.
Yale Center for British Art, Paul Mellon Collection.

One of a number of watercolors and paintings dating from the late
1760s and early 1770s which reflect the influence of the seventeenth-
century Flemish painter David Teniers. All of them are variations on
the theme of a group of cottages clustered around the same church
spire, with figures and animals in the foreground. Two small paintings
of similar subjects, treated in a way reminiscent of Dutch or Flemish
seventeenth-century cabinet pictures, are also in the Mellon Collection
at Yale University (Hayes, *Landscape Paintings*, 1982, vol. II, nos. 100
and 101).

Gainsborough's early landscapes were influenced above all by Dutch
artists like Ruisdael, Wijnants and Hobbema, but after he moved to
Bath in 1759 he became increasingly aware of the Flemish school,
notably Snyders, Teniers and Rubens, whose works he saw in the
collections of his West Country patrons. As John Hayes has pointed
out, the church spire in this watercolor bears little resemblance to those
in the neighborhood of Bath, and was probably taken from paintings
by artists like Teniers or Van Goyen. In a letter to his physician, Dr.
Rice Charlton, Gainsborough refers to a copy that he had made of "a
little dutch spire." The original of the copy was evidently the landscape
with figures by Bout and Boudewijns included in Dr. Charlton's sale of
1790 together with a copy by Gainsborough. It was doubtless such
paintings that he had in mind when composing the present watercolor.

John Barrell has interpreted another such village scene (Hayes,
Landscape Paintings, 1982, vol. II, no. 104) as "a dejected portrayal of
the village community . . . a place of poverty and despair" (*The Dark
Side of the Landscape*, 1980, pp. 64–5). He sees it as a reflection (whether
conscious or unconscious, Dr. Barrell does not say) of the contempo-
rary notion that the poverty of rural laborers was a direct result of their
fecklessness, and that this could be redeemed only by hard work and
piety.

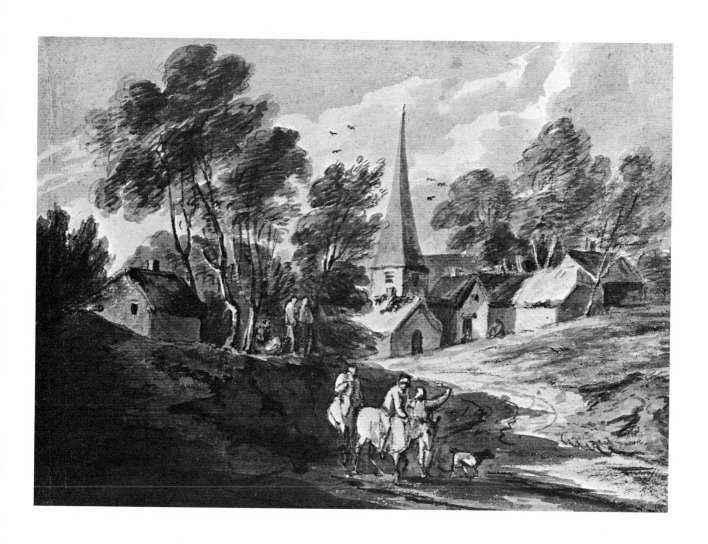

51. LANDSCAPE WITH HORSEMEN AND BUILDINGS c. 1770–75

Chalks and watercolor, varnished.
8³⁄₈ × 12³⁄₈ in. (21.3 × 31.4 cm.)
Exhibitions: Knoedler, 1914, no. 16 (bought by G. D. Widener, Philadelphia).
Private Collection.

This drawing did not come to light until after the publication in 1970 of John Hayes's *catalogue raisonné*. It can probably be dated in the early 1770s, a period when Gainsborough was experimenting with varnished drawings. He explained this complex technique in a letter to William Jackson, in January 1773: "make the black and white of your drawing, the Effect I mean, & disposition in rough, Indian ink shaddows & your lights of Bristol made white lead which you buy in lumps at any house painters . . . when you see your Effect, dip it all over in skim'd milk; put it wet on [your] Frame . . . let it dry, and then you correct your [Effects] with Indian ink when dry & if you want to add more lights or alter, do it and dip again . . . then tinge in your greens, your browns with sap green & Bistre, your yellows with Gall stone & blues with fine Indigo &c &c . . . float it all over with Gum water . . . varnish it 3 times with Spirit Varnish such as I sent you. . . . Swear now never to impart my secret to any one living." On the other hand, a later dating cannot be entirely ruled out: the buildings on the right of the composition can be parallelled in drawings made from nature in the early 1780s (cf. e.g. Hayes, *Drawings*, nos. 538, 539, 550).

According to John Hayes, this drawing is another of those originally belonging to Goodenough Earle (1699–1788/9) of Barton Grange (see nos. 12, 16, 42 and 79).

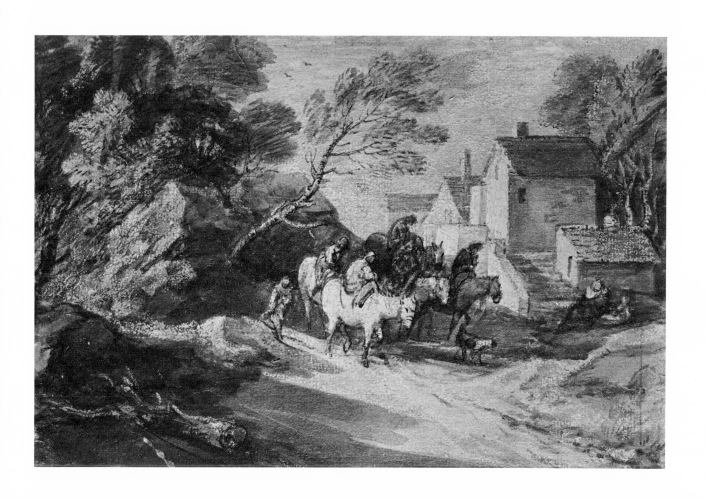

52. STUDY OF A YOUNG WOMAN SEATED AT A TABLE c. 1775–80

Black chalk, heightened with white, on gray paper, trimmed at all four corners.
12⁵/₁₆ × 9¹/₄ in. (31.3 × 23.4 cm.)
Literature: Hayes, *Drawings*, no. 51.
Exhibitions: *Gainsborough and Reynolds in the British Museum*, 1978, no. 42.
The Trustees of the British Museum (1895–7–25–1).

A study from life, which can be dated to the late 1770s because of the dress and hair style of the sitter. The granular texture of the chalk and the bold hatching are characteristic of Gainsborough's style at this date; in effect they resemble the soft-ground etching with which he was experimenting from c. 1775. Gainsborough's concern with immediacy and likeness caused him on occasion to neglect anatomical precision: here he has had difficulties with the girl's forearms.

At some time, the drawing was probably pasted into an album, from which it would have been removed by trimming the corners. The fact that the girl's headdress is only partially shown may indicate that originally the sheet was considerably larger. However, Gainsborough may deliberately have chosen to concentrate on the sitter's face and to omit distracting detail.

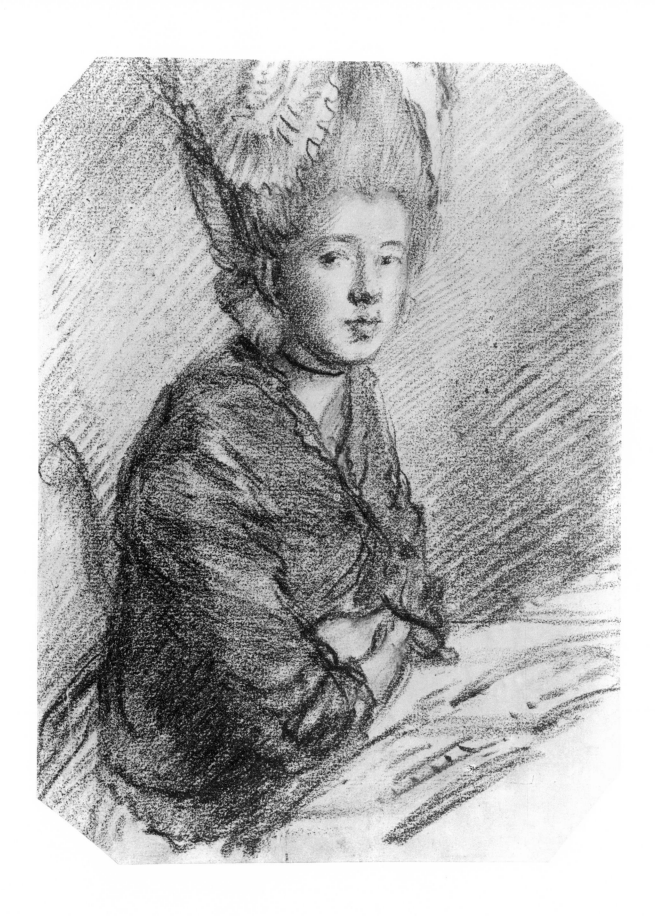

53. A WOODED LANDSCAPE WITH A HERDSMAN AND CATTLE c. 1775–80

Black chalk and gray and gray-black washes, heightened with white, on buff paper.
10¹³/₁₆ × 14¹/₈ in. (27.5 × 35.9 cm.)
Collector's mark of the Spencer Collection, Althorp (Lugt 2341ᵃ) at bottom right.
Literature: Hayes, *Drawings*, no. 389.
Private Collection.

One of a group of drawings by Gainsborough which were in the Spencer Collection at Althorp (see also no. 60). It is not known how or when they came there, but as Henry Bate-Dudley noted in his obituary, Gainsborough is known to have parted with a few drawings during his lifetime "either as gifts to very particular friends, or select persons of fashion." Gainsborough painted portraits of members of the Spencer family over a period of twenty years beginning in the early 1760s.

This drawing can be dated in the late 1770s on grounds of style. Its probable connection with a painting dated c. 1777–78, *Landscape with a Country Cart passing over a rocky Mound* (Hayes, *Landscape Paintings*, 1982, vol. II, no. 118) has not hitherto been noticed. The main compositional elements are retained in the painting, although donkeys are substituted for the cattle, the ground at the right is made rockier and a cart and figures are added. Such changes are characteristic of Gainsborough, for whom drawings (certainly in his later years) served to stimulate ideas for paintings, rather than as studies to be slavishly followed.

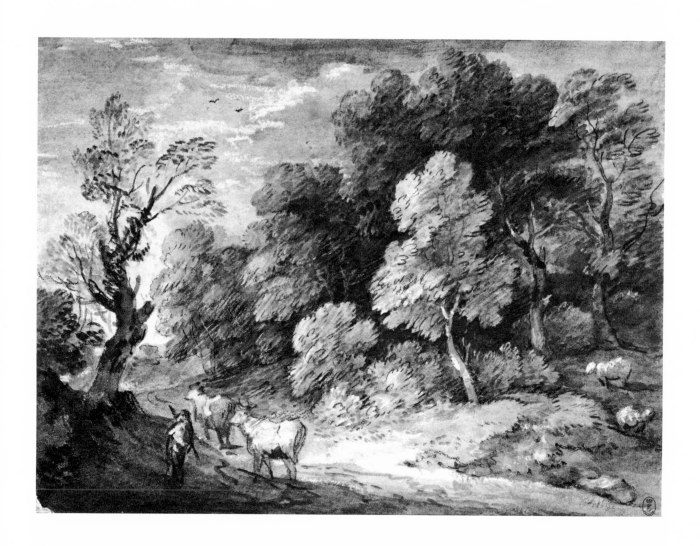

54. A ROCKY WOODED LANDSCAPE WITH
A FIGURE DRIVING SHEEP c. 1775–80

Black chalk and stump heightened with (partly oxidized) white on blue paper.
11⁷/₈ × 16¹/₁₆ in. (30.2 × 42.0 cm.)
Literature: Hayes, *Drawings*, no. 396.
Exhibitions: *Gainsborough and Reynolds in the British Museum*, 1978, no. 75.
The Trustees of the British Museum (1910–2–12–260).

The idealized composition is evidently inspired by Gaspard Dughet, whose landscapes would have been familiar to Gainsborough both in the original and through the medium of engraving. Such drawings may also reflect his practice of constructing models of artificial landscapes. W. H. Pyne wrote that he had "more than once sat by him of an evening, and seen him make models, or rather thoughts, for landscape scenery . . . He would place cork or coal for his foregrounds, make middle grounds of sand and clay, bushes of mosses and lichens, and set up distant woods of broccoli" ("Ephraim Hardcastle"=W. H. Pyne, *Wine and Walnuts*, 2nd ed., 1824, vol. II, p. 197). As Reynolds subsequently remarked in his XIVth Discourse: "Like every other technical practice, it seems to me wholly to depend on the general talent of him who uses it . . . it shows the solicitude and extreme activity which he [Gainsborough] had about everything related to his art; that he wished to have his objects embodied as it were, and distinctly before him." (Sir Joshua Reynolds, *Discourses on Art*, ed. Robert R. Wark, New Haven and London, 1975. Discourse XIV, delivered 10 December 1788).

55. MOUNTAINOUS LANDSCAPE WITH FIGURES
AND BUILDINGS c. 1775–80

Black chalk and stump, heightened with white chalk, on blue-gray paper.
10⁵/₁₆ × 15¹⁵/₁₆ in. (26.2 × 40.5 cm.)
Literature: Hayes, *Drawings*, no. 397.
Lent by The Metropolitan Museum of Art, Rogers Fund, 1907.

Like the preceding drawing, this has been dated by John Hayes in the mid 1770s. Gainsborough's choice of black chalk on blue paper for such studies may have been influenced by the Old Master tradition with which he seems to have identified more than is usually believed, particularly in his emphasis at this period on compositions from the mind rather than observations from nature. The mood of such drawings was well described by Edward Edwards in his *Anecdotes of Painters*, 1808: "In his latter works, bold effect, great breadth of form, with little variety of parts, united by a judicious management of light and shade, combine to produce a certain degree of solemnity. This solemnity, though striking, is not easily accounted for, when the simplicity of materials is considered, which seldom represent more than a stony bank, with a few trees, a pond, and some distant hills."

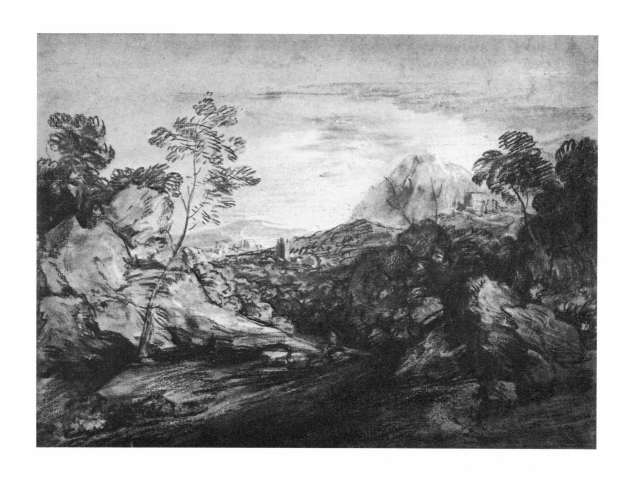

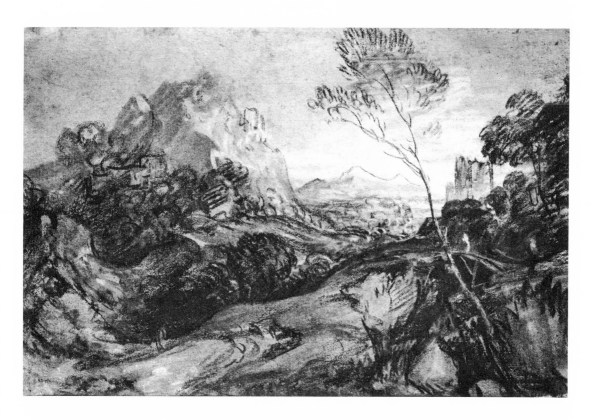

56. A WOODED LANDSCAPE WITH THREE HORSES DRINKING AT A POOL c. 1775

Black, white, red and blue chalks on blue-gray paper.
9¼ × 11⅝ in. (23.5 × 29.5 cm.)
Literature: Hayes, *Drawings*, no. 406.
Private Collection.

Probably dating from the mid 1770s, this drawing is one of a number in colored chalks, a medium occasionally used by Gainsborough in the last ten years of his life (see also no. 88). The composition is broadly derived from Rubens. The chalk has been skilfully handled to soften the outlines and produce a hazy, atmospheric effect. Reynolds's comments on Gainsborough's portraits are no less applicable to these drawings: "that in this indetermined manner, there is the general effect, enough to remind the spectator of the original; the imagination supplies the rest, and perhaps more satisfactorily to himself, if not more exactly, than the artist with all his care, could possibly have done." The viewer is more than a mere passive spectator, but is required to bring his own imaginative powers to bear on what he sees.

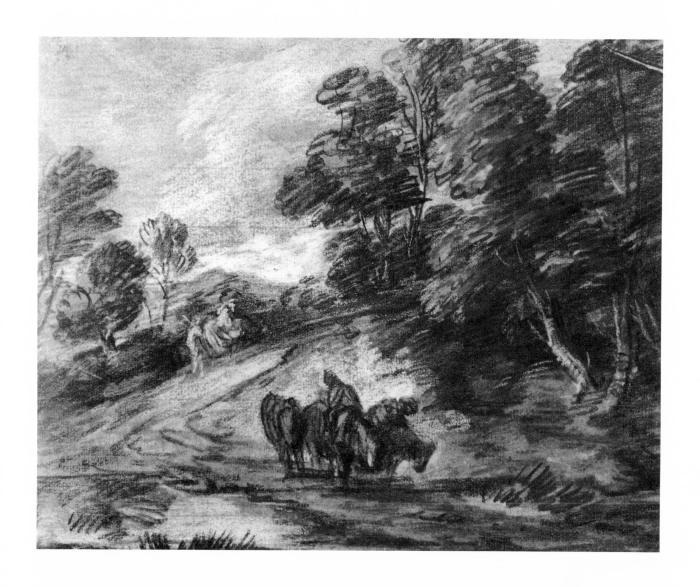

57. WOODED LANDSCAPE WITH FIGURES OUTSIDE A COTTAGE DOOR c. 1778

Gray and gray-black washes, with white chalk.

10^{11}/$_{16}$ × 13^{5}/$_{8}$ in. (27.1 × 34.6 cm.)

Literature: Hayes, *Drawings*, no. 478; Hayes, *Landscape Paintings*, 1982, vol. II, p. 475 and pl. 121a.

H. R. H. The Duchess of Kent.

A study for the painting now in Cincinnati (Hayes, *Landscape Paintings*, 1982, vol. II, no. 121), painted c. 1778. Gainsborough made few significant alterations in the final composition beyond grouping the figures more harmoniously. The subject of the simple rustic family at the cottage door, which first appears in Gainsborough's work in the early 1770s, is treated in some of his most ambitious late paintings. Though its origin is in Dutch and Flemish seventeenth-century *genre* painting, in Gainsborough's hands the theme is brought up to date by reflecting the late eighteenth-century Romantic cult of the rustic idyll and, at the same time, contemporary social developments. Here we see a peasant family treated with some degree of realism: mother, grandmother and nine children of various ages, gathered on and near the steps of a picturesque rural thatched cottage surrounded by trees. It was idyllic scenes of this sort by Gainsborough which Reynolds described as possessing "such a grace, and such an elegance, as are more often found in cottages than courts." To the left of the composition, however, a woodcutter, bowed down by a load of sticks, strikes a more pathetic note. Here Gainsborough may have intended to represent the changed social conditions of the countryside which had forced a previously independent peasantry, if they were not to work as hired laborers, to scrape a bare living by gathering wood or taking up some other hard and unrewarding occupation. (A third and increasingly unattractive possibility for the peasants was to desert the countryside altogether for the new manufacturing towns.) In his book, *The Dark Side of the Landscape*, 1980, John Barrell suggests that the two sides of Gainsborough's ambivalent attitude are here reflected separately: the idyllic aspect in the women and children, and the realistic in the woodcutter. The former, he suggests, look contented, as if enjoying well-earned repose, while the woodcutter—assuming that he is the husband—is condemned to unending labor in order to support his family. It cannot be said that Gainsborough's art was wholly without realistic intent, but Dr. Barrell is surely attributing to him a didactic purpose foreign to his nature.

An alternative interpretation is proposed by Marcia Pointon, in "Gainsborough and the Landscape of Retirement" (*Art History*, December 1979, pp. 441–55). She rejects the notion of Gainsborough's social message and at the same time suggests that he was more receptive to contemporary literary ideas than has generally been supposed. In Bath he had made the acquaintance of the Rev. Richard Graves (1715–1804), through whom he would certainly have known the works of the pastoral poet William Shenstone (1714–1763). The writings of

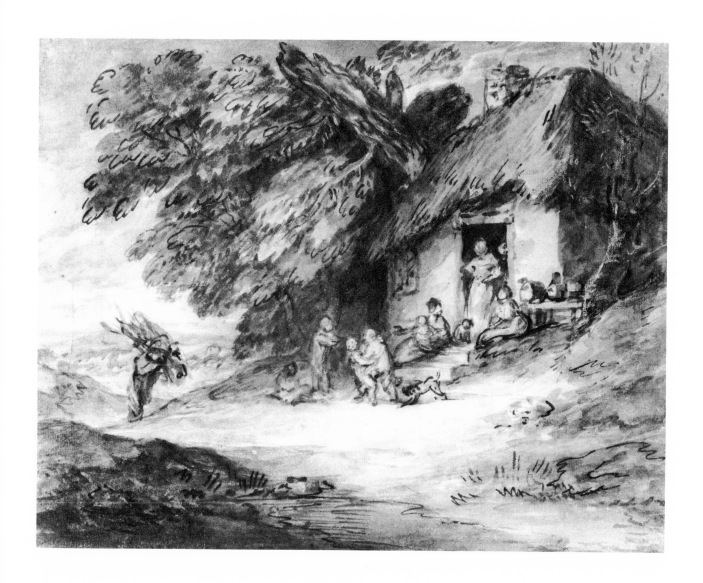

Shenstone and his circle celebrate the ideal of retirement from the city and from society to an existence in which man would reflect on how he could follow a virtuous existence in a fallen world by leading a life of rural solitude. That some of the artist's contemporaries shared this interpretation of his paintings is suggested by Graves's poem, "On Gainsborough's Landskips . . ." (published in *Shenstone's Miscellany*, 1759–63), in which Graves compares Milton's description of the expulsion of Adam and Eve from the Garden of Eden with Gainsborough's paintings: "Each Landskip seems 'a Paradise regain'd'." Another cottage subject, exhibited in 1780 (Hayes, *Landscape Paintings*, 1982, vol. II, no. 123), was described in a contemporary review as "a scene of happiness that may truly be called Adam's Paradise." In his letters, Gainsborough expressed the desire to "walk off to some sweet Village where I can paint Landskips and enjoy the fag End of Life in quietness and ease," which suggests disenchantment with the pressures of urban life. However, his rustic subjects might also be seen as simply providing a vicarious expression of pastoral retirement for patrons who would have found the reality uncomfortable.

58. STUDY OF A CHILD ASLEEP early 1780s

Black chalk and stump with touches of white chalk on blue paper.
$7^9/_{16} \times 5^3/_4$ in. (19.2 × 14.6 cm.)
Literature: Hayes, *Drawings*, no. 53; Hayes, *Gainsborough*, 1975, p. 222 and pl. 84.
Exhibitions: *Gainsborough*, The Tate Gallery, London, 1980–81, no. 35; Grand Palais, Paris, 1981, no. 102.
Private Collection.

A number of studies of children date from the 1780s, and were mostly made in connection with a new type of composition that Gainsborough had begun to develop towards the end of his life: the "fancy subject," several of which are of children in a rustic setting and painted on the scale of life. The present drawing could be of a child brought into the studio as a model for such a painting. Until recently, the drawing was framed horizontally, and it was difficult to see how she could be sleeping in such a position.

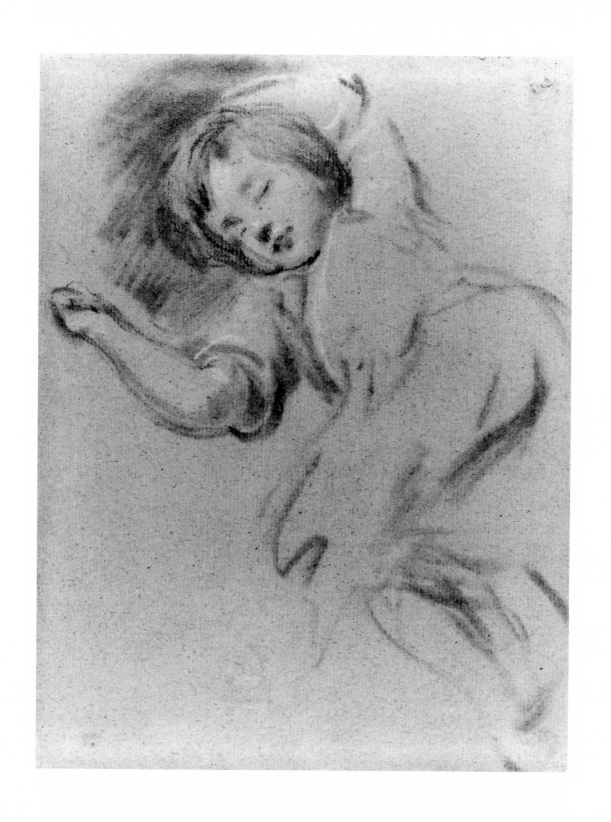

59. STUDY OF A WOMAN IN A MOB CAP
c. 1780–85

Black and white chalks on buff paper.
$7^{11}/_{16} \times 5^{3}/_{8}$ in. (19.5 × 13.7 cm.)
Literature: Hayes, *Drawings*, no. 54.
Exhibitions: *Gainsborough*, The Tate Gallery, London, 1980–81, no. 36.
Yale Center for British Art, Paul Mellon Collection.

A portrait study dating from the early to mid 1780s, perhaps of a member of the artist's family. The strongly cast shadows suggest that this drawing was made at night: according to Ozias Humphry, Gainsborough often worked by candlelight and "his Painting Room even by Day (a Kind of darkened Twilight) had scarcely any Light."

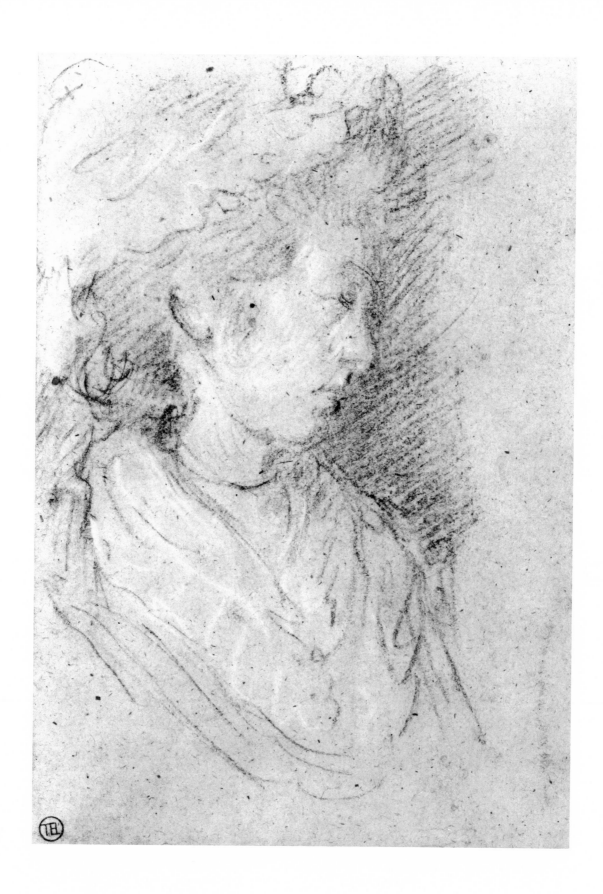

60. A WOODED UPLAND LANDSCAPE WITH A BRIDGE AND FIGURES c. 1780

Black and white chalks, with gray and gray-black washes.

11⅛ × 14½ in. (28.1 × 36.8 cm.)

Collector's mark of the Spencer Collection at Althorp (Lugt 2341ᵃ) at bottom right.

Literature: Hayes, *Drawings*, no. 495.

National Gallery of Art, Washington. Gift of Robert H. and Clarice Smith, 1982.

Close in subject and composition to Gainsborough's late painting in the National Gallery of Art, Washington, *The Mountain Landscape with a Bridge* of c. 1783–84 (Hayes, *Landscape Paintings*, 1982, vol. II, no. 151), no. 60 can likewise be dated in the early 1780s. In the painting, as in the drawing, the most striking characteristic of the composition is its powerful effect of lateral movement produced by the bridge and the figure crossing it, the rhythm of the composition being emphasized by the broad handling of the chalk. The bridge is a fantastic construction perhaps derived from French rococo landscape, which made its appearance in Gainsborough's work as early as 1759 (Hayes, *Drawings*, no. 243). Like no. 53 this drawing descended in the family of the Earls Spencer, who were patrons both of Gainsborough and of Reynolds.

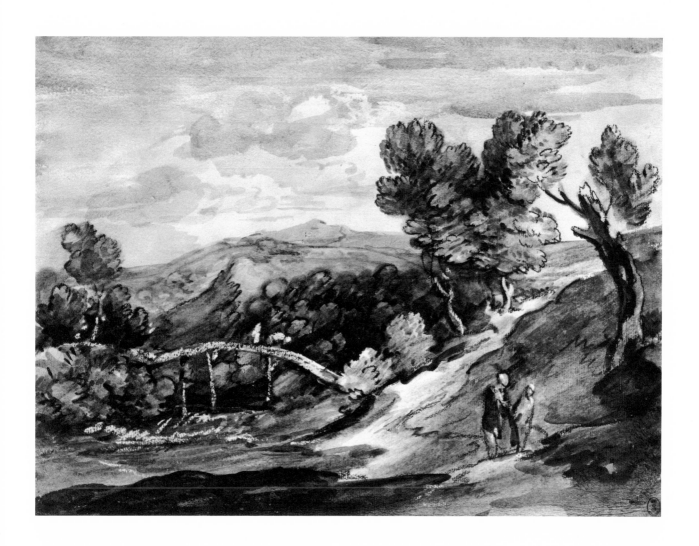

61. PEASANTS RETURNING FROM MARKET
c. 1780–83?

Gray, gray-black and brown washes.

7⅝ × 9⅝ in. (19.4 × 24.4 cm.)

Literature: Hayes, *Drawings*, no. 502.

Exhibitions: *Gainsborough*, The Tate Gallery, London, 1980–81, no. 30; Grand Palais, Paris, 1981, no. 101.

Anonymous Loan.

Peasants travelling to or from market were among Gainsborough's favorite subjects. In composition, this drawing is close to the paintings now at Kenwood, c. 1768–71, and at Royal Holloway College, c. 1773 (Hayes, *Landscape Paintings*, 1982, vol. II, nos. 95 and 107), in which the figures are similarly silhouetted against the sky as they travel over the brow of the hill. In spite of the resemblance in mood and general disposition of the figures between the present drawing and the Holloway College picture, the possibility that one is a study for the other would seem to be ruled out by Hayes's dating of the drawing to the early 1780s.

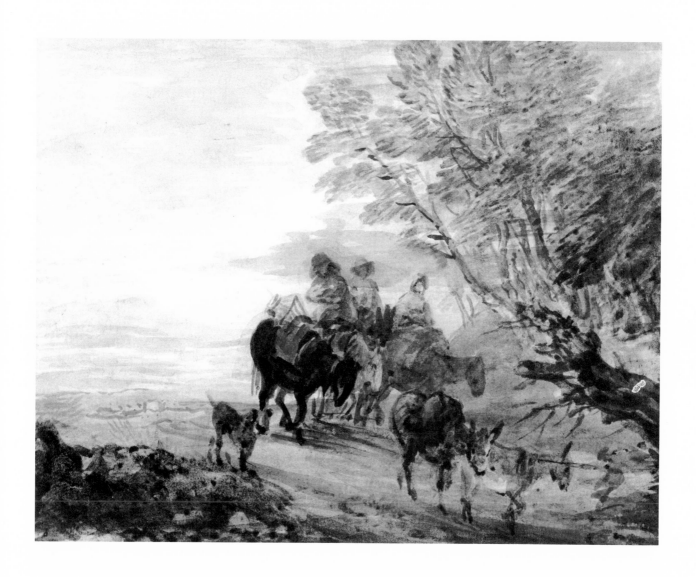

62. A WOODED LANDSCAPE WITH A COUNTRY MANSION AND FIGURES ["THE CHISWICK GATEWAY"] c. 1780–83

Gray wash.

9⅞ × 14⅛ in. (25.1 × 35.9 cm.)

Literature: Hayes, *Drawings*, no. 518.

From the Castle Howard Collection.

The buildings in Gainsborough's landscapes are usually rustic huts or peasants' cottages, but in the early and mid 1780s a grander type of house makes its appearance. These might be described as English country houses incongruously made up of simple block-like forms derived from the buildings in the backgrounds of paintings by Nicolas Poussin and Gaspard Dughet. In their combination of classical detail with conscious irregularity they foreshadow the Romantic style of Italianate "villa" architecture popularized by the Picturesque movement. Uvedale Price's writings reflect a concern for the relationship of houses to their landscape settings which Gainsborough, to judge from drawings such as this, would have endorsed: the "architect of buildings in the country should be *architetto pittore*, for indeed he ought not only to have the mind, but the hand of the painter; not only to be acquainted with the principles but, as far as design goes, with the practice of landscape painting" (*Essays on the Picturesque*, vol. II, 2nd ed., 1798).

The tradition, based on the lines by Alexander Pope inscribed on a label on the back of the drawing, and beginning "Ho! Gate, how came ye here? I came from Chelsea last year," that the gateway is copied from the one designed by Inigo Jones for Beaufort House, Chelsea, removed to Chiswick in 1738, is unfounded.

142

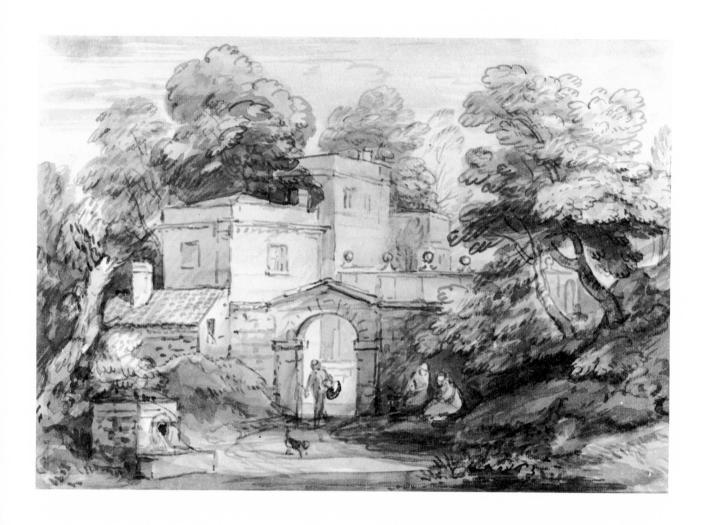

63. GLASTONBURY ABBEY c. 1782

Black and white chalks on gray paper.

6½ × 8³⁄₁₆ in. (16.5 × 21.1 cm.)

Inscribed, in a later hand, in ink bottom left: *Glastonbury Abby* (illegible word) *T. Gainsborough.*

Collector's mark of A. G. B. Russell (Lugt 2770ᵃ) at bottom left.

Literature: Hayes, *Drawings*, no. 573; Hayes, *Landscape Paintings*, 1982, vol. I, p. 160 and fig. 191.

Exhibitions: *Gainsborough*, The Tate Gallery, 1980–81, no. 32.

Collection of Lady Witt.

According to Henry Bate-Dudley (1745–1824) who knew him well during the last decade of his life, Gainsborough, accompanied by his nephew Gainsborough Dupont, "about six years before his death made a tour through the west of England to observe the diversity of land-scape, the varied combination of objects and tinges of hue in a country so rich and romantic" (*Morning Herald*, 19 September 1789). This is the language of the Picturesque movement, and Gainsborough's visits to the West Country, probably in 1782, and to the Lake District in the following year, were "Picturesque Tours" of a type undertaken by countless British artists and travellers in the late eighteenth century. Gainsborough seems to have made only a few drawings while on these tours: his motive in travelling was not that of artists like Paul Sandby or Thomas Hearne who gathered topographical material to be turned into engraved views. He could, in theory, have drawn this view of Glastonbury Abbey when he was living in Bath between 1759 and 1774, but its style suggests a date in the early 1780s. It shows the ruined Abbey with St. Michael's Chapel on Glastonbury Tor, in typical Pic-turesque fashion, with its façade viewed from an angle, and with moss and fern clinging to its masonry.

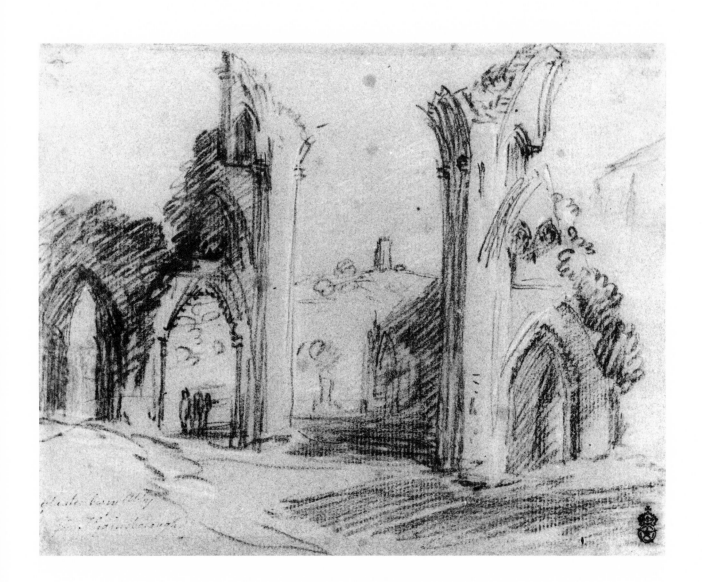

64. A MOUNTAIN LANDSCAPE WITH A SHEPHERD AND SHEEP c. 1783–84

Black chalk and stump with white chalk on buff paper.

9³/₁₆ × 14⁵/₁₆ in. (23.3 × 36.3 cm.)

Literature: Hayes, *Drawings*, no. 590; Hayes, *Landscape Paintings*, 1982, vol. II, p. 516 and pl. 146b.

Exhibitions: *Gainsborough*, The Tate Gallery, London, 1980–81, no. 34.

Museo de Arte de Ponce (The Luis A. Rerre Foundation).

Drawn shortly after Gainsborough returned from a tour of the Lake District in the late summer of 1783, this is a study for the landscape painting commissioned by the Prince of Wales which was exhibited at Schomberg House in July 1784 (now on loan to the Neue Pinakothek, Munich, from the Bayerische Landesbank). The Prince failed to pay for the painting and it stayed in the artist's studio until settlement of the debt in 1793, five years after Gainsborough's death. In 1810 the Prince gave this landscape and its companion, *The Harvest Waggon* (Art Gallery of Ontario) to Mrs. Fitzherbert.

The drawing is based on Gainsborough's recollections of the rugged landscape of the Lake District. The mountains in the background are a generalized impression of the Langdale Pikes, of which he had made a study in 1783 (Hayes, *Drawings*, no. 577), but the drawing is in no sense a topographical one. In the painting Gainsborough added a group of cows at the left-hand side, and a cluster of buildings in the middle distance. The most significant change, however, is that of mood. Henry Bate-Dudley's review of the Schomberg House exhibition, published in *The Morning Herald*, 26 July 1784, noted of the painting, "a solitary gloom diversifies a part of it, so as to awaken corresponding ideas in the mind."

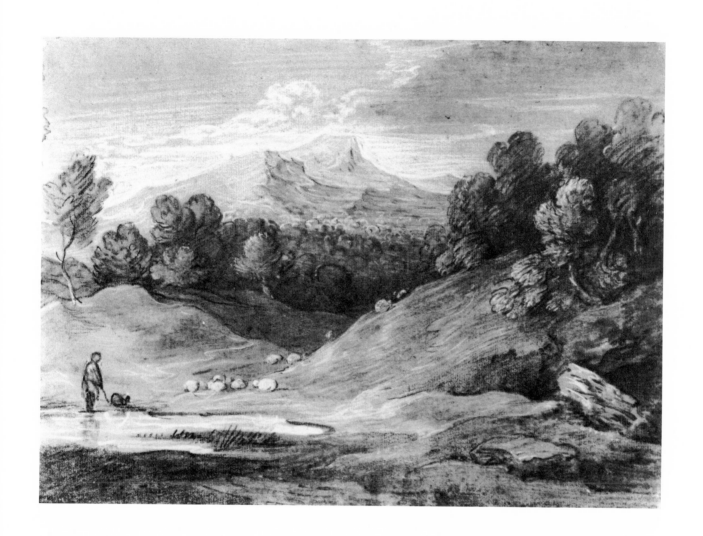

65. STUDY FOR THE PORTRAIT OF THE DUKE AND DUCHESS OF CUMBERLAND WITH LADY ELIZABETH LUTTRELL c. 1783–85

Black chalk and stump heightened with white on buff paper.
17 × 12⁷/16 in. (43.2 × 31.6 cm.)
Literature: Hayes, *Drawings*, no. 58; D. Manning, "Gainsborough's Duke and Duchess of Cumberland with Lady Elizabeth Luttrell," *The Connoisseur*, June 1973, pp. 85–93; Hayes, *Gainsborough*, 1975, p. 223 and pl. 158.
Exhibitions: *Gainsborough and Reynolds in the British Museum*, 1978, no. 78.
The Trustees of the British Museum (1902–6–17–6).

A study for Gainsborough's portrait of George III's youngest brother, Henry Frederick, Duke of Cumberland (1745–90) and his wife Anne (1743–1808), with the Duchess's sister Lady Elizabeth Luttrell (d. 1799). To judge from Gainsborough's first sketch, now in the Royal Collection (Hayes, *Drawings*, no. 57), he originally intended a horizontal design; in this drawing, the composition has been changed to an upright format, a shape emphasized by the trees which frame the figures. Although painted on a rectangular canvas, the final composition was completed as an oval; Gainsborough must have changed his mind while working on the picture, for the areas now obscured by spandrels were originally sketchily painted with a continuation of the landscape, which he later covered with a thin layer of paint. In the painting, which is markedly Watteauesque in character, the Duke's pose is closer to that in the initial study, and an urn on a plinth is introduced to add depth to the composition.

The Duke of Cumberland, "pert, insolent and senseless," who married the widowed Mrs. Horton in 1771, had previously involved himself in a notorious liaison with Lady Grosvenor. The Duchess "had more the air of a woman of pleasure than a woman of quality . . . there was something so bewitching in her languishing eyes . . . and her coquetry was so active, so varied, and yet so habitual, that it was difficult not to see through it, and yet as difficult to resist it." Her sister was a notorious gambler, later imprisoned for debt.

Although said to have been painted "at the Duke's insistence," the picture was included among those exhibited for sale at Schomberg House by the artist's widow and nephew in 1789. At fifty guineas it remained unsold, but later was bought by or on behalf of the Prince of Wales (later George IV) at Mrs. Gainsborough's sale at Christie's in 1792.

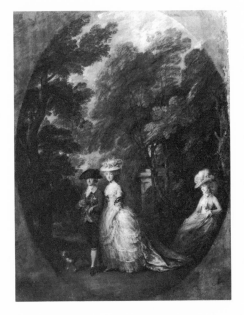

Thomas Gainsborough. *The Duke and Duchess of Cumberland with Lady Elizabeth Luttrell*, c. 1783–85. Oil on canvas. Oval. 64¹/2 × 49 in. (163.8 × 124.5 cm.) Reproduced by Gracious Permission of Her Majesty Queen Elizabeth II.

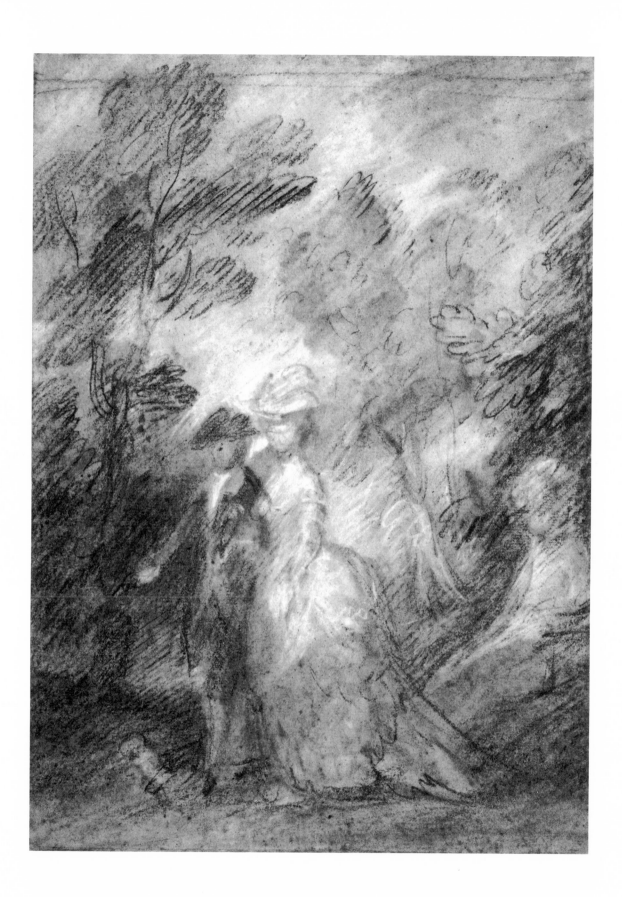

66. STUDY FOR *DIANA AND ACTAEON* c. 1784–85

Black and white chalks with washes of gray and gray-black on buff paper.
10¹/₁₆ × 13⅛ in. (25.6 × 33.3 cm.)
Literature: Hayes, *Drawings*, no. 810; Hayes, *Gainsborough*, 1975, p. 225 and pl. 165;
Hayes, *Landscape Paintings*, 1982, vol. I, p. 174 and vol. II, p. 538 and pl. 160a.
Exhibitions: *Gainsborough*, The Tate Gallery, London, 1980–81, no. 40; Grand Palais,
Paris, 1981, no. 105.
Anonymous Loan.

The earliest of the three surviving studies for the painting *Diana and Actaeon*, now in the Royal Collection. This is the only example in Gainsborough's work of a subject from classical mythology, and it was painted at a time when he was consciously developing a new approach to the role of the human figure in his landscapes. Unlike many of his contemporaries, Gainsborough was never tempted in the direction of "history painting;" indeed his friend William Jackson recorded that he "thought he should make himself ridiculous by attempting it" (*The Four Ages*, 1798, p. 179). *Diana and Actaeon*, however, offered him the challenge of combining a group of figures with a wooded landscape, which he explored in his preparatory drawings. There is no record that Gainsborough was commissioned to paint *Diana and Actaeon*. This was probably a private work (as were a number of his late "fancy" pictures), which may explain why the painting was not completed and has the character of an enlarged sketch. Although Francis Hayman had painted the same subject in the 1760s, it is more likely that Gainsborough was influenced in his choice of theme by Francis Wheatley's *Bathers by a Waterfall* (Yale Center for British Art), painted in 1783, with which *Diana and Actaeon*

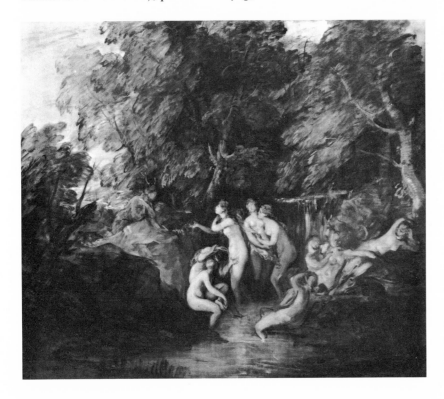

Thomas Gainsborough. *Diana and Actaeon.*
Oil on canvas. 62¼ × 74 in. (158.1 × 188.0 cm.). Reproduced by Gracious Permission of Her Majesty Queen Elizabeth II.

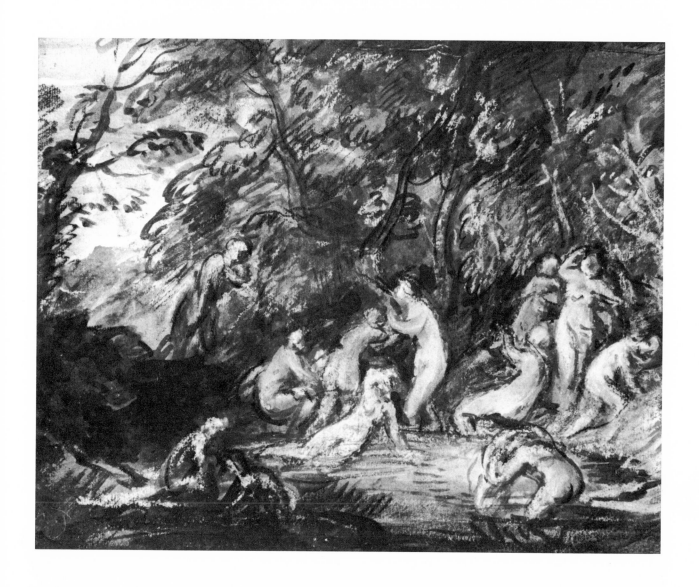

shares some similarity of composition: on the whole, however, his treatment has closer affinities with French painting of the period, notably that of Fragonard.

The subject is taken from Ovid's *Metamorphoses*, Book III. Actaeon, hunting in a sacred valley, came by accident upon Diana's bathing place. The goddess threw a handful of water in his face, whereupon he was transformed into a stag and torn to pieces by his own hounds. Gainsborough's development of the design may be traced from the present drawing, in which the confusion caused by Actaeon's appearance is vividly captured, particularly in the group of nymphs on the right who turn away: Diana is at the center of the composition, about to throw the water at Actaeon. The tonal contrasts emphasize the glimmering white bodies of the nymphs against the dark trees. Unusually for Gainsborough, one of the figures—the seated nymph to the left of Diana—was probably based on an Antique prototype known to him through a bronze by Adriaen de Vries (c. 1560?–1626) which he also used for the painting *Musidora* (The Tate Gallery), another late work.

67. STUDY FOR *DIANA AND ACTAEON* c. 1784–85

Black chalk with washes of gray and yellow, heightened with white.
10¹³/₁₆ × 14¹/₁₆ in. (27.5 × 35.7 cm.)
Literature: Hayes, *Drawings*, no. 812; *Gainsborough*, 1975, p. 225; Hayes, *Landscape Paintings*, 1982, vol. II, p. 538 and pl. 160c.
Exhibitions: *Gainsborough*, Grand Palais, Paris, 1981, no. 106.
The Trustees of the Cecil Higgins Art Gallery (P. 118).

This drawing is the last in order of the three surviving designs for the painting of *Diana and Actaeon* in the Royal Collection. In the second

Thomas Gainsborough. Second study for *Diana and Actaeon*. Gray and gray-black washes and white chalk on buff paper. 11 × 14⁷/₁₆ in. (27.9 × 36.7 cm.). Huntington Art Gallery, San Marino.

(Huntington Library and Art Gallery, San Marino), Gainsborough has simplified the composition by reducing the number of figures: Diana is moved to the left, the nymphs form a separate group to the right, and Actaeon is shown attempting to shield himself from the water thrown at him by the goddess, but unsuccessfully since the horns have begun to sprout. This third study, which comes close to the final result, combines elements from the two previous drawings. It is less agitated in mood though instead of moving forward towards Diana, Actaeon recoils in horror. In the painting, his pose was altered yet again, and he is shown kneeling as if begging for mercy. The waterfall, only sketchily suggested in the third drawing, serves to link together the groups of figures. Numerous *pentimenti* on the canvas show that in spite of all his careful preparations, Gainsborough continued to evolve fresh ideas as he went along. Such a procedure was characteristic of his methods, indeed it is this spontaneity that gives many of his paintings their particular beauty. The mood of poetic melancholy argues knowledge of Van Dyck's *Cupid and Psyche* in the Royal Collection, as Sir Oliver Millar has suggested.

68. A WOODED LANDSCAPE WITH A COTTAGE, FIGURES AND A BOAT ON A LAKE c. 1783–85

Brown chalk and oil on brown prepared paper, varnished.

8¼ × 11⅜ in. (21.0 × 28.9 cm.)

Inscribed on the *verso*: Earl of Bessborough.

Literature: Hayes, *Drawings*, no. 667; Hayes, *Gainsborough as Printmaker*, 1972, pl. 75.

Engraved: Soft-ground etching with aquatint (in reverse direction), by Thomas Rowlandson, in *Imitations of Modern Drawings*, c. 1784–88.

Birmingham Museums and Art Gallery.

In subject and treatment this drawing may be compared with Gainsborough's transparency painted on glass, *A Wooded Moonlight Landscape with a Cottage by a Pool*, datable c. 1781–82 (Hayes, *Landscape Paintings*, 1982, vol. II, no. 134). It was among the drawings engraved by Rowlandson in his *Imitations of Modern Drawings*, published c. 1784–88, in a style that is almost a parody of Gainsborough's own soft-ground etchings. Rowlandson coarsens the contours of all the forms and reduces Gainsborough's characteristically summary but expressive line to a series of calligraphic flourishes.

69. A WOODED LANDSCAPE WITH HORSEMEN AND FIGURES c. 1783

Black and brown chalks, with washes of gray and brown, and oil, varnished.
8¹¹/₁₆ × 12 in. (22.1 × 30.5 cm.)
Literature: Hayes, *Drawings*, no. 724.
Courtauld Institute Galleries, University of London.

Gainsborough adapted this composition in an aquatint executed
c. 1783–85 but not published until 1797 when Boydell issued a series of
twelve prints by the artist in varying techniques. Aquatint, a form of
tone etching which reproduces the effect of a wash drawing, was in-
vented in France in the late 1760s. The first English practitioner was
Peter Burdett of Liverpool who may, as John Hayes has suggested,
have taught the technique to Gainsborough in the early 1770s. Gains-
borough would also have been aware of the numerous aquatints by
Paul Sandby, the popularizer of the process. Very few of Gainsbor-
ough's prints were published in his lifetime (why, is still not clear), but
it is characteristic of his interest in all the current techniques that he
should have experimented with aquatint. See John Hayes, *Gainsborough
as Printmaker*, 1972, no. 14.

70. A WOODED LANDSCAPE WITH BUILDINGS, LAKE AND A ROWING BOAT c. 1784?

Black chalk and stump with white chalk.

10¾ × 14⅜ in. (27.3 × 36.5 cm.)

Literature: Hayes, *Drawings*, no. 627; Hayes, *Landscape Paintings*, 1982, vol. I, p. 132 and pl. 160.

Exhibitions: *Gaspard Dughet and his influence on British Art*, The Iveagh Bequest, Kenwood, 1980, no. 80.

Collection of Hugh Cavendish.

This drawing of the mid 1780s reflects the influence of Gaspard Dughet (1615–1675), whose compositional formula was clearly admired by Gainsborough. The grouping of the buildings clustered on the hillside by a lake is reminiscent of a Dughet such as the *Classical Landscape with a Lake* (National Gallery of Scotland); while the rowing boat (which recurs in a number of paintings and drawings by Gainsborough) seems to be derived from seventeenth-century Bolognese landscape painting.

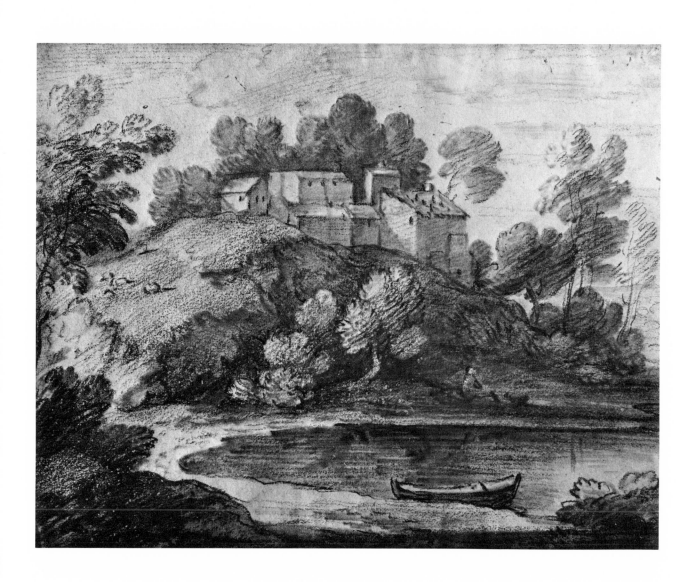

71. A MOUNTAINOUS LANDSCAPE WITH A HERDSMAN AND COWS PASSING A COTTAGE c. 1784

Black chalk and stump.

10^{15}/$_{16}$ × 14^3/$_4$ in. (27.8 × 37.5 cm.)

Literature: Hayes, *Drawings*, no. 636.

Exhibitions: *Gainsborough*, The Tate Gallery, London, 1980–81, no. 37.

Engraved: Soft-ground etching with aquatint (in reverse direction), by Thomas Rowlandson, in *Imitations of Modern Drawings*, c. 1784–88.

Collection of Hugh Cavendish.

The technique used by Gainsborough in drawings like this was described by Edward Edwards in his *Anecdotes of Painters*, 1808: "a process rather capricious, truly deserving the epithet bestowed upon them by a witty lady, who called them moppings. Many of these were in black and white, which colours were applied in the following manner: a small bit of sponge tied to a bit of stick, served as a pencil for the shadows, and a small lump of whiting, held by a pair of tea-tongs was the instrument by which the high lights were applied; beside these there were others in black and white chalks, India ink. . . . with these various materials he struck out a vast number of bold, free sketches of landscape and cattle, all of which have a most captivating effect to the eye of an artist, or connoisseur of real taste."

In this drawing Gainsborough seems to have used a combination of methods to achieve the densely worked effect, probably "mopping-in" certain areas, and allowing the natural tone of the paper to provide highlights; the granular texture of the chalk resembles his soft-ground etchings.

The composition is an idiosyncratic mixture of the sublime and the picturesque. The mountains at the left are inspired by the classicized landscapes of Gaspard Dughet, while on the other side is a cottage, the introduction of which would have been objected to by William Gilpin—"Nothing can reconcile me to a *cottage*. In nature it pleases me . . . But when I see it in a picture, I always remove my eye . . . I can give no *reason*, why a cottage may not make a pleasing picture. All I can say, is, that my eye is so captivated with sublime subjects, that it will bear no other."

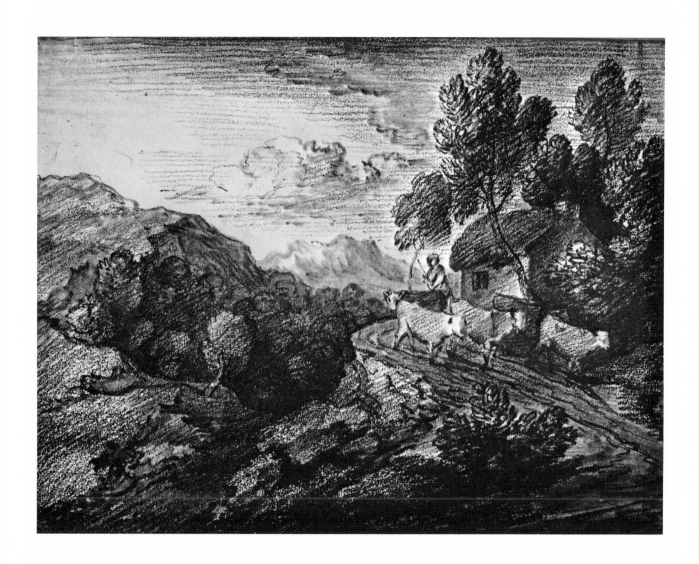

72. A WOODED UPLAND LANDSCAPE WITH FIGURES, CATTLE AND SHEEP c. 1785

Black chalk and stump and watercolor.
11 1/16 × 14^{11}/16 in. (28.1 × 37.3 cm.)
Literature: Hayes, *Drawings*, no. 657.
Staatliche Museen Preussischer Kulturbesitz, Kupferstichkabinett, Berlin (12881).

In its use of black chalk and stump this drawing resembles nos. 70, 71 and 73 but unusual for this period when most of Gainsborough's drawings were in monochrome, is the addition of watercolor, applied in light, liquid washes.

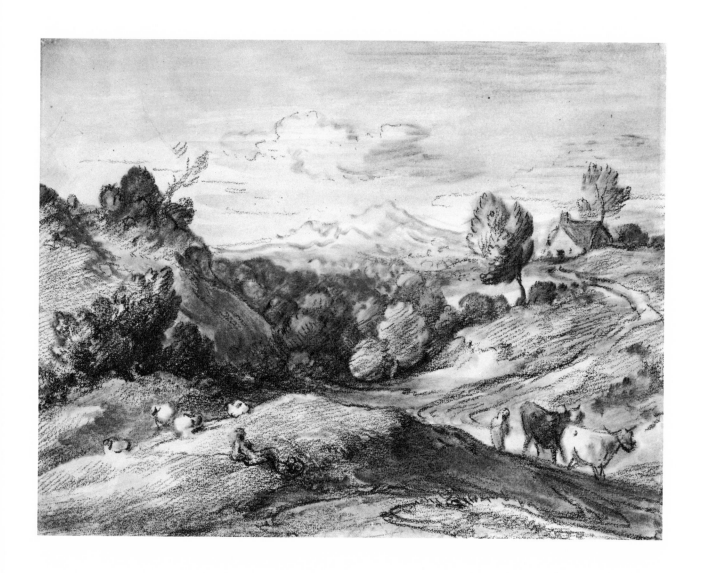

73. A WOODED LANDSCAPE WITH A COUNTRY CART c. 1785

Black chalk and stump with white chalk on buff paper.
10¹⁵/16 × 14³/4 in. (27.7 × 37.5 cm.)
Literature: Hayes, *Drawings*, no. 661; Hayes, *Gainsborough*, 1975, p. 224 and pl. 150.
Victoria and Albert Museum, London, (Dyce 671).

One of the latest interpretations of a motif that first appears in Gainsborough's work as early as the 1750s (see no. 12). Drawings of this sort, rapidly executed in soft black chalk so that the emphasis is one of continuous rhythmic movement, recall Margaret Gainsborough's comment to the diarist Joseph Farington that her father "scarcely ever in the advanced part of his life drew with black lead pencil as He cd. not with sufficient expedition make out his effects" (29 January 1799).

74. A WOODED LANDSCAPE WITH FIGURES AND A WHEELBARROW c. 1785

Brown chalk, gray and brown washes and oil on buff paper, varnished (an old crease in the paper at bottom right).
8¹/2 × 12¹/8 in. (21.6 × 30.8 cm.)
Literature: Hayes, *Drawings*, no. 664.
The Pierpont Morgan Library, New York (III, 60).

An example of Gainsborough's late drawing style at its freest and most rapid, in which the forms of the landscape and the figures seem to merge together. It is one of a small group of drawings datable in the mid 1780s, which are similar in composition, handling and technique —in particular the rough highlights in oil (see Hayes, *Drawings*, nos. 663 and 665).

It was drawings by Gainsborough of this kind that the amateur artist Dr. Thomas Monro (1759–1833) tried particularly to imitate. Dr. Monro owned a large collection of the artist's drawings and was also one of the earliest patrons of Girtin, Cotman and Turner.

164

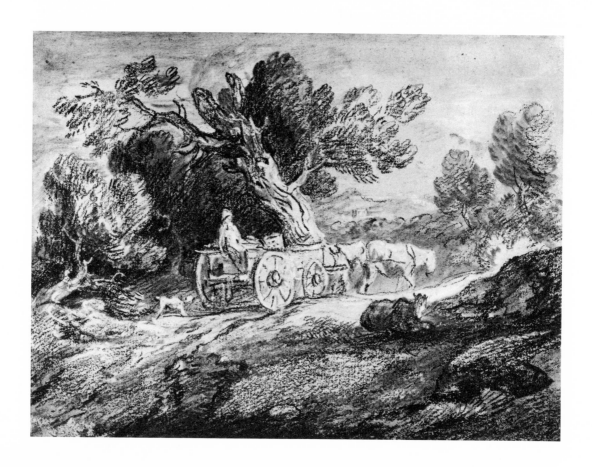

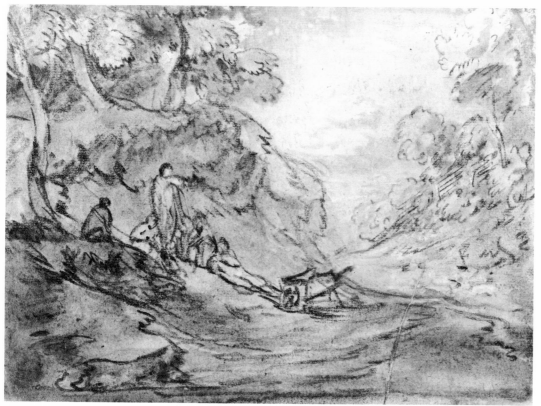

75. AN UPLAND LANDSCAPE WITH COWS
mid 1780s

Brown wash over black chalk or possibly an offset outline.

$7^{15}/_{16} \times 10^{1}/_{2}$ in. (20.2 × 26.7 cm.)

Stamped bottom left below image: *T. Gainsborough*, and inscribed at bottom left: *W. E. Nassau's sale 1824 no. 29* and on the *verso*: *1824 W. E. Nassau's sale N29*. A gold-tooled arabesque border surrounds the drawing.

Collectors' marks of William Esdaile (Lugt 2617) at bottom right and Franz Koenigs (Lugt 1023ᵃ) on the *verso* at bottom left.

Literature: Hayes, *Drawings*, no. 708.

Exhibitions: *Gainsborough*, The Tate Gallery, London, 1980–81, no. 39.

Museum Boymans–van Beuningen, Rotterdam (E10).

This drawing is one of a distinct group of landscape drawings in a very loose technique of brown or gray wash, sometimes with the addition of white bodycolor, over what appears to be underdrawing in an oily black chalk. They were probably made either for sale or for presentation, since each is surrounded by a border of embossed arabesque decoration in gold made by a bookbinder's *rouleau*, and some are stamped, also in gold, with Gainsborough's initials or his name. Their coloring and general appearance suggest that Gainsborough was setting out to appeal to the collector of old master drawings by emulating such still fashionable landscape draftsmen of an earlier generation as Marco Ricci, whose pen and wash drawings he may have had in mind.

Laurence Binyon's opinion, in his catalogue of British drawings in the British Museum (vol. II, 1900, p. 176), that the black underdrawing in the three drawings of this group from that collection was produced "by transference" (i.e. offset from another sheet) has been generally followed. Microscopic examination of these three, however, reveals nothing that can definitely be identified as offsetting. The di-

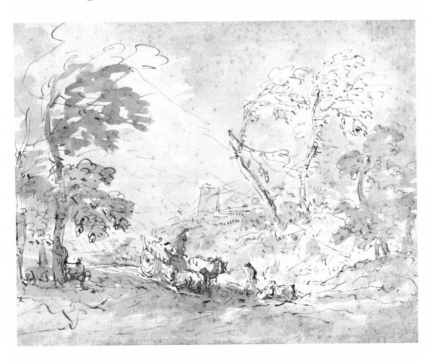

Marco Ricci (1676–1730). *Italian Landscape.*
Pen and wash. Fogg Art Museum.

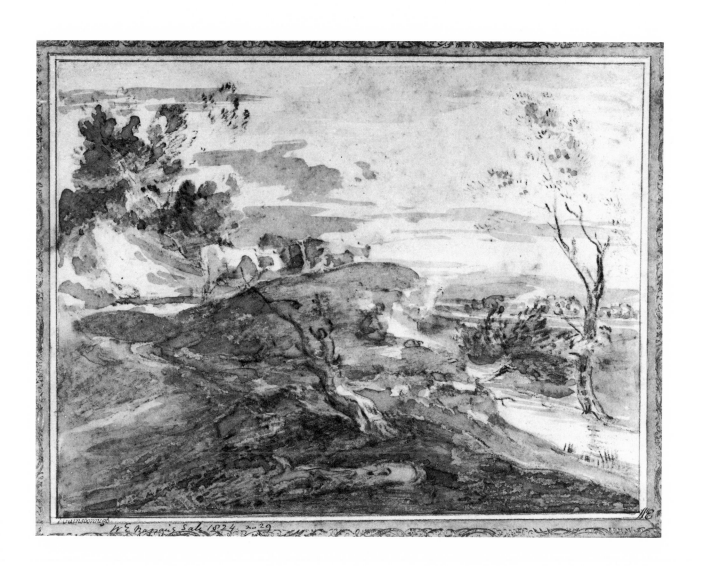

Gainsborough

W.E Nassau's Sale 1824. No 29

rection of the hatched underdrawing in one of the British Museum group (Hayes, *Drawings*, no. 586) is characteristic of a right-handed draftsman, such as Gainsborough was; had it been an offset, the hatching would have been in the opposite direction. Furthermore, the only apparent purpose of making an offset outline to be "worked up" would have been the production of more than one version of the composition —a common practice in the eighteenth century—but no second versions of any of this group are known. Rowlandson made replicas of his most successful designs using a method of offsetting (perhaps influenced by contemporary French practice), and the watercolorist Francis Nicholson (1753–1844) recalled that he could make up to six colored versions of a composition daily.

Gainsborough had begun experimenting with soft-ground etching in the mid 1770s, and it may be that his interest in expanding the range of techniques available to him accounts for the somewhat unusual appearance of such drawings. As Reynolds remarked of Gainsborough, "he neglected nothing which could keep his faculties in exercise, and derived hints from every sort of combination" (Sir Joshua Reynolds, *Discourse on Art*, ed. Robert R. Wark, New Haven and London, 1975. Discourse XIV, delivered 10 December 1788).

The earliest recorded owner of this drawing was George Nassau (1756–1823), a member of a Suffolk family, whose father had been painted by Gainsborough c. 1757 (see no. 19), and who was recorded as owning twenty-eight drawings by Gainsborough in 1820. At his sale in 1824 it was bought by William Esdaile (1759–1837), an eminent collector, particularly of landscape drawings, who owned approximately one hundred examples by Gainsborough.

76. AN OPEN LANDSCAPE WITH A HERDSMAN, COWS AND SHEEP c. 1785

Brown chalk (?) with gray wash heightened with white on gray paper.
9⅞ × 12½ in. (25.2 × 31.7 cm.)
Collector's mark of John Thane (Lugt 1544) at bottom left.
Literature: Hayes, *Drawings*, no. 694.
Lent by The Metropolitan Museum of Art, Rogers Fund, 1907.

Like no. 75, this drawing has been described as an offset outline, with added wash. Close examination suggests that the underdrawing was not produced by transference from another sheet but is probably in dark brown chalk of a rather oily type. The right-handed hatching of the outlines confirms that it is not an offset.

In style this landscape differs slightly from the so-called offsets of which no. 75 is a representative example. The use of white bodycolor and gray paper rather than transparent brown wash on white paper gives a less ethereal effect, closer to that of the studies in which the surface texture is intensified by oil paints.

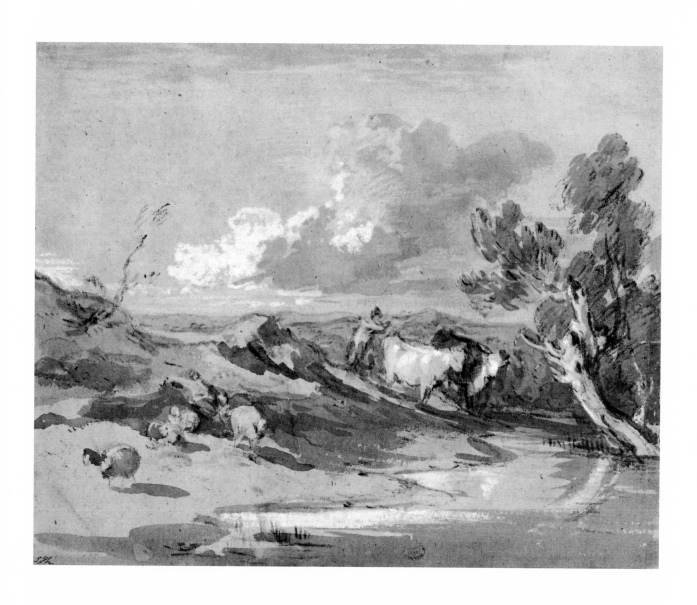

77. A MOUNTAIN LANDSCAPE WITH FIGURES AND SHEEP AT A FOUNTAIN c. 1785

Gray and gray-black wash and oil over black chalk on brown prepared paper, varnished.

8½ × 11¹³/₁₆ in. (21.6 × 30.0 cm.)

Literature: Hayes, *Drawings*, no. 725.

Yale Center for British Art, Paul Mellon Collection.

A characteristic example of a type of drawing dating from the mid 1780s in which chalk and monochrome washes are combined with oil paint. Gainsborough had used a somewhat similar technique in the early 1770s, and exhibited a series of drawings in imitation of oil paintings at the Royal Academy in 1772; those dating from the 1780s are sketchier in treatment. The motif of animals grouped around a fountain occurs in a number of his landscapes of the 1780s, notably in the one painted c. 1783 which was presented to the Royal Academy by Margaret Gainsborough (Hayes, *Landscape Paintings*, 1982, vol. II, no. 138).

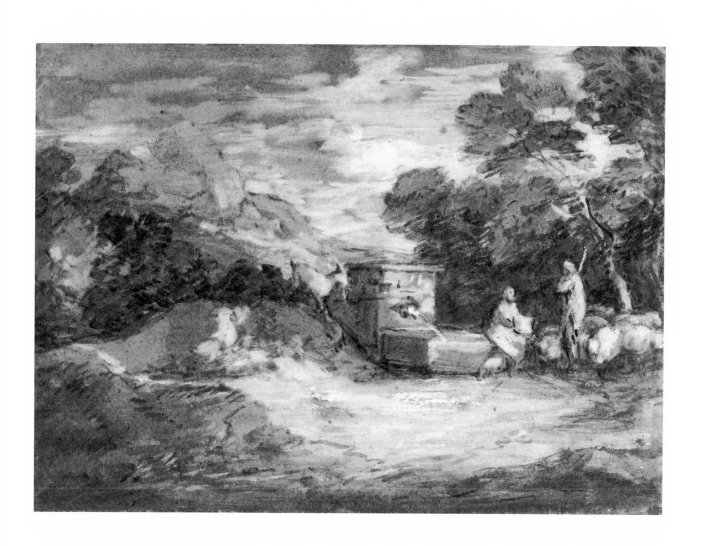

78. A COASTAL SCENE WITH SHIPPING, FIGURES AND COWS c. 1784–88

Gray and brown washes, with oil, varnished.

$8^9/_{16} \times 11^{13}/_{16}$ in. (21.7 × 30.2 cm.)

Verso: Collector's mark of the Rev. C. M. Cracherode (Lugt 607) with the date *1788*.

Literature: Hayes, *Drawings*, no. 728.

Exhibitions: *Gainsborough and Reynolds in the British Museum*, 1978, no. 64.

Engraved: In reverse, by Thomas Rowlandson, in *Imitations of Modern Drawings*, c. 1784–88.

The Trustees of the British Museum (G.g. 3–391).

In subject and composition this late drawing by Gainsborough echoes the river landscapes of Cuyp, an artist whom he greatly admired. It was copied in reverse as a soft-ground etching with aquatint by Rowlandson, who etched a number of plates after Gainsborough's drawings, five of which were published in Gainsborough's lifetime. Perhaps acquired directly from Rowlandson or his publisher John Thane, this drawing was one of a group bequeathed by C. M. Cracherode to the British Museum in 1799: they were probably the first works by Gainsborough to enter a public collection.

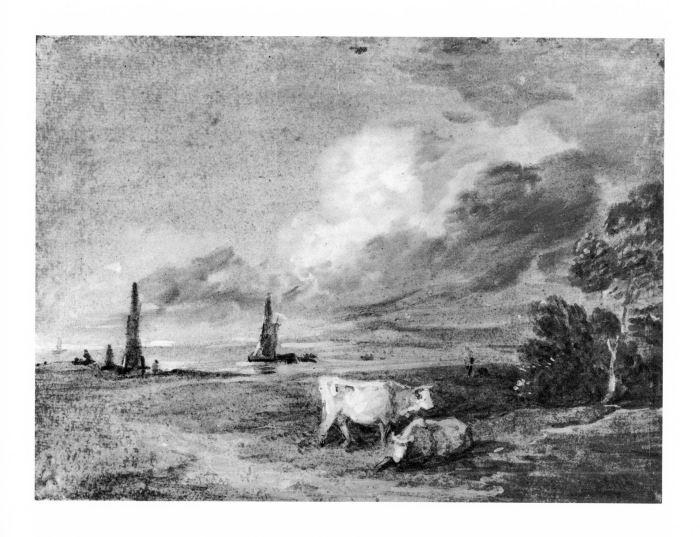

79. A HERDSMAN AND COWS
NEAR A WATERING PLACE c. 1785–87

Watercolor and oil on reddish-brown prepared paper, varnished.

$8^3/_8 \times 12^1/_{16}$ in. (21.3 × 30.6 cm.)

Literature: Hayes, *Drawings*, no. 731.

Exhibitions: *Gainsborough*, The Tate Gallery, London, 1980–81, no. 47; Grand Palais, Paris, 1981, no. 110.

Private Collection.

Even though most of Gainsborough's drawings are independent works, only a few being direct studies for paintings, his drawings often resemble his paintings very closely in both subject matter and general appearance. In this drawing, which John Hayes has dated c. 1785–7 (a slightly earlier dating is perhaps suggested by comparison with, for example, Hayes, *Landscape Paintings*, 1982, vol. II, no. 133), Gainsborough has worked watercolor and oil paint into an impasto on a reddish-brown ground, almost as if he were using a canvas. This mixed technique combined rapidity of execution and richness of effect. Since the 1770s Gainsborough had anticipated Turner's idiosyncratic methods by experimenting with unusual technical combinations. In 1773 he described in detail to his friend William Jackson his way for making varnished watercolors heightened with white lead (see M. Woodall, *Letters*, pp. 177–9). It was at this time that he also began using touches of oil paint to give added depth to his watercolors.

This was another of the drawings probably presented by the artist to Goodenough Earle (1699–1788/9) of Barton Grange in Somerset, most of which are now in American collections.

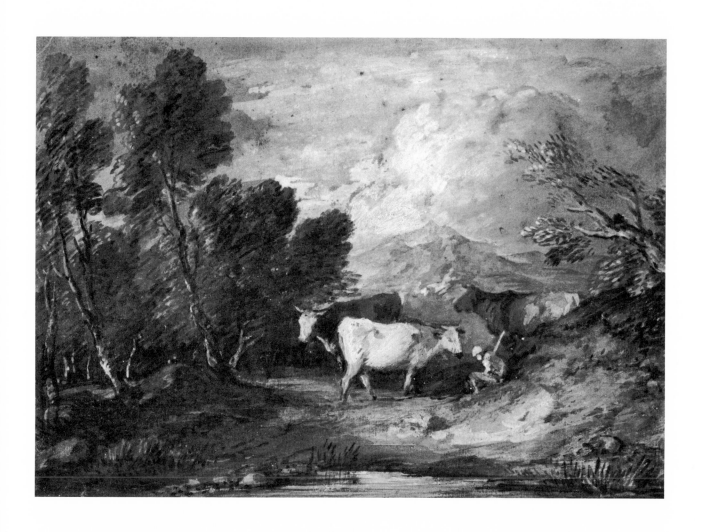

80. A WOODED LANDSCAPE WITH FIGURES ON HORSEBACK c. 1785–88

Oil and black chalk, varnished.

8^1/$_{16}$ × 11^1/$_2$ in. (20.5 × 29.2 cm.)

Literature: Hayes, *Drawings*, no. 738.

Exhibitions: *English Watercolours and Drawings: the J. Leslie Wright Bequest*, Birmingham Museums and Art Gallery, 1980, no. 30.

Birmingham Museums and Art Gallery.

A drawing comparable with no. 79 in technique, notably the use of bold highlights in oil. Although quite different in mood and treatment, it is interesting to note that even in the last years of his life Gainsborough employed compositional formulae developed decades earlier: essentially, this drawing is based on a similar serpentine design as that in the *Open Landscape with a Drover and Calves in a Cart*, c. 1755 (no. 12).

176

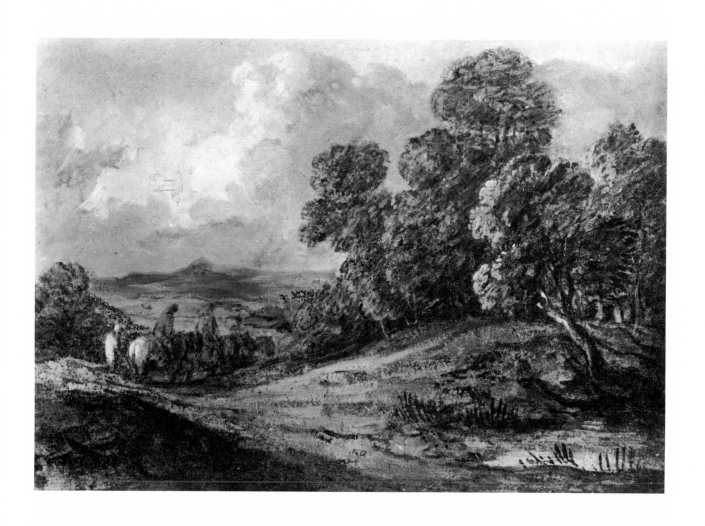

81. A WOODLAND GLADE WITH A SHEPHERD AND HIS FLOCK c. 1785?

Pencil, black chalk and stump, with orange-brown and white chalks and brown wash on gray paper.

9³/₁₆ × 12³/₁₆ in. (23.3 × 30.9 cm.)

Literature: Hayes, *Drawings*, no. 765.

Exhibitions: *One Hundred Master Drawings from New England Private Collections*, Wadsworth Atheneum, Hartford, Connecticut; Hopkins Center Art Galleries, Dartmouth College; Museum of Fine Arts, Boston, 1973, no. 34.

Collection of Mr. Eric H. L. Sexton.

This drawing has been dated by John Hayes in the mid to later 1780s, but it may be slightly earlier to judge from comparison with similar ones of c. 1780–82 (Hayes, *Drawings*, nos. 512 and 521). The composition is more enclosed than in most of Gainsborough's late drawings, so that only glimpses of the distant landscape are visible through the trees. The combination of colored chalks and wash is manipulated with a freedom and fluidity anticipating the drawings of the later 1780s in which subject matter was largely subordinated to a sense of movement.

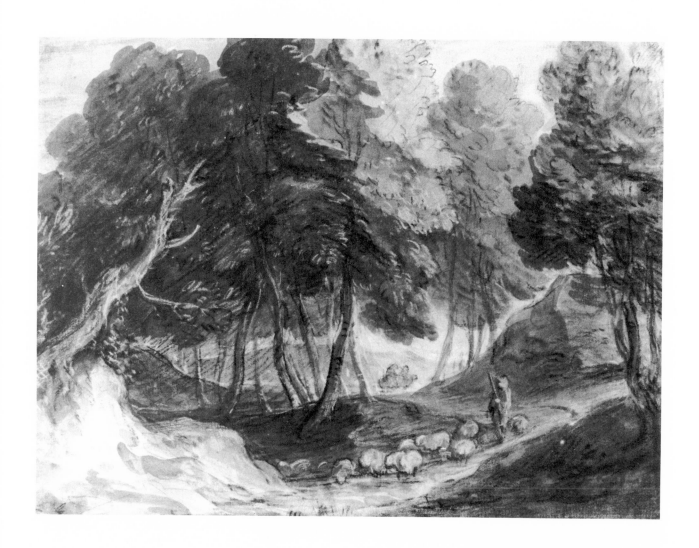

82. STUDY OF A LADY, PERHAPS FOR *THE RICHMOND WATER-WALK* c. 1785

Black chalk and stump, heightened with white, on buff paper.
19½ × 12⅜ in. (49.5 × 31.4 cm.)
Literature: Hayes, *Drawings*, no. 59; Hayes, *Gainsborough*, 1975, p. 226 and pl. 151.
Exhibitions: *Gainsborough and Reynolds in the British Museum*, 1978, no. 72; *Gainsborough*,
The Tate Gallery, London, 1980–81, no. 41; Grand Palais, Paris, 1981, no. 107.
The Trustees of the British Museum (1910–12–250).

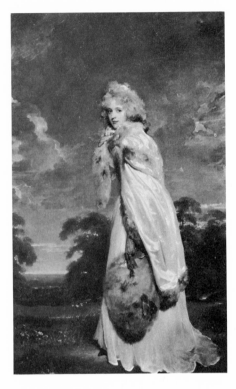

Sir Thomas Lawrence (1769–1830). *Elizabeth Farren, later Countess of Derby*. Oil on canvas. 94 × 57½ in. (238.8 × 146.1 cm.). The Metropolitan Museum of Art, New York.

One of a group of five full-length studies of women (of which four are exhibited here, nos. 82, 83, 84 and 85). No. 83 is essentially a rapidly sketched repetition of no. 82; and Hayes, *Drawings*, no. 63 seems certainly to represent the same woman. They are datable c. 1785–90 on the strength of the costume, in particular the broad-brimmed hat and the hair style with loose ringlets falling below the shoulders. The tradition that they all represent Georgiana, Duchess of Devonshire (d. 1806), cannot be traced back earlier than c. 1830, but the identification seems to be supported by comparison with Gainsborough's portrait of her (Waterhouse, no. 195) in its original full-length form as recorded in an engraving: apart from the angle of the hat, the figure corresponds closely, in reverse, with no. 85. On the other hand, a long inscription by a former owner, J. W. Croker, on a label once on the back of the frame of the present drawing, records that it was given to him by William Pearce, to whom it had been given by the artist, who was a close friend. According to a memorandum by Pearce, which Croker transcribed, it was a study for a painting commissioned by King George III who had "expressed a wish to have a picture representing that part of St. James's Park which is overlooked by the garden of the Palace—the assemblage being there, for five or six seasons, as high dressed and fashionable as Ranelagh: . . . while sketching one morning in the Park for this picture, [Gainsborough] was much struck by what he called 'the *fascinating leer*' of the Lady who is the subject of the drawing. He never knew her name, but . . . observing that he was sketching, she walked to and fro two or three times, evidently to allow him to make a likeness." Croker adds that Sir Thomas Lawrence visited him for several days in succession in order to study the drawing, when he was engaged on the portrait of Elizabeth Farren, later Countess of Derby (The Metropolitan Museum of Art, New York), in 1790.

Convincing though Pearce's account appears, it cannot be taken literally: he seems to have confused Gainsborough's painting of *The Mall*, 1783 (Frick Collection, New York), for which there is no evidence that it was commissioned by the King (indeed, it remained unsold in Gainsborough's possession until his death), with a projected picture, recorded only in a brief reference in *The Morning Herald*, 20 October 1785, by Henry Bate-Dudley, that "Gainsborough is to be employed, as we hear, for Buckingham House on a companion to his beautiful Watteau-like picture of the Park-Scene [*The Mall*]; the landscape [to be] Richmond Water-walk or Windsor—the figures all portraits." Dr.

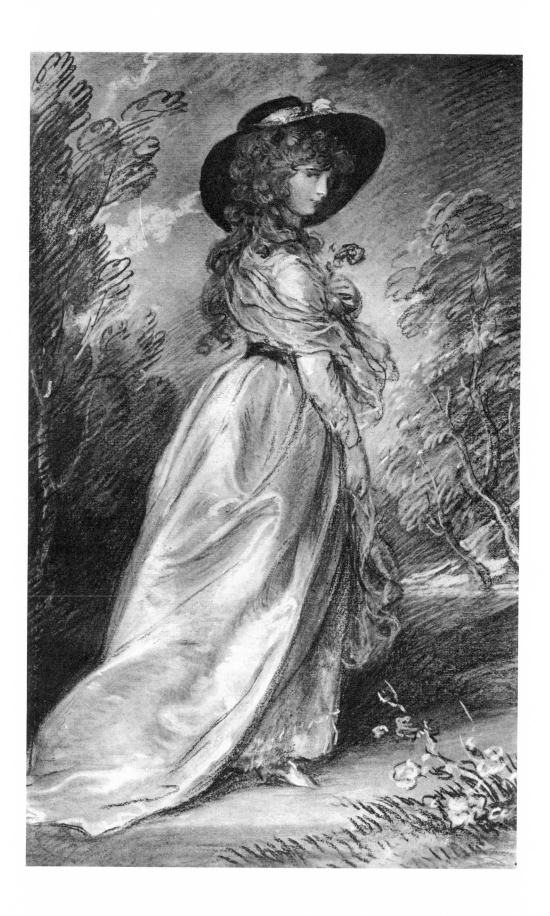

Hayes (*Burlington Magazine*, CXI, 1969, pp. 28–31) argues that the group of figure studies under discussion was made for this never-executed painting, but the evidence seems inconclusive. It is unfortunate that no composition sketch is known, in which, as with *Diana and Actaeon*, or the *Duke and Duchess of Cumberland*, Gainsborough's intentions could be more clearly discerned. It may be added that in these drawings, with the exception of no. 83, the placing of each figure on the sheet and its relation to the landscape background are more suggestive of studies for single portraits than for an elaborate figure composition. The close similarity of dress in all five studies may even suggest that, as for *The Mall*, Gainsborough used a costumed doll.

83. STUDY OF A LADY, PERHAPS FOR *THE RICHMOND WATER-WALK* c. 1785

Black chalk and stump heightened with white on buff paper.
19¼ × 12⅜ in. (48.9 × 31.4 cm.)
Literature: Hayes, *Drawings*, no. 60.
Engraved: Lithograph published by the artist's great-nephew Richard Lane,
1 January 1825.
Private Collection.

This drawing is closely related to the previous one, although less highly finished, and is perhaps a study of the same figure: the stance is almost identical except that the head is turned away from the spectator. A similar pose had been used by Gainsborough for the principal figure in the left foreground of *The Mall*, 1783. Of the five drawings connected by Dr. Hayes with *The Richmond Water-walk*, this is the only one that is primarily an idea for a pose, rather than a study for a portrait.

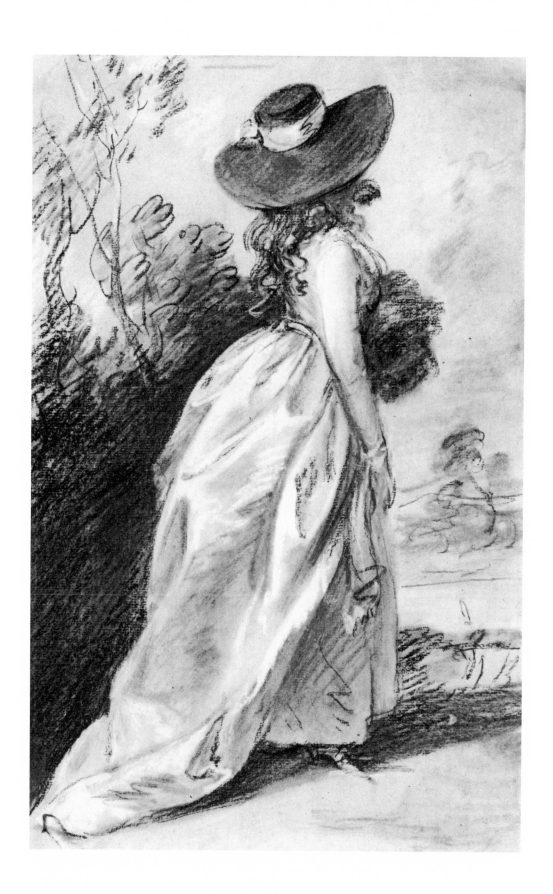

84. STUDY OF A LADY, PERHAPS FOR *THE RICHMOND WATER-WALK* c. 1785

Black chalk and stump heightened with white on buff prepared paper.
19¹/₂ × 12¹/₄ in. (49.5 × 31.1 cm.)
Literature: Hayes, *Drawings*, no. 61.
Exhibitions: *Gainsborough*, The Tate Gallery, London, 1980–81, no. 42; *European Drawings 1375–1825*, The Pierpont Morgan Library, New York, 1981, no. 112.
Engraved: Lithograph published by the artist's great-nephew Richard Lane,
1 January 1825.
The Pierpont Morgan Library, New York (III, 63b).

Like the two preceding drawings, this one has been connected, by Dr. Hayes, with Gainsborough's projected painting of *The Richmond Water-walk*; but it seems not impossible that it was made as a study for his portrait of Lady Sheffield (Waterhouse, no. 609) painted in the spring of 1785, which is in exactly the same pose, even including the slight turn of the head. It was probably this study which was catalogued in Henry Briggs's sale in 1831 as a drawing of the Duchess of Devonshire, a misidentification which may have originated with the artist's daughter Margaret, a previous owner.

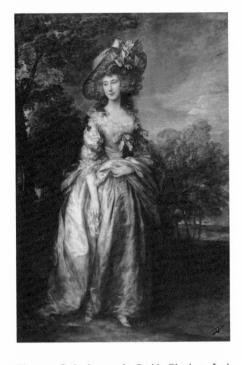

Thomas Gainsborough. *Sophia Charlotte, Lady Sheffield*, c. 1785–86. Oil on canvas. 89¹/₂ × 58³/₄ in. (227.3 × 149.2 cm.). National Trust, Waddesdon Manor.

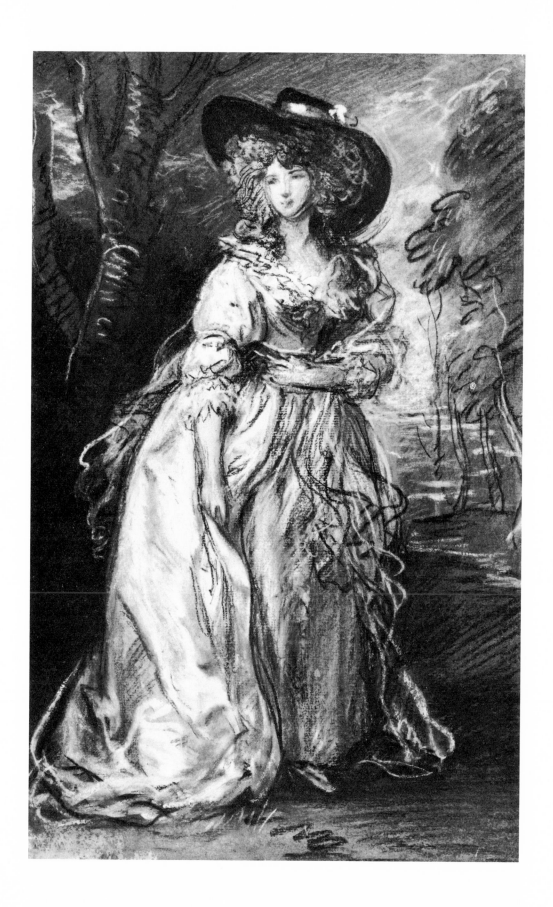

85. STUDY OF A LADY, PERHAPS FOR *THE RICHMOND WATER-WALK* c. 1785

Black chalk and stump, heightened with white, on buff paper (trimmed at all four corners and made up).

19¹/₁₆ × 12¹/₄ in. (48.4 × 31.1 cm.)

Collector's mark of the 4th Earl of Warwick (Lugt 2600) at bottom right.

Literature: Hayes, *Drawings*, no. 62.

Exhibitions: *Gainsborough and Reynolds in the British Museum*, 1978, no. 73.

Engraved: Lithograph published by the artist's great-nephew Richard Lane, 1 January 1825.

The Trustees of the British Museum (1897-4-10-20).

Like the three preceding drawings, this one has been connected by John Hayes with the projected painting of *The Richmond Water-walk*. It is sketchier than no. 84 and the head is only lightly blocked in. Gainsborough used exactly the same pose in reverse for the full-length portrait of the Duchess of Devonshire (Waterhouse, no. 195), the original appearance of which is now known only from copies and engravings, having been cut down in the early nineteenth century. Apart from the angle at which the hat is placed, this drawing corresponds closely with the painting as engraved by Robert Graves in 1870. The stiffness of the pose suggests that this study was not drawn from life.

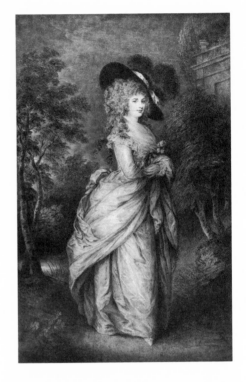

after Thomas Gainsborough. *Georgiana Duchess of Devonshire*. Engraving by R. Graves, published 1870. 16¹/₄ × 10³/₈ in. (39.8 × 25.7 cm.). The Trustees of the British Museum.

186

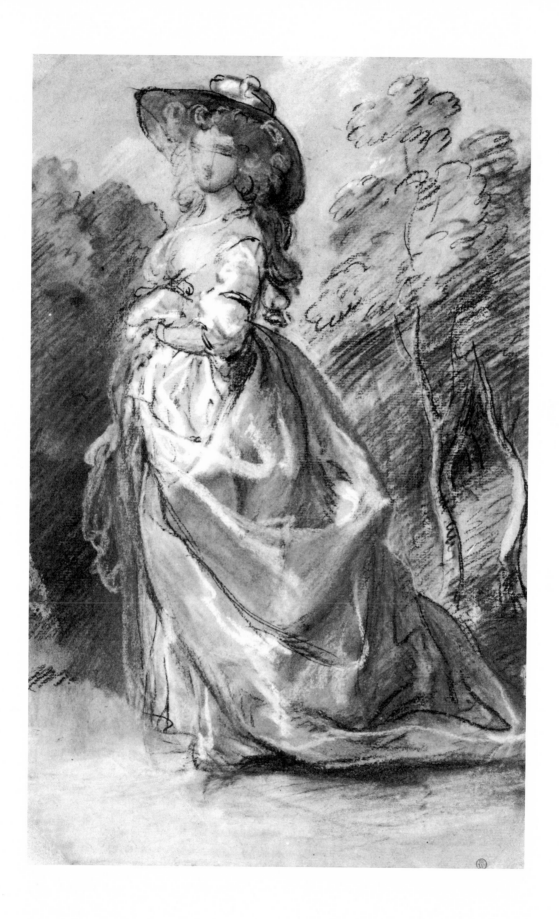

86. STUDY FOR *THE HOUSEMAID* c. 1785–88

Black chalk and stump, heightened with white, on gray paper.
13⅝ × 9¾ in. (34.6 × 24.8 cm.)
Literature: Hayes, *Drawings*, no. 837.
The Trustees of the Tate Gallery.

A study for the late unfinished picture, *The Housemaid*, in the Tate Gallery, painted c. 1785–88. The resemblance between the features of the figure and those of the Hon. Mrs. Graham (National Gallery of Scotland), exhibited in 1777, gave rise to the legend that she was the subject of the Tate picture; but the resemblance—which is not at all apparent in this drawing—is probably coincidental. Nevertheless, there is an element of contrived simplicity about the picture which suggests that Gainsborough may have had in mind the notion of a sophisticated Arcadian rusticity. It is perhaps worth noting in this connection that the Duchess of Devonshire went to a ball in 1786 "en servante."

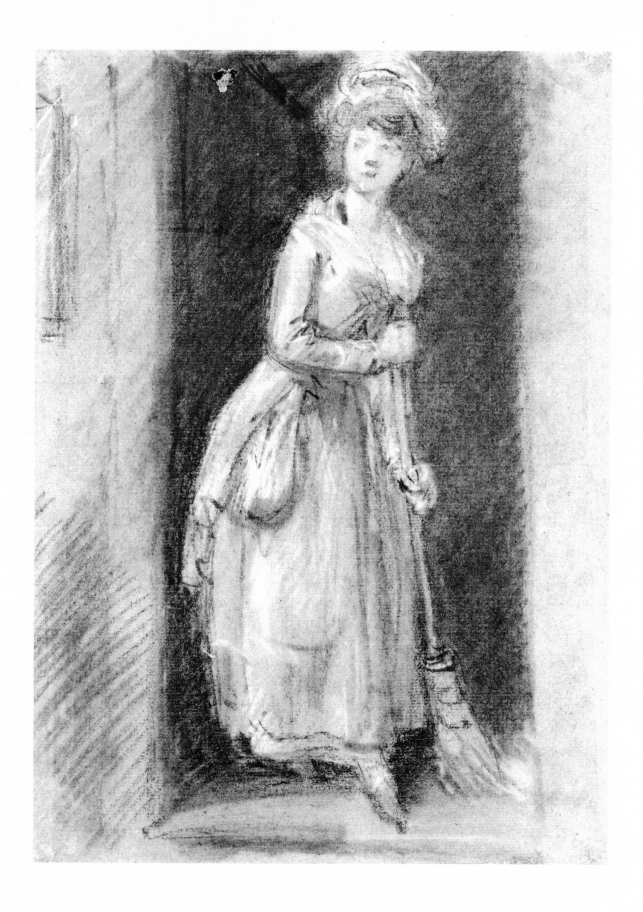

87. STUDY OF A WOODMAN CARRYING FAGGOTS c. 1787

Black chalk and stump heightened with white on buff paper.
20¼ × 12¹⁄₁₆ in. (51.4 × 30.6 cm.)
Inscribed in pencil at bottom left: *Tho.ˢ Gainsborough Del.ᵗ*
Literature: Hayes, *Drawings*, no. 850.
Exhibitions: *Gainsborough*, The Tate Gallery, London, 1980–81, no. 45.
Private Collection.

Both in subject and in mood this drawing is closely related to the life-size picture of *The Woodman*, which Gainsborough painted only a year before his death. It was destroyed by fire in 1810 and is known only through an engraving. Though the pose and action of the figure are different, the same model appears in both. Gainsborough himself regarded the painting as his masterpiece, and it was highly admired by contemporary connoisseurs including the King and Sir Joshua Reynolds, being sold after his death for the unusually high price of 500 guineas.

Why was this picture so highly regarded, and what were Gainsborough's intentions in painting it? It is one of the group of "fancy" pictures begun in 1781, solemn in mood and representing such rustic themes as *The Woodgatherers* (The Metropolitan Museum of Art) and *The Cottage Door* (Huntington Art Gallery, San Marino, California), with which he also had a considerable success. But *The Woodman* goes beyond any of these in depicting, not some obviously appealing young woman or child, but a decrepit old man. The figure stands with his eyes turned heavenward like a Murillo saint, leaning on a stick and sheltering from the storm under a tree. Other pictures from the same group also hark back more or less directly to earlier religious paintings, and it is not difficult to recognize in this drawing an echo of the theme of *Christ Carrying the Cross*. Yet it is by no means certain that Gainsborough intended these religious allusions to be overtly recognizable: he may simply have been following the precept, and practice, of Reynolds, in his XIIth Discourse: "It often happens that hints may be taken and employed in a situation totally different from that in which they were originally employed" (Sir Joshua Reynolds, *Discourses on Art*, ed. Robert R. Wark, New Haven and London, 1975). Gainsborough's purpose may have been merely to apply the nobility and pathos of a religious image to a contemporary secular figure, and to demonstrate in his *Woodman* that a peasant could be both a hero and a man of feeling, characteristics usually associated only with the leisured classes. It is, indeed, hard to say how far his sympathetic depiction of the poor aimed at being didactic. His fondness for village children was noted by Uvedale Price; he found the condescension of his upper-class patrons repellent, and the model for *The Woodman* (and also for no. 88 in this exhibition) was "a poor smith worn out by labour" on whom he took pity and "enabled by his generosity to live." All this suggests a man inspired by impulse rather than by a self-chosen mission to improve

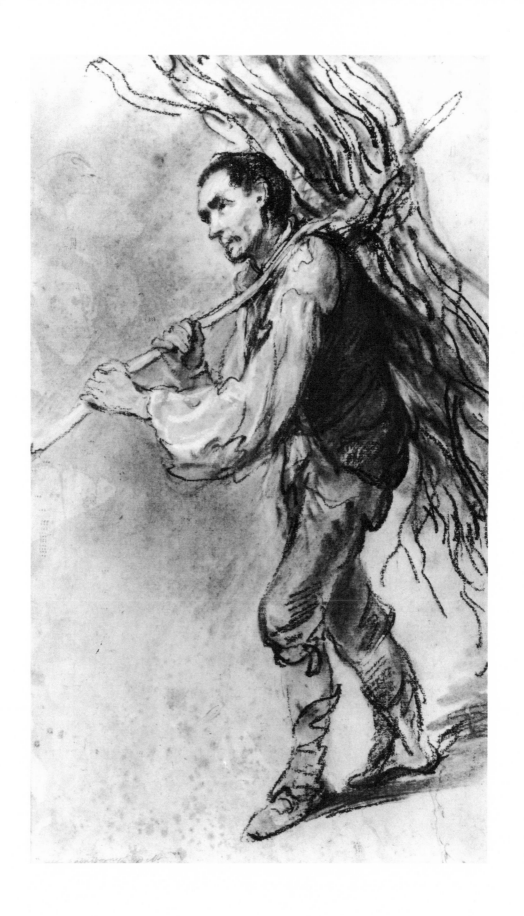

society. The argument put forward by John Barrell (*The Dark Side of the Landscape*, 1980) that Gainsborough used his peasant scenes to perpetuate the myth, so convenient to his rich patrons, of the "submissive poor"—an idea that similarly implies commitment to a social purpose— is surely at variance with everything we know of the artist's character.

88. A WOODED LANDSCAPE WITH FIGURES BY A POOL c. 1788

Black chalk and stump with touches of red chalk, gray and brown washes with some bodycolor, on buff paper.

15½ × 12½ in. (39.4 × 31.7 cm.)

Collector's mark of T. E. Lowinsky (Lugt 2420ᵃ) at bottom right.

Literature: Hayes, *Drawings*, no. 803: Hayes, *Landscape Paintings*, 1982, vol. I, p. 171, vol. II, p. 572 and pl. 185a.

Exhibitions: *English Landscape 1630–1850*, Yale Center for British Art, New Haven, 1977, no. 36; *Gainsborough*, The Tate Gallery, London, 1980–81, no. 49; Grand Palais, Paris, 1981, no. 113.

Yale Center for British Art, Paul Mellon Collection.

A study for Gainsborough's *Peasant Smoking at a Cottage Door* (University of California at Los Angeles), one of the most impressive of his pastoral subjects, painted in 1788, the year of his death. This drawing includes most of the essential features of the composition: the figures in a woodland setting, the foreground dominated by an arching tree trunk are there, but not yet the cottage. The woodcutter who in the drawing is seated on a pile of sawn branches, in the painting becomes a younger man on the steps of the cottage. The model for this figure is the one used in the previous year for *The Woodman* (see no. 87).

As Christopher White has pointed out, the technique of this study is a development of the kind of chalk drawing on colored paper made by the late seventeenth-century Dutch landscape draftsman Anthonie Waterloo, whom Gainsborough had always admired. The combination of chalk, wash and bodycolor imparts a particularly atmospheric quality to the drawing.

In his book *The Dark Side of the Landscape*, John Barrell has convincingly parallelled the painting with contemporary moral tracts directed at the peasantry. He cites as an example William Paley's *Reasons for Contentment Addressed to the Labouring Part of the British Public*, 1792. Paley claimed that "if the face of happiness can anywhere be seen, it is in the summer evening of a country village; where, after the labours of the day, each man at his door, with his children, amongst his neighbours, feels his frame and his heart at rest, every thing about him pleased and pleasing, and a delight and a complacency in his sensations far beyond what either luxury or diversion can afford. The rich want this; and they want what they must never have." Barrell suggests that the imagery of Gainsborough's late pastoral subjects was recognized by his patrons as conveying a socio-political message which endorsed the notion of the "deserving poor" satisfied with their humble lot. It may be, however,

that this interpretation is mistaking for propaganda what was regarded at the time merely as a statement of fact. While it was no doubt in the interests of the rich that the poor should remain contented with their lot, the rich were not necessarily insincere in attributing to them a particular quality of moral innocence. Gainsborough, like Paley, seems to have felt a genuine hankering for the virtuous simplicity of rural life. Whether his contemporaries necessarily interpreted his art in these terms is uncertain; his friend Henry Bate-Dudley, writing in May 1788 of the painting now in Los Angeles, recognised only one aspect of its character: "Tis reading *Poetry*, and compressing all its enchantments to the glance of the eye."

89. A ROCKY WOODED LANDSCAPE WITH A WATERFALL, CASTLE AND MOUNTAINS c. 1787–88

Black chalk and stump, heightened with white, on prepared paper.
$8^7/_8 \times 12^5/_8$ in. (22.6 × 32.0 cm.)
Literature: Hayes, *Drawings*, no. 804.
Exhibitions: *Gainsborough and Reynolds in the British Museum*, 1978, no. 77.
The Trustees of the British Museum (1910–2–12–259).

Like no. 90, this landscape must date from the last years of the artist's life, and is similarly constructed according to the theory of Picturesque composition which found its best known expression in the drawings and aquatinted illustrations of William Gilpin. Gainsborough, however, has treated the formula with an altogether greater richness and variety of texture.

The Rev'd. William Gilpin (1724–1804), *after* William Gilpin. *Dinevawr Castle*. Aquatint from *Observations on the River Wye*, 1783.

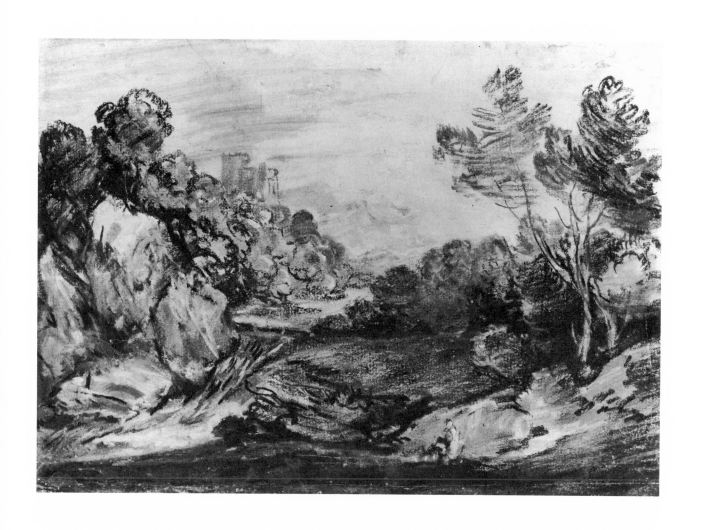

90. A WOODED LANDSCAPE WITH A CASTLE GATEWAY AND DISTANT MOUNTAINS
c. 1785–88

Black chalk and stump, heightened with white, on faded blue paper.
10⁷/₁₆ × 12¹⁵/₁₆ in. (26.5 × 32.9 cm.)
Literature: Hayes, *Drawings*, no. 806; Hayes, *Landscape Paintings*, 1982, vol. I, p. 163
and pl. 193.
Exhibitions: *English Landscape 1630–1850*, Yale Center for British Art, New Haven,
1977, no. 34; *Gainsborough*, The Tate Gallery, London, 1980–81, no. 50; Grand Palais,
Paris, 1981, no. 114.
Yale Center for British Art, Paul Mellon Collection.

The imagery of this drawing, which must date from the late 1780s, can
be seen as a parallel to one aspect of the theoretical writings of the
Picturesque movement. Though Gainsborough's inclinations were not
literary, it is clear from his letters that he had read Dr. John Brown's
descriptive guide to the Lake District before going there in 1783. The
present drawing suggests that he may also have known the series of
"Picturesque Tours" which William Gilpin initiated in the same year
with the publication of his *Tour of the Wye*. While Gainsborough may
have agreed with many of Gilpin's observations, it would have been
uncharacteristic of him to derive his subject matter directly from liter-
ary models. Many landscape features singled out by Gilpin as being
particularly "picturesque" had in fact figured in Gainsborough's work
from the 1750s onwards, but it is in his later, more generalized land-
scapes that his imagery most closely approaches Gilpin's. Gilpin's
fondness for "the castle, or the abbey, to give consequence to the
scene," the irregular silhouettes of distant mountains and rocky clefts
overhung with trees, seems to be echoed in this drawing.

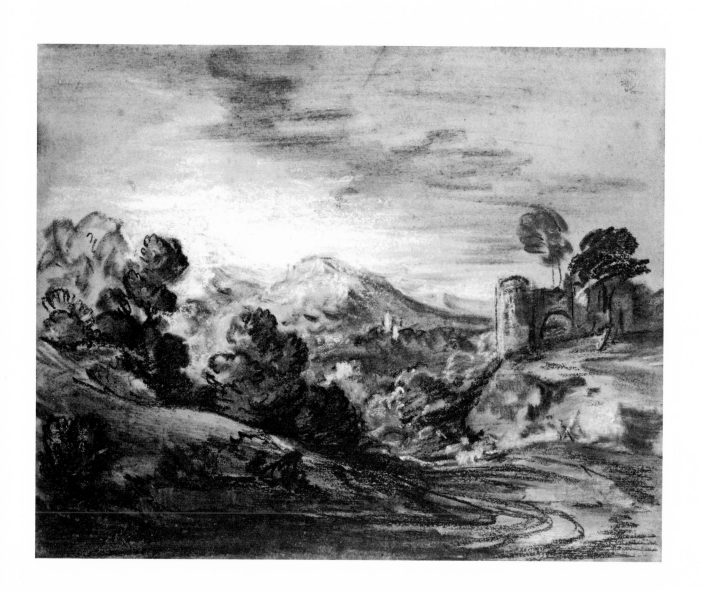

91. A WOODED LANDSCAPE WITH A COW AT A WATERING PLACE c. 1787–88

Black and brown chalks, with gray and gray-black washes, heightened with white.
9^{1}/$_{2}$ × 14^{11}/$_{16}$ in. (24.1 × 27.3 cm.)
Collector's mark of the 4th Earl of Warwick (Lugt 2600) at bottom right.
Literature: Hayes, *Drawings*, no. 809; Hayes, *Gainsborough*, 1975, p. 229 and pl. 171;
Hayes, *Landscape Paintings*, 1982, vol. I, p. 171 and pl. 208.
Exhibitions: *Gainsborough*, The Tate Gallery, London, 1980–81, no. 51.
Staatliche Museen Preussischer Kulturbesitz, Kupferstichkabinett, Berlin (4666).

One of Gainsborough's latest and most freely executed drawings. The forms are suggested with a full brush, to which black and brown chalk and white heightening are added to supply dramatic effects of light and shade which recall—notably in the reflections in the water and the silhouetted form of the cow—his experiments, made earlier in the 1780s, with landscapes painted on glass and illuminated from behind with candlelight, "viewed through a magnifying lens, by which means the effect produced is truly captivating, especially in the moon-light pieces, which exhibit the most perfect resemblance of nature" (Edward Edwards, *Anecdotes of Painters*, 1808, p. 141).

The rapid notation and exclusion of detail is a development from Gainsborough's style of the 1770s, but he may have also been aware of Alexander Cozens's blot drawings or of his treatise, *A New Method of Assisting the Invention of Drawing Original Compositions of Landscapes*, published not long before his death in 1786, which was illustrated by aquatints after his drawings. Gainsborough's combination of landscape elements in his late drawings and paintings has something in common with Cozens's comments in *A New Method* . . . : "Composing landscapes by invention, is not the art of imitating individual nature; it is more; it is forming artificial representations of landscape on the general principles of nature, founded in unity of character, which is true simplicity; concentrating in each individual composition the beauties, which judicious imitation would select from those which are dispersed in nature."

Alexander Cozens (1717–1786). *A Wooded Landscape with a Pool*. Black wash. 6^{3}/$_{4}$ × 8^{1}/$_{4}$ in. (17.2 × 20.9 cm.). Private Collection, England.

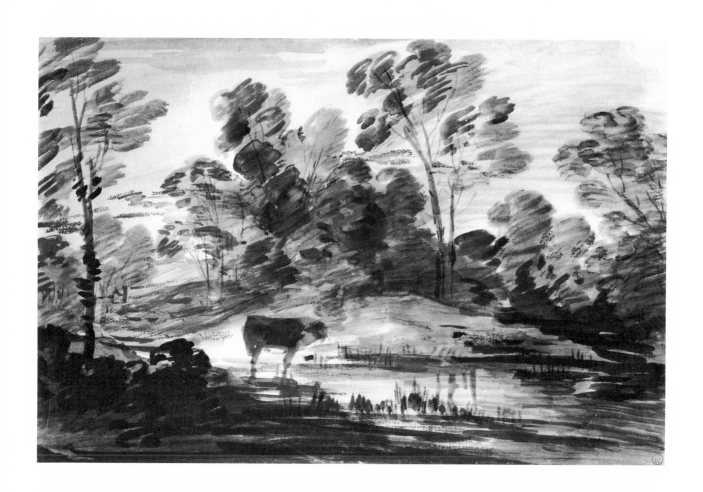

CHRONOLOGY

1727 Birth of Thomas Gainsborough, the fourth son and youngest child of John Gainsborough, clothier, and Mary Burrough; baptized May 14 at the Independent Meeting House, Friars Street, Sudbury, Suffolk.

1733 Bankruptcy of John Gainsborough.

c. 1740 Went to London, where he worked in the studio of Hubert-François Gravelot, the French draftsman and engraver, and came under the influence of the painter Francis Hayman.

c. 1745 Established his own studio in London, shortly before Gravelot left for Paris in October.

1746 Married Margaret Burr on July 15 at Dr. Keith's Mayfair chapel, London.

1747 Burial of his first daughter Margaret recorded at St. Andrew's, Holborn, London, on March 1.

1748 Returned to Sudbury. Birth of his daughter Mary. Death of John Gainsborough.

1752 Birth of a younger daughter, Margaret. Moved to Ipswich, Suffolk.

1753 First met his future biographer, Philip Thicknesse.

1758–59 Worked as an itinerant portrait painter, chiefly in Buckinghamshire.

1759 October 22–23: sale, in Ipswich, of Gainsborough's household goods and of paintings and drawings by him. Moved to Bath, Somerset.

1761 First exhibited at the Society of Artists.

1763 Seriously ill in the autumn, to the extent that his death was mistakenly noted in the *Bath Journal*. Moved to a house just outside the city.

1766 Moved to a house in The Circus, Bath.

1768 A founding member of the Royal Academy.

1769 Three paintings by Gainsborough included in the inaugural Royal Academy exhibition.

1772 His nephew, Gainsborough Dupont (1754–1797), apprenticed to him.

1773 Quarrelled with the Royal Academy about the hanging of his pictures, which resulted in his not contributing to the annual exhibitions until 1777.

1774 Left Bath and settled in London, probably in the autumn. Leased the west wing of Schomberg House, Pall Mall.

1777 Exhibited again at the Royal Academy (including his first portraits of members of the royal family).

1780 Marriage of the artist's daughter Mary to Johann Christian Fischer, February 21.

1781 Exhibited full-length portraits of George III and Queen Charlotte (thereafter receiving numerous commissions from members of the royal family); exhibited his first "fancy" picture.

c. 1781–82 Constructed his peep-show box, for which he painted small landscape transparencies.

c. 1782 Made a tour in the West Country with his nephew Gainsborough Dupont.

1783 Made a tour of the Lake District with an old Suffolk friend, Samuel Kilderbee.

1784 Final quarrel with the Royal Academy, occasioned by the refusal of the Hanging Committee to place his portrait of the three eldest Princesses as he wished; he never again exhibited at the Academy. In July, he held an exhibition of paintings in his studio at Schomberg House, and continued to organize such exhibitions annually.

1788 Died at Schomberg House on August 2 and was buried on August 9 in Kew Churchyard.

1789 Paintings and drawings by Gainsborough remaining in his studio, together with his collection of old masters, exhibited for private sale at Schomberg House, March–May. The greater number remained unsold.

1797 Following the death of Gainsborough Dupont, a sale was held at Christie's, April 10–11, in which Mrs. Gainsborough attempted to sell the remaining paintings.

1798 Death of Mrs. Gainsborough in December.

1799 In accordance with Mrs. Gainsborough's will, a sale was held at Christie's, May 10–11, at which her remaining pictures and drawings, together with Gainsborough's books and musical instruments, were sold. Margaret Gainsborough, the artist's younger daughter, sold a number of drawings privately.

1820 Death of Margaret Gainsborough, December 18.

1826 Death of Mary Fischer (née Gainsborough) in July.

SELECTED BIBLIOGRAPHY

Allentuck, Marcia: "Sir Uvedale Price and the Picturesque Garden: the evidence of the Coleorton Papers," in *The Picturesque Garden and its Influence outside the British Isles*, ed. N. Pevsner, 1974.

Barrell, John: *The Dark Side of the Landscape: The Rural Poor in English Painting 1730–1840*, 1980.

Boydell, John: *Etchings by the late Mr. Gainsborough. Twelve Prints of Landscape Scenery . . .* , 1797.

Buchwald, Emilie: "Gainsborough's 'Prospect, Animated Prospect'," *Studies in Criticism and Aesthetics 1660–1800*, ed. H. Anderson and J. Shea, 1967.

Clifford, Timothy, Antony Griffiths, and Martin Kisch: *Gainsborough and Reynolds in the British Museum* (exhibition catalogue, British Museum), 1978.

Coke, David: *The Painter's Eye* (exhibition catalogue, Gainsborough's House, Sudbury), 1977.

Corri, Adrienne: "Gainsborough's early Career: new Documents and two Portraits," *The Burlington Magazine*, April 1983, pp. 210–16.

Cunningham, Allan: *The Lives of the most eminent British Painters, Sculptors, and Architects*, 1829–33, vol. I, pp. 319–47.

Edwards, Edward: *Anecdotes of Painters*, 1808, pp. 129–43.

Farington, Joseph: *Diary*, 1793–1821. Original manuscript in the Royal Library, Windsor Castle; typescript in the British Museum Print Room. Selected extracts edited by James Greig, *The Farington Diary*, 8 vols., 1922–28. Full edition is in preparation, ten volumes of which have been published: Kenneth Garlick and Angus Macintyre, eds., *The Diary of Joseph Farington*, vols. I–VI (1793–1804); Kathryn Cave, ed., *The Diary of Joseph Farington*, vols. VII–X (1805–10).

Fulcher, George Williams: *Life of Thomas Gainsborough, R.A.*, 1856.

Hayes, John: Gainsborough Drawings (exhibition catalogue, Arts Council of Great Britain), 1960–61.

Hayes, John: "The Holker Gainsboroughs," *Notes on British Art I*, Apolo, June 1964, supplement pp. 2–3.

Hayes, John: "The Drawings of Gainsborough Dupont," *Master Drawings*, vol. 3, no. 3, 1965, pp. 243–56.

Hayes, John: "The Gainsborough Drawings from Barton Grange," *The Connoisseur*, February 1966, pp. 86–93.

Hayes, John: "Gainsborough's 'Richmond Water-walk'," *The Burlington Magazine*, January 1969, pp. 28–31.

Hayes, John: "Gainsborough and the Gaspardesque," *The Burlington Magazine*, May 1970, pp. 308–11.

Hayes, John: *Gainsborough as Printmaker*, 1971.

Hayes, John: *Gainsborough: Paintings and Drawings*, 1975.

Hayes, John: *Gainsborough* (exhibition catalogue, The Tate Gallery, London), 1980–81.

Hayes, John: *Gainsborough* (exhibition catalogue, Grand Palais, Paris), 1981.

Hayes, John: *The Landscape Paintings of Thomas Gainsborough*, 2 vols., 1982.

Hazlitt, William: *Morning Chronicle*, 10 May 1814; *The Champion*, 31 July 1814.

Hazlitt, William: *Criticisms on Art: and Sketches of the Picture Galleries of England*, 1843.

Humphry, Ozias: *Biographical Memoir*, c. 1802 (manuscript in the Royal Academy, London).

Jackson, William: *The Four Ages*, 1798.

Lane, Richard: *Studies of Figures by Gainsborough*, 1825.

Lindsay, Jack: *Thomas Gainsborough: His Life and Art*, 1981.

Mannings, David: "Gainsborough's Duke and Duchess of Cumberland with Lady Luttrell," *The Connoisseur*, June 1973, pp. 85–93.

Millar, Oliver: *Gainsborough* (exhibition catalogue, The Queen's Gallery, Buckingham Palace, London), 1970.

Millar, Oliver: *The Later Georgian Pictures in the Collection of Her Majesty The Queen*, 1969.

Paulson, Ronald: "Gainsborough: Form versus Representation," *Emblem and Expression: Meaning in English Art of the Eighteenth Century*, 1975.

Pointon, Marcia: "Gainsborough and the Landscape of Retirement," *Art History*, December 1979, pp. 441–55.

Pyne, William Henry (under pseudonym of Ephraim Hardcastle): *Wine and Walnuts*, second edition, 1824.

Reynolds, Sir Joshua: Discourse XIV, 10 December 1788, *Discourses on Art*, ed. R. Wark, 1959.

Rowlandson, Thomas: *Imitations of Modern Drawings*, 1788.

Siple, E. S.: "Gainsborough Drawings: The Schniewind Collection," *The Connoisseur*, June 1934, pp. 353–58.

Siple, Walter H.: *Exhibition of Paintings and Drawings by Thomas Gainsborough, R.A.* (exhibition catalogue, Cincinnati Art Museum), 1931.

Stainton, Lindsay: *Gainsborough and his Musical Friends* (exhibition catalogue, Kenwood, London), 1977.

Thicknesse, Philip: *Sketches and Characters of the most Eminent and most Singular Persons now living*, 1770.

Thicknesse, Philip: *A Sketch of the Life and Paintings of Thomas Gainsborough, Esq.*, 1788.

Wark, Robert: "Thicknesse and Gainsborough: Some New Documents," *Art Bulletin*, December 1958, pp. 331–34.

Wark, Robert: *Gainsborough and the Gainsboroughesque* (exhibition catalogue, Huntington Art Gallery, San Marino), 1967–68.

Waterhouse, Ellis: *Gainsborough*, 1958.

Wells, William and John Laporte: *A Collection of Prints, illustrative of English Scenery: from the Drawings and Sketches of Gainsborough: In the various Collections of the Right Honourable Baroness Lucas; Viscount Palmerston; George Hibbert, Esq.; Dr. Monro; and several other Gentlemen*, 1802–05.

Whitley, William T.: *Thomas Gainsborough*, 1915.

Woodall, Mary: "A Note on Gainsborough and Ruisdael," *The Burlington Magazine*, January 1935, pp. 40–45.

Woodall, Mary: *Gainsborough's Landscape Drawings*, 1939.

Woodall, Mary, ed.: *The Letters of Thomas Gainsborough*, 2nd edition, revised, 1963.

Gainsborough Drawings

was composed in Baskerville and Times Roman types
by The Stinehour Press, Lunenburg, Vermont.

Offset lithography is by The Meriden Gravure Company
Meriden, Connecticut.

Book design Alex and Caroline Castro
Baltimore, Maryland.